DENVER ART MUSEUM

Major Works
in the Collection

Library of Congress Catalog Card Number: LC 81-66357
ISBN 0-914738-21-6
Printed in the United States of America

Director of Publications: Marlene Chambers
Editor: Margaret Ritchie
Editorial assistance: Jane Hilberry, Carol Rawlings
Design: Cynthia Davis

Collection research: Asian art, Ronald Otsuka, curator; Native
American art, Richard Conn, curator; African and Oceanic art,
Jonathan Batkin, curatorial assistant; New World art, Robert
Stroessner, curator; European art, Cameron Wolfe, curator;
American art, Ann Daley, curator; contemporary art, Dianne
Vanderlip, curator, Deborah Allen, curatorial assistant; textiles
and costumes, Imelda DeGraw, curator.

Photography: Otto Nelson and Lloyd Rule except Fang Ngi
Society mask, Montagnais bark container, and Kwakiutl Secret
Society mask by Jonathan Batkin.
Cover photo: Howard Sokol

Typography: Lettergraphics/Denver, Inc.
Printing: A. B. Hirschfeld Press

This publication has been made possible in part by a grant
from the National Endowment for the Arts, Washington, D.C.,
a federal agency.

Frontispiece:
Mask, Kwakiutl, British Columbia, collected at Awikenox, Rivers
Inlet, late 19th century. Cedar, native paint. 28 cm. h. 1949.3641

The properties which Northwest Coast families jealously
guarded as the source of their prestige included intangibles like
legends explaining the origin of family titles and crest symbols,
as well as such practical assets as fishing grounds. These
legends were entertainingly dramatized at feasts as a public
reminder that they were valid private property. Made for such a
drama, this mask represents Bukwus, the Wild Man of the Forest.
The zoomorphic ears and beak and the staring eyes set in deep
concavities emphasize his uncivilized nature. Paint is used here
to define the subtly varied, repeated forms: green and ochre
offer a dramatic contrast to the glossy, metallic graphite.

Foreword

This new guide to the collections of the Denver Art Museum is published as part of the tenth anniversary celebration of the opening of the museum's extraordinary building in 1971. A work of art in itself, designed by the late Gio Ponti of Milan and James Sudler Associates of Denver, the new building brought the museum's extensive collections together under one roof for the first time and allowed them to be presented in effective and informative settings. At last, the public could perceive the full range, depth, and quality of the museum's holdings of world art.

Because all other major cities are at great distances from Denver, the museum's policy for the past half-century has been to build a collection representative of all major periods and cultures in the history of art in the belief that residents of the Rocky Mountain region should have the opportunity to understand and enjoy the course of world culture through the visual arts. Although it is not comprehensive, Denver's collection includes several areas of particular strength. Among the first art museums to perceive the artistic quality and individuality of various native art forms, the Denver Art Museum has been fortunate to assemble one of the largest and finest collections of Native American art in any American art museum.

Its pre-Columbian collections and, to a lesser extent, those of Africa and Oceania, have become increasingly fine and representative. The spectrum of Latin American art has also been expanded by acquisition of an exceptionally large and fine collection of Spanish colonial painting, sculpture, and decorative arts spanning four centuries.

As the following pages reveal, all of the museum's seven curatorial departments possess areas of particular importance and numerous individual works of exceptional quality. Over the past half-century, the museum has been able to assemble approximately 30,000 works of art. Their presence here is in full measure due to the exceptional generosity of thousands of donors who have contributed the objects themselves or funds for their purchase. Since the museum's extremely limited endowment funds for acquisition still yield less than $20,000 annually, the quality and scope of the collection is truly a tribute to extraordinary levels of private benefaction for the public good. Unlimited gratitude is offered those countless donors, as well as the trustees, directors, and curators over many decades, whose enthusiasm, energies, and intelligence have provided the city of Denver, the state, the nation, and, indeed, the world with both an important collection of art and some new perceptions about native arts.

The Denver Art Museum's primary objective for the future is the enhancement and expansion of its collections.

Important new collections have recently been acquired, and others will follow. Substantial purchase funds and acquisition endowment funds have been pledged and will greatly increase again in the next several years. The remarkably high public attendance that the museum and its collections have enjoyed since the opening of the new building a decade ago—the highest attendance rate per capita of any art museum in the country—has been most fulfilling. As Denver becomes a dominant force in the life and economy of the nation in the next decade, the Denver Art Museum has set a goal of growth and excellence for its collection.

I would like to take this occasion to pay personal tribute to Otto Karl Bach, my predecessor and director of the Denver Art Museum for 30 of the most important years of growth in its history. His unflagging commitment has guided the formation of this major public trust.

Thomas N. Maytham
Director

The Museum

The Denver Art Museum was founded in 1893 by a group of Denver citizens motivated by a strong desire for "the advancement of art interest in the city of Denver." Full membership in the Artists' Club, as the group was called, was initially restricted to "elected, qualifying artists." Under the leadership of Mrs. Emma Richardson Cherry and with Harvey Otis Young and Charles Partridge Adams among its charter members, the organization defined as its goal "...to cultivate and promote a general interest and appreciation of the arts, and to advance such interest and appreciation by any appropriate means." Since the club lacked a permanent building, an art collection, and capital funding, "appropriate means" took the form of an annual exhibition held in whatever space could be scavenged— an empty store or the University of Denver College of Art, which then had a downtown location.

The Artists' Club soon voted to extend membership to two amateur painters: Anne Evans, daughter of Colorado's second territorial governor, and Marion Grace Hendrie, daughter of pioneer Denver businessman Charles Francis Hendrie. Both women were destined to have tremendous impact on the growth of the museum and its present-day collections. Miss Evans, who advocated the acquisition of native art, provided funds for the development of the collections and eventually donated her personal collection of santos and American Indian objects to the museum. Marion Hendrie's collection of early 20th century works, together with a permanent endowment for the purchase of art objects, was bequeathed to the museum in the late 1960s.

In 1917 the Artists' Club changed its name to the Denver Art Association, opened its membership to non-artists, and hired its first director, Reginald Poland, who is credited with increasing the number of exhibitions and initiating a lecture program. Under its second director, George William Eggers, the association again changed its name—this time to the Denver Art Museum—and in 1922 acquired its first official home, a brownstone mansion presented by Jean Chappell Cranmer and Delos A. Chappell as a memorial to their parents.

The fledgling museum captured the interest of Mayor Benjamin F. Stapleton, who recommended relocating it in or near the Civic Center. In 1925 the museum received its first financial encouragement from the city, an appropriation of $3,000. The museum's lecture program was spurred in 1926 when Miss Florence Martin funded the Cooke-Daniels Lecture Foundation in memory of Major William Cooke-Daniels and his wife, Cicely. Income from this trust continues to bring to Denver leading scholars and performers in all areas of the arts and related fields.

7

Two major events occurred in 1932. Under the directorship of Cyril Kay Scott, the museum moved its permanent collection and offices to the newly built City and County Building flanking Civic Center. Until its demolition in 1970, Chappell House was to remain the permanent home of the American Indian collection, as well as a temporary exhibition site. About the same time, the museum entered into a four-party agreement with the City and County of Denver and trustees of the estates of Helen Dill and Rachael M. Schleier, both important donors to the museum. The agreement established the Denver Art Museum as the official art agency of the city and provided for an annual municipal appropriation for museum operation and maintenance. Money for acquisitions and educational programs was to come from other sources. In addition, the city agreed to acquire land for a new museum facing Civic Center. The museum undertook to raise funds for the building. The trustees of the Dill estate promised to pay for finishing and furnishing the museum's quarters in the City and County Building; works of art would be purchased with the balance of the trust. The Schleier trustees committed their resources to erecting a new museum building.

This demonstration of municipal and private support for the museum generated a spate of growth in its holdings. During the 1930s the museum received Miss Evans's collection, as well as that of Walter C. Mead, a gift which launched the Asian art collection. Donald J. Bear, who succeeded Scott as museum director, used a portion of the Dill bequest to purchase important works of European and American art. The museum also hired Frederic H. Douglas as curator of Indian art, an act which ensured the future preeminence of the Native American collection.

Douglas additionally held the post of museum director from 1940 to 1942, when Army service temporarily interrupted his career. Charles Bayly Jr., at that time president of the museum, served as acting director until the appointment of Otto Karl Bach in 1944. A prominent businessman and patron of the arts, Bayly made many significant gifts of art to the museum during his lifetime and at his death bequeathed to the museum funds for future buildings, as well as art purchases.

During his 30-year tenure as director, Bach pursued twin goals: building the museum into the major resource of world art for an eight-state region and achieving the permanent facility agreed to by the city in 1932. Capitalizing on Douglas's newly acquired interest in Oceanic art and his own enthusiasm for African art, Bach added these areas of collecting to the already prestigious American Indian Department. At his urging, acquisition of pre-Columbian art was also actively pursued. The 1950s and 1960s saw dramatic growth in the museum's holdings;

the Guthrie-Goodwin, Kress Foundation, Guggenheim, Hendrie, and Freyer collections enriched the Asian, European, and Spanish colonial departments, and numerous other gifts of art and funds for purchases poured in from the supporting community. As the collection grew, Bach enlarged the museum's role as educator, with particular emphasis on public school programs.

Progress toward a permanent home followed a more circuitous path. In 1949 an old building on West 14th Avenue between Acoma and Bannock streets was converted by architect Burnham Hoyt into the Schleier Memorial Gallery. In 1952 another building in the block was renovated as the Children's Museum, which later became the Living Arts Center. By 1953 the museum's collections and programs were located in five separate buildings— three sites on the Acoma/Bannock block, Chappell House, and the City and County Building. At this point the city and the museum formed a new agreement providing for the purchase by the city of specific land and buildings on the Civic Center block in exchange for the museum's equity in the City and County Building, where throngs of museum visitors were "causing traffic problems in the halls." These negotiations paved the way for the erection of what is now the Bach Wing, the only Civic Center unit prior to the present building which was actually constructed according to museum specifications. The South Wing, as it was then known, opened in 1954. In 1956 yet another building in the block was remodeled to house the burgeoning Asian art collection.

In 1965 the city acquired the last parcel of land for the new building and appropriated $125,000 toward its cost. The museum trustees hired James Sudler Associates and the late Gio Ponti to design the structure, authorized a $4 million building-fund campaign, and personally pledged nearly $300,000 of the amount. The following year the city council voted a second appropriation of $175,000 and committed itself to providing a total of $1 million for the building. Corporations, foundations, and private citizens supplied the additional funds. When the campaign goal was reached in 1967, the trustees decided to extend the drive to $6 million, a sum which would allow completion of the entire seven stories rather than the first three floors as originally planned. Ground was broken in 1968, and the striking new building opened to the public in October 1971.

Since occupying its new home, the museum has continued to develop and refine its collections and to expand its educational services to the community and to the state. In 1974 the Hanley Collection of American and European art became part of the permanent holdings. Bach retired the same year after a long and distinguished career, and the trustees appointed Thomas N. Maytham to succeed him.

The next few years witnessed a substantial increase in contemporary art acquisitions and the hiring in 1978 of the first full-time curator for that department. With the retirement of the mortgage on the new building in 1979, the trustees began planning for the resources and facilities necessary to continue the museum's operation and growth during the 1980s. Since 1893, the cumulative efforts of many dedicated, determined, and public-spirited people have succeeded in building a major museum uniquely suited to meet the needs of its constituency.

The Building

The Denver Art Museum building is itself as much a work of art as the objects it houses. Architects Gio Ponti of Milan, Italy, and James Sudler Associates of Denver have created a vertical structure which provides easy access to each gallery, as well as versatile exhibition and storage space for the permanent collection. The building also possesses extraordinary visual interest. Galleries, offices, and storage are located in two seven-story towers arranged like a square figure eight and centrally joined by a service core containing elevators, lobbies, and public facilities. By stacking the galleries, the architects have enabled visitors to reach desired exhibits quickly by elevator instead of by lengthy treks through the endless corridors common in most traditionally designed museums. Administrative offices, additional storage, a photography lab, and workshops are situated on two lower levels. The Bach Wing, the only part of the old complex still in use, opens off the main lobby and houses galleries and offices.

To break up the massive appearance of the towers, the entire structure is wrapped by a thin curtain wall faced with one million warm gray tiles especially developed to the specifications of the architects by Corning Glass Works. Because ceramic tile cannot withstand the rigorous extremes of Denver weather, the tiles are made of self-cleaning glass which is resistant to abrasion, corrosion, and impact. Highly reflective of both sunlight and moonlight, the sparkling tiles create an ever-changing facade. Brilliantly colored versions of the tile enliven the main stairwells inside the building.

Abstract patterns of flat tile and glass blocks, windows baffled to prevent direct sunlight from striking the fragile art objects within, and a pierced roof line reminiscent of fortress crenellation break up the flat surfaces of the curtain wall and add to the sculptural richness of the building. From inside, the windows frame vistas of the Rocky Mountains and the surrounding city. When lit from within at night, the building creates what Ponti described as "nocturnal architecture."

Services and Facilities

The museum offers a variety of services to visitors and the community. Free building highlight tours are available daily, and the Education Department schedules numerous tours of temporary exhibitions and the permanent collection. The department also generates lectures, films, concerts, and other special events open to the public. Particular emphasis is given to sharing the museum's resources with local schools and colleges through various internships and touring and outreach programs.

Membership in the museum provides many special ways to learn about and appreciate art. It is also an essential source of museum support. Benefits and privileges are appropriate to membership categories, which range from individual and family to patron, benefactor, and associate.

The shop, located on the main floor, provides an excellent selection of art books, note cards, replicas, imported jewelry, and other gift items, as well as posters, postcards, art magazines, and exhibition catalogs. Also located on the main floor is the restaurant, which offers convenient meal and bar service. A shaded patio is open during the summer. All public areas of the museum are completely accessible to the handicapped.

The Collection

The permanent collection comprises seven curatorial departments: Asian art, native arts, New World art, European art, American art, contemporary art, and textiles and costumes. Prefaced by a summary of the origins and nature of each collection, major works from the departments are illustrated and briefly described in this handbook. Where no specific donor is credited, objects were purchased with general acquisition funds. Works identified as belonging to the Helen Dill, Dora Porter Mason, and Marion G. Hendrie collections have been so designated to honor the donors of the purchase funds. Height precedes width in all measurements.

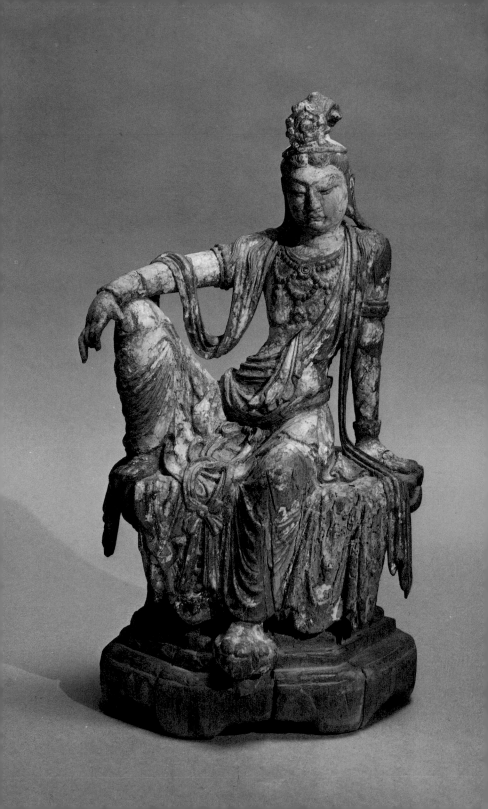

Asian Art

Reflecting the diverse creative concepts of a vast and complex area, the museum's holdings of Asian art demonstrate the wide-ranging achievements of artists and craftsmen from the Near and Middle East, India, Tibet, Nepal, Southeast Asia, the Indonesian islands, China, Korea, and Japan. Although general in scope, the collection shows special strengths in Indian sculpture, Japanese painting, and Chinese decorative arts.

Originating in 1915 with a gift from Walter C. Mead, who donated a group of Japanese and Chinese art objects and curios "to the people of Denver," the collection was exhibited at the Denver Museum of Natural History until 1933, when it was transferred to the Denver Art Museum's new galleries in the City and County Building. In 1937, for the nominal sum of one dollar, Mead sold the museum the remainder of his large collection—several thousand ceramic, metal, lacquer, cloisonné, ivory, and jade objects accumulated over more than a quarter of a century. With the assistance of nationally prominent scholars, the museum subsequently undertook a critical analysis of the Mead Collection which led to a judicious series of exchanges, sales, and purchases that vastly improved its overall quality. Among the treasures acquired in this way was the 9th/10th century Chinese image of Guanyin, the Bodhisattva of Compassion.[1]

In 1946 Harry B. Goodwin and his wife, Mary Guthrie Goodwin, began making a series of substantial gifts to the museum. The resulting Guthrie-Goodwin Collection, which

Guanyin Seated in Royal Ease, China, Tang dynasty or Five Dynasties period, 9th/10th century. Polychromed wood. 43.2 cm. h. Walter C. Mead Collection. 1946.4

Buddhism reached China during the Han dynasty (206BC-AD 220), where it confronted Confucianism and Daoism, two native systems of thought and religious belief. Over the centuries, a distinctly Chinese style of Buddhist art emerged. Images of Guanyin, the Bodhisattva of Compassion, in a posture of royal ease became particularly popular during the Song dynasty (960-1279). The face and body of this image, however, have an affinity with the fluid figural style developed during the Tang dynasty (618-906). Gracefully balanced in a position between tension and relaxation, this Guanyin sits upon a lotus throne with a hexagonal base. Some of what appears to be the original polychrome, applied over a layer of white ground, has survived.

includes Indian stone sculpture and wood carving, as well as Nepalese and Tibetan bronzes and paintings, represents their continued support over a 25-year period. The purchase of a superb Chola period bronze *Śiva Naṭarāja* in 1947 brought to the museum one of its most prized possessions. The preeminence of Indian sculpture within the Asian collection was assured by a large gift from Irene Littledale Britton in 1972. Among the sculptures in her collection was an engaging granite representation of Nandi, Śiva's sacred bull, which has proved to be one of the most popular sculptures on view in the Asian department. The geographic and stylistic range of the museum's holdings in South Asian sculpture was greatly extended by Cambodian and Nepalese works in the Irene Littledale Britton Collection and generous gifts from the Harold P. and Jane F. Ullman Collection. The department's growing collection of Tibetan *tankas* (banner paintings) and Indian miniature paintings in the Rajput and Mogul styles offers a contrast to the sculpture that dominates this section of its galleries.

Since 1980, the Japanese holdings have boasted a sculptural masterwork, a monumental 10th century image of a Shintō deity carved from a single block of wood. But the collection is most notable for the number, quality, and variety of its scroll and screen paintings. Major currents of the Edo period are well represented in significant works by Sakai Hōitsu, who painted in the native Rimpa style; Maruyama Ōkyo, who founded a school influenced by the realistic painting techniques of China and Europe; and Itō Jakuchū, one of the Three Eccentrics, who developed a highly individualistic style. An impressive landscape by Sesson Shūkei and a depiction of the legendary Hotei by Yamada Dōan give powerful expression to the 16th century Zen painting tradition. The Japanese collection has been greatly diversified by recent gifts of decorative arts from Mr. and Mrs. George A. Argabrite, whose collection contains outstanding examples of 18th and 19th century lacquer ware, metalwork, ceramics, and ivories.

In addition to its rare devotional image of Guanyin, the Chinese collection contains bronze ritual vessels of the Shang and Zhou dynasties. Its major growth, however, has been in decorative arts. A distinguished group of lacquer ware illustrates an extensive range of carved and inlaid styles. One of the most interesting examples is a Ming document box elaborately inlaid with gold and mother-of-pearl. The earliest piece in the ceramic collection is a burnished earthenware jar from the Neolithic period. Also on display are works showing significant technical achievements like the three-color glazing technique of Tang potters and the monochromatic porcelains produced by Qing artisans. Elegant furniture, domestic table screens, and a large and representative study collection of jade carvings add depth and breadth to the holdings.

The department's principal areas of strength are complemented by small, but fine, core collections of Korean ceramics, furniture, and paintings, ancient Near Eastern bronzes and seals, and Islamic ceramics and metalwork. Long-term loans from important private collections and appropriate rugs, fabrics, and garments from the museum's textile department amplify the Asian art galleries.

1. This publication uses the pinyin system of romanization of Chinese terms.

Winged Deity, Assyria, Nimrud, 9th century BC. Limestone. 49.5 x 54.6 cm. Charles Bayly Jr. Fund and general acquisition funds. 1963.1

This fragmentary representation of a winged deity once formed part of a wall relief in the Northwest Palace of Assurnasirpal II at Calah, modern Nimrud. Originally painted with bright colors, the entire relief panel probably showed a second winged deity to the left of a central tree, a symmetrical composition characteristic of Mesopotamian art. Use of colored reliefs to decorate palace interiors apparently began when Assurnasirpal moved the capital of the Assyrian Empire from Assur to Nimrud on the banks of the Tigris River.

Bowl, Iran, Nishapur, Samanid period, 10th century. Glazed earthenware. 21.9 cm. dia. 1967.93

Deep bowls with flaring sides and low ring bases are characteristic of a type of polychrome ware produced at Nishapur under Samanid rule. Courtly subjects like hunting scenes were frequent motifs in Nishapur pottery, with human and animal forms, particularly facial features, rendered in a stylized manner. Here, a horseman, surrounded by birds, rosettes, and angular Kufic motifs, dominates the interior composition, which is painted in black, green, and yellow under a transparent glaze. The exterior of the bowl is decorated with a band of vertical bladelike elements.

Elephant, India, Mathurā, Kushan period, 2nd century. Red sandstone. 13.9 cm. h. Guthrie-Goodwin Collection. 1964.17

This figure comes from the religious center of Mathurā, southern capital of the Kushans, who dominated northwestern India, Pakistan, and Afghanistan from about the 1st to the 7th century. The art produced in Mathurā under Kushan patronage was a continuation of ancient Indian traditions. Carved on both sides from a mottled red sandstone commonly used there, this flattened figure of an elephant presumably came from either a Buddhist or a Jain monument and may once have been part of a stone gateway.

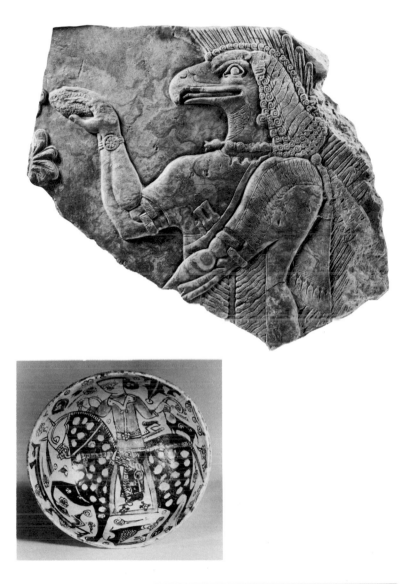

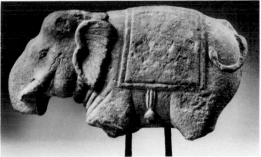

Dancing Female, India, Madhya Pradesh, 8th/9th century. Pink sandstone. 67.3 cm. h. Gift of Irene Littledale Britton. 1972.60

Flanked by two small musicians, this bejeweled dancer displays the idealized physical proportions characteristic of female figures in Indian sculpture. An image of fecundity, she presumably was one of several celestial dancers decorating niches high on the exterior wall of a temple. Although worldly in her beauty, she is a divine being, spiritually attractive to worshippers.

Maitreya, India, Pāla period, early 10th century. Black schist. 81.3 cm. h. Inscribed around stele. Gift of Irene Littledale Britton. 1972.59

Representations of Maitreya, the Buddha of the future, may depict him either as a Buddha or as a bodhisattva. Distinguished by the small stupa on his crown, he is shown here as a bodhisattva, adorned with rich ornaments, a Buddhist rosary in his right hand and a lotus in his left. One of the last strongholds of Buddhism in India was the Bihār/Bengal region, where the rulers of the Pāla dynasty governed from the 8th to the 12th century and developed a distinctive art form based on the classical Gupta style. The monumentality and dignity in subtly modeled images like this Maitreya are characteristic of the finest examples of Pāla sculpture during the 10th century.

Vishnu Chaturmūrti (Vaikuntha Vishnu), Kashmir, Papaharanaga, 9th/10th century. Black chlorite. 44.2 cm. h. Gift of the Harold P. and Jane F. Ullman Collection. 1979.72

One of the three principal Hindu deities, Vishnu, the Preserver, has many animal and human avatars, including the boar and the lion. In Kashmir, Vishnu was frequently represented in a syncretic form with four heads rather than one. Here, a frontal human head is flanked by heads of a boar and lion, and a fierce face is carved on the back of the image. Use of a finely grained stone enabled the artist to achieve in the carved ornaments a sharpness characteristic of Kashmirian sculpture. The image was originally full length and had four arms.

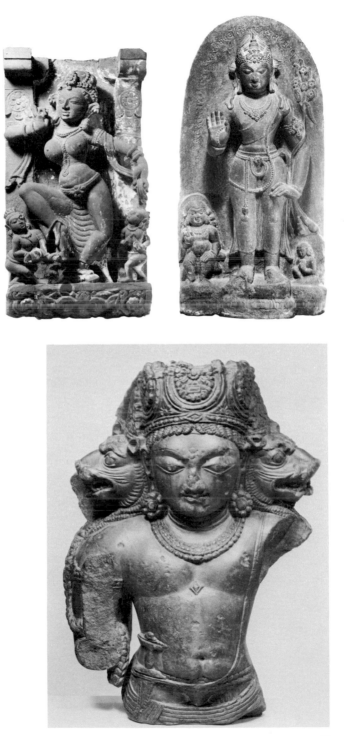

Dancing Ganeśa, India, Madhya Pradesh(?), 11th/12th century. Buff sandstone. 62.3 cm. Charles Bayly Jr. Fund and 1967 Benefit Ball. 1968.24

The elephant-headed god Ganeśa is the son of Śiva and Pārvatī. In this six-armed image, he moves to the accompaniment of musicians playing a drum and cymbals; two of his arms are posed in dance gestures while others hold identifying symbols including a goad and a flower. Ganeśa's trunk reaches toward a bowl of his favorite sweetmeats, which originally formed part of the composition. Called the "Remover of Obstacles," Ganeśa is popular as a bestower of prosperity and good fortune who aids worshippers in their undertakings. Images like this demonstrate the Indian sculptor's astonishing ability to join human and animal forms into a convincing figure.

Standing Buddha, Pakistan, Gandhāra, 2nd/3rd century. Gray schist. 27.9 cm. h. Charles Bayly Jr. Collection by exchange. 1954.23

Bearing three identifying marks of a Buddha—the *ushnisha* (cranial knob), the *urna* (mark in the center of the forehead), and elongated earlobes—this standing figure is from the region of Gandhāra, now northern Pakistan and southern Afghanistan. Part of the Kushan Empire, Gandhāra was a Buddhist center which developed a distinctive style of art affected by western traditions, particularly provincial Roman influences, evident here in the facial features and drapery folds. The unworked back of the image and its posture suggest that it may be from a narrative relief.

Mother Goddesses and Ganeśa, relief fragment, India, Madhya Pradesh, probably Gwalior, 10th century. Buff sandstone. 59.7 cm. h. Charles Bayly Jr. and Walter C. Mead collections by exchange. 1964.24

Reliefs representing the seven mother goddesses appeared in many later Hindu temples, usually as lintels over a doorway or shrine. This fragment of a larger relief shows Ganeśa and only three of the goddesses—the emaciated Chāmundā, Indrānī holding an infant, and the boar-headed Vārāhī. The latter two represent the energy inherent in the gods Indra and Varāha. The openwork carving of the figures adds to the relief's sculptural richness.

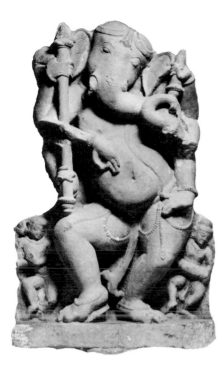

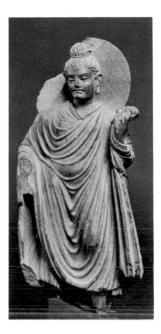

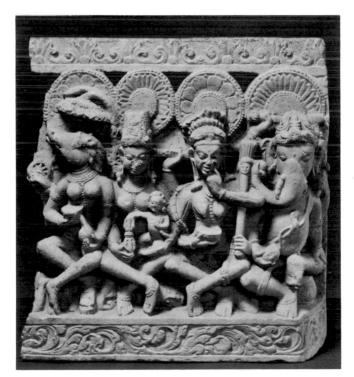

Shrine, India, Gujarāt or Rājasthān, 1085. Bronze. 18.2 cm. h. Inscribed on back. 1968.28

Identification of the main figure on this Jain shrine is difficult because it has been rubbed smooth through centuries of worship. If the symbol on the front of the throne cushion is a conch, he may be Ariṣṭanemi, the 22nd of the 24 Jain sages. Bearing a dated dedicatory inscription, the shrine is a remarkably early example of Jain bronze sculpture.

Sadāśiva with Umā, India, Rājasthān or Uttar Pradesh, 11th/12th century. Gray limestone. 47 cm. h. Gift of the Harold P. and Jane F. Ullman Collection. 1976.154

Sadāśiva, the representation of Śiva with ten arms and five faces, is the form of the Hindu deity held in highest esteem by Saivite worshippers. Each supernumerary physical member symbolizes a different aspect of the god; the two lateral faces visible here emphasize his creative and destructive aspects. Several figures, including the elephant-headed god Gaṇeśa and the bull Nandi, appear beneath the throne on which Śiva sits with his consort Umā, who is also known as Pārvatī. The emphasis on detail and the crisp quality of the carving are typical of late Hindu sculpture produced in northern India.

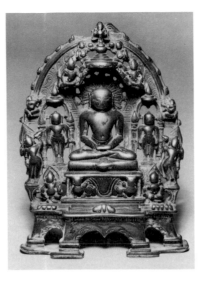

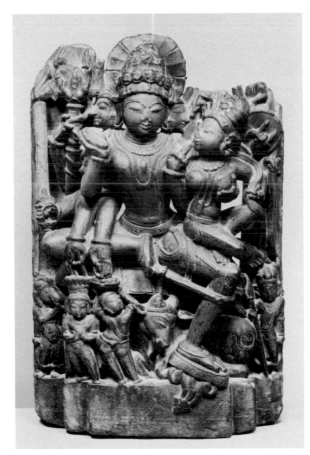

Śiva Natarāja, India, Tanjore district(?), late Chola period, 13th century. Bronze. 93.7 cm. h. Dora Porter Mason Collection. 1947.2

The Hindu god Śiva as Lord of the Dance, or Naṭarāja, sets everything in motion, never ceasing his life-creating movement. Encircled by an aureole of flames, Śiva's dancing image represents the endless rhythmic cycle of creation and destruction. Each gesture and attribute has its meaning; thus, transcendent principles are embodied in sculptural form. Images like this were enshrined on pedestals within a temple's innermost sanctuary, where worshippers could contemplate them as a means of gaining understanding and truth. The South Indian bronzes depicting the god in his cosmic dance are characterized by the purity and clarity of form evident in this superb example. Cast in the round, the statue could be carried in processions by means of poles.

Nandi, India, Chola period, 11th/12th century. Granite. 57.2 cm. h. Gift of Irene Littledale Britton. 1964.14

Images of Nandi, Śiva's sacred bull, are associated with places of Saivite worship throughout India. The statues are especially popular in South India, where they are generally housed in a hall facing the sanctum. In this representation Nandi, adorned with garlands and bells, licks his muzzle in an engaging gesture. The sculptor has portrayed his bovine figure with a taut compactness of form, and his alert expression and air of composure imbue him with a quality of spiritual awareness.

Agni, India, Uttar Pradesh, 12th/13th century. Buff sandstone. 61.9 cm. Gift of the Harold P. and Jane F. Ullman Collection. 1973.83

Although his images are rarely found on early temples, Agni, the god of fire, is commonly worshipped in Hindu homes. Represented variously as the sun in the heavens, as lightning in midair, or as fire on earth, the god is shown here with flames emanating from his head. In accordance with certain texts that identify Agni's vehicle as a goat, two goat-headed figures appear at his right side, one with a human body. The increased stylization and rigidity of the figures in this statue are characteristic of sculptural development during the late 12th and 13th centuries in Central and North India.

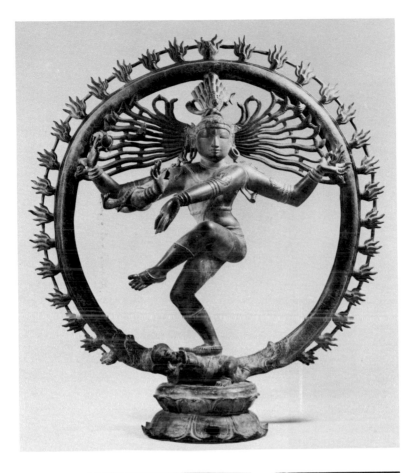

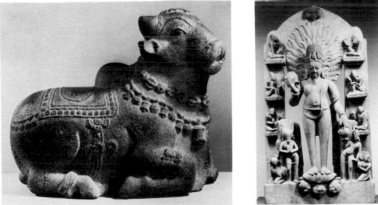

Folio from a *Bhāgavata Purāṇa,* India, Rājasthān or Mewar(?), 1525-1550. Color on paper. 17.8 x 23. 8 cm. Inscribed "Nana" upper left. Purchased with gifts from Mrs. William H. Downs and Art Benefit Bridge. 1964.102

This manuscript page is from one of the earliest known illustrated versions of the *Bhāgavata Purāṇa,* a popular Hindu epic. It also represents the earliest manner of Rajput painting, a style marked by strong colors and lively compositions. The Rajputs preferred religious themes for subject matter and followed ancient indigenous painting traditions. Nana, whose name appears on this page, was presumably one of the artists who illustrated the manuscript. This folio is from the epic's tenth book, which deals with the cowherd god Krishna, an incarnation of Vishnu. In the episode depicted here, the daughter of the demon king of Sonitapura, having fallen in love with a portrait of Krishna's blue-skinned grandson Aniruddha, has him mystically abducted to her side. In a later chapter, Krishna invades the kingdom to free Aniruddha.

Annapūrṇā, India, Madurai, 14th century. Bronze. 19.1 cm. h. Gift of Irene Littledale Britton. 1964.3

Among the Hindu pantheon, Dēvī, the Great Goddess, is venerated as the source of all energy and creation. Known by many names, including Pārvatī and Durgā, she appears here in the form of the youthful goddess Annapūrnā, with high breasts and a face as round as the moon. Annapūrnā, whose name means "full of food," is worshipped in association with Śiva, whom she nourished from her store of provisions. Most representations show her holding a spoon or ladle; here she holds a lotus flower and a ball of food.

Appar, India, Madras, Tanjore, 13th century. Bronze. 49 cm. h. Guthrie-Goodwin Collection. 1962.298

The great Saivite saint Appar, or Tirunāvukkarasu, lived during the 7th century at the time of the Pallava ruler Mahendravarman I of Kānchipuram, whom Appar supposedly converted to Saivism. One of numerous Tamil saints, Appar was a wandering hymnist who visited temples, singing praises to Śiva's glory and propagating Saivite worship. Here, he stands with his hands pressed together in worship, holding a tool on his left shoulder, which, according to certain accounts, he used to clean the grounds of temples that he visited. Holy men and religious teachers such as Appar were often worshipped in their own right, and their sanctified images were highly venerated. Large bronze images of Saivite saints, with their gracefully fluid poses, are unique to the South India region of Tamilnadu.

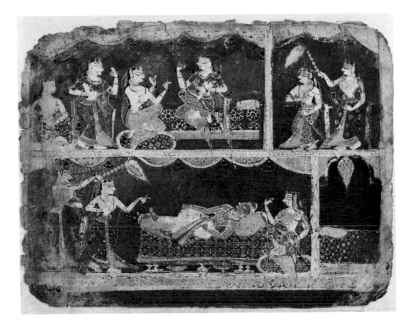

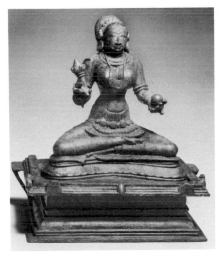

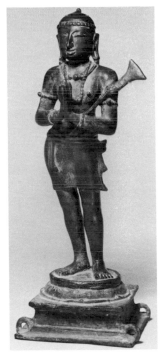

Nidhamal, *Lady and Her Attendant on a Terrace*, India, Mogul dynasty, 1700-1750. Color, gold on paper. Signed lower left. 21.3 x 9.2 cm. Guthrie-Goodwin Collection. 1957.46

The painter Nidhamal was active during the reign of Emperor Mohammad Shah (1719-1748), under whose patronage the Mogul tradition of Indian miniature painting was revived. Unlike the Rajputs, the Moguls commissioned illustrations of dynastic history and Persian epics, which were executed in a delicate naturalistic style. In this elegant portrayal of a lady attended by a maid holding a hookah, the artist delights in creating fine ornamental patterns while rendering his scene with crisp precision and refinement. The lavish use of orange tones for the sunset, canopy, and ripening fruit on the trees is characteristic of Nidhamal's style.

Storage jar, Vietnam, Thanh Hoa, 11th/12th century. Glazed stoneware. 19.4 cm. h. Charles Bayly Jr. Collection by exchange. 1954.40

Inspired by Chinese ceramics of the Song dynasty, this globular storage jar with a brown crackled glaze comes from the northern Vietnamese province of Thanh Hoa. Archaeological evidence of Han and Song dynasty kilns has been reported from this region, where a variety of vessel types was produced. In this example, the domed lid is surmounted by a lotus bud encircled with lotus petals, which are repeated around the shoulder of the jar. The lotus flower, which has symbolic significance in Hindu and Buddhist art, is used here as a purely decorative motif.

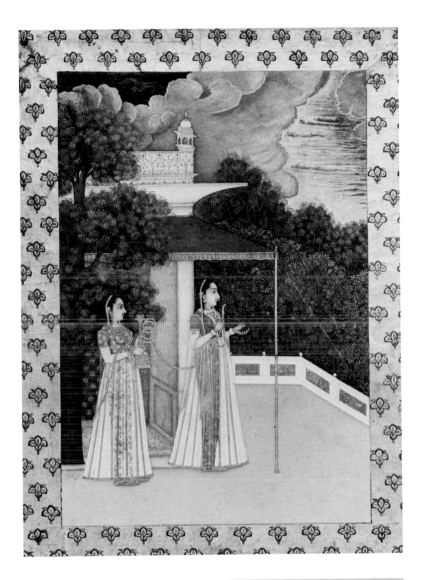

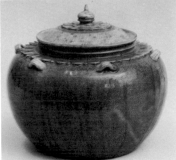

Head of Buddha, Thailand, Sukhothai style, 15th century. Bronze. 38.1 cm. h. Gift of Mrs. Rene Rodriguez and H.M. Sarkisian. 1956.37

Sukhothai sculptors developed a distinctive style of linear abstraction and modeling based on descriptions of gods and heroes found in classical Indian writings, where various anatomical features were compared to familiar objects: the head to an egg, the nose to a parrot's beak, the eyebrow to a drawn bow, and the chin to a mango stone. By embodying such visual similes in this head of Buddha, the artist has created an idealized form that surpasses the realistic human physiognomy.

Padmasambhava, Tibet, 15th/16th century. Bronze, silver, copper, turquoise. 21.9 cm. h. Inscribed around base. Purchased with gift from Florence J. Reust in memory of her son, Ralph W. Jacobs. 1980.57

This bronze is an idealized representation of Padmasambhava, an Indian mystic venerated by Tibetan Buddhists. Invited to Tibet in the 8th century by King Trisong Detsen, he established the first Buddhist monastery there and is referred to by Tibetans as Guru Rimpoche, or Precious Teacher. The image is typical of the saint's depiction in Tibetan art. Because his Indian name means "lotus-born," he is portrayed seated on a lotus blossom, and the lappets of his cap are turned up to resemble petals. He holds a skull cup in his left hand and a thunderbolt in his right; a trident with skulls, a head, and ribbons rests against his shoulder. The facial features are inlaid with silver and copper, the ear ornaments with turquoise. Finely worked floral bands adorn his robes.

Mahākāla, Tibet, 18th century. Gilt bronze. 35.5 cm. h. Walter C. Mead Collection. 1933.14

The originality of Tibetan artists is particularly well expressed in their portrayal of wrathful divinities. Mahākāla (Tibetan, *mGon po*), the Great Black One, is the defender of the Law. Here, the torsion and movement of the body, as well as the terrifying head with its three eyes and crown of five skulls, emphasize the popular god's protective powers. Wearing ornaments of snakes and human heads and garments of elephant and tiger skins, he defends Buddhism by trampling an elephant-headed figure holding a skull cup, the Hindu god Gaṇeśa.

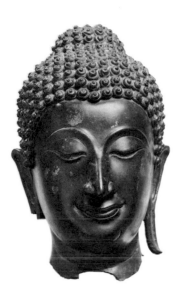

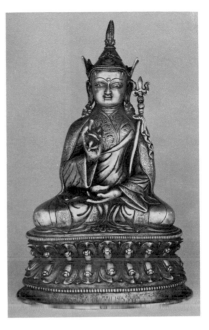

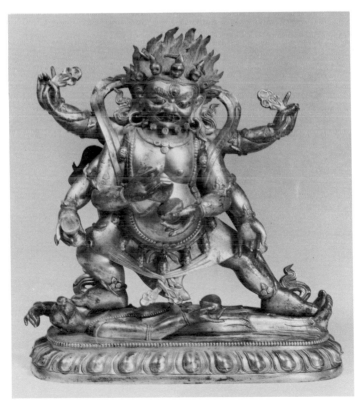

The Arhats Kanakavatsa and Cūḍapanthaka with Hva šaṅ and Attendants, Tibet, late 18th century. Color, gold on cloth. 59.7 x 40. 7 cm. Anonymous gift. 1974.98

Elaborately mounted with Chinese silk, this *tanka* is one of two known survivors from a set of seven banner paintings representing Buddha encircled by the Great Arhats (ascetics who attain enlightenment through their own efforts). Here, two Arhats are depicted seated on thrones and attended by the dark-skinned, pot-bellied Hva šaṅ, who is surrounded by children playing. Various deities occupy the four corners of the *tanka*. The landscape elements, derived from Chinese pictorial traditions, are skillfully integrated with the main images.

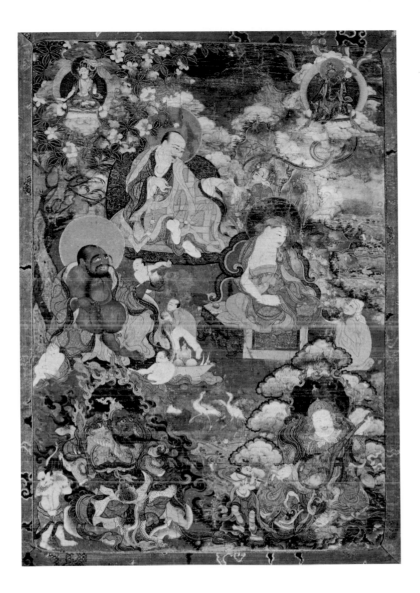

Śiva with Avatars of Vishnu and Brahma (detail), Nepal, 18th/early 19th century. Color on cloth. 62.3 x 201.9 cm. Gift of Eleanor Manning. 1957.93

In this colorful painting, the central image of Śiva and his consort Pārvatī is flanked by two rows of figures depicting their sons, Gaṇeśa and Kārttikeya, and the ten avatars of Vishnu. A four-headed image of Brahma appears in the sky in the upper right tier. The figures are set against a stylized landscape—undulating red mountains, capped by ruffled clouds, with stiff-legged birds flying in the blue sky. To achieve a hypnotic gaze in the frontal faces of Śiva, the artist has placed the pupils at the inner corner of each eye, a practice characteristic of Nepalese painting since the end of the 17th century.

Manjuśrī and Prajñā, Nepal, 1571. Gilt bronze, semiprecious stones. 19.6 cm. h. Inscribed around base. Gift of Irene Littledale Britton. 1972.127

The bodhisattva Manjuśrī is particularly popular in Nepal, where Buddhists associate him with the Kātmāndu Valley, which he is believed to have created by cutting through the mountains with his sword to drain the imprisoned waters of a lake. The deity of perfect wisdom and knowledge, he is commonly portrayed with his consort in Nepalese and Tibetan art. Presented together, the two figures are a visual manifestation of the abstract concepts of Buddhism known as *upāya* (the method) and *prajñā* (wisdom), symbolized by the male and the female. He is the means, she the end: together they achieve ultimate reality by removing ignorance.

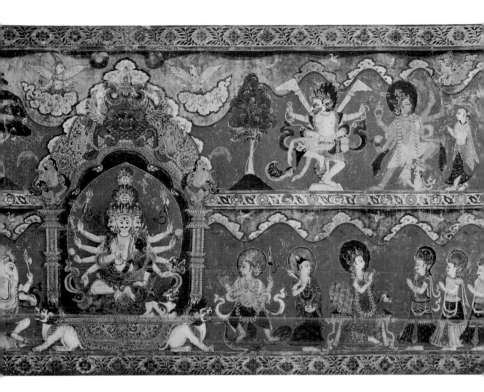

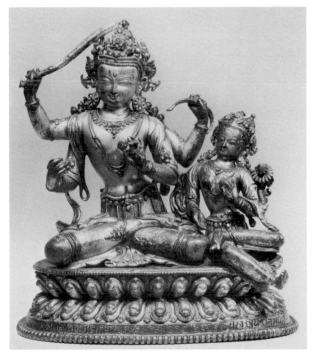

35

Wand, China, Eastern Zhou, Warring States period,
5th-3rd century BC. Bronze. 37.5 cm. I. 1969.19

Two bronze snakes with bifurcated tails have been
ingeniously entwined to form this unusual device, which
may have been used as a shaman's wand. Pictorial
representations of fantastic figures holding similar
branched wands or serpentlike forms have been
discovered dating from the Eastern Zhou and Han
dynasties. This wand reportedly came from Changsha,
the Zhu state site in Hunan province.

Jue, China, Shang dynasty, Anyang period, 13th-11th
century BC. Bronze. 20.6 cm. h. Two-character inscription
under handle. Charles Bayly Jr. Collection by exchange.
1954.4

Vessels of China's Bronze Age civilization have long been
studied and admired for their beauty, level of technical
achievement, and epigraphic information. Jue,
assymetrical tripod vessels like this which have been
found in tombs, were used in burial rituals for heating and
serving wine. The finely worked band, with taotie (monster
masks) raised in relief above the spiral-patterned ground,
is a decorative motif commonly found on Shang bronzes.

Jar, China, Gansu province, Yangshao culture, Neolithic
period, c. 2000 BC. Polychromed pottery. 41.3 cm. h.
Gift of Dr. and Mrs. Otto Karl Bach. 1948.2

Neolithic settlements of China's Yangshao culture have
been discovered throughout the middle reaches of the
Yellow River. Characterized by a burnished earthenware
pottery decorated with black and red geometric patterns,
the culture is named after the village where typical
remains were first excavated. Yangshao pottery was built
by the coil method and fired in an oxidizing atmosphere.
Since its lower portion is not decorated and the two loop
handles are set low on the body, this thin-walled jar was
probably supported by being set into sandy ground.

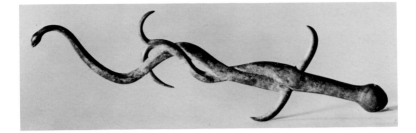

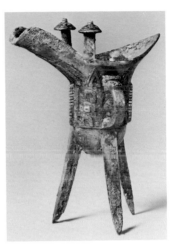

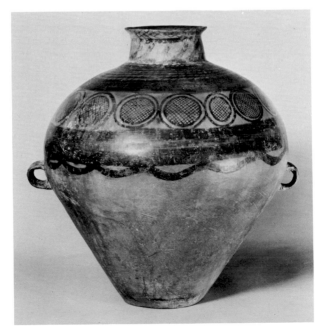

Sutra with frontispiece (detail), China, late Song or early Yuan dynasty, 13th/14th century. Blockprint on paper. Entire sutra 30.5 x 815.8 cm. Oriental Cooking School Benefit Fund. 1977.34

The frontispiece of this sutra is identical to an illustration found in the Jishazang, a 6,362-volume Chinese translation of the Tripitaka, a complete canon of Buddhist scriptures and writings which was originally recorded before the 1st century AD in Pali, an Indic language. It seems likely that this printed frontispiece and text come from the rare edition produced between 1231 and 1322 under the supervision of the Yanshengyuan monastery at Jisha, Jiangsu province. Illustrations such as this are valuable historical documents for the study of Chinese Buddhist art and its interrelationship with Nepalese and Tibetan styles.

Mirror, China, late Six Dynasties period or Sui dynasty, 6th/early 7th century. Bronze. 19.4 cm. dia. Inscribed around border. Charles Bayly Jr. Collection by exchange. 1954.6

Since in China a circle and square could symbolize heaven and earth, this mirror probably had a cosmological significance, which was reinforced by the supernatural animals of the four directions decorating its back: the Red Phoenix of the South, the Black Tortoise and Snake of the North, the Green Dragon of the East, and the White Tiger of the West. In mirrors of this type, the outer border is often inscribed. Here, the inscription is an eight-line poem referring in part to the "mountain haunts of fairies" and the "waters of wisdom." Although mirrors are often excavated from tombs, they probably had a long existence as family treasures before being buried.

Bi, China, Han dynasty, 2nd/1st century BC. Green jade. 24.8 cm. dia. Charles Bayly Jr. Collection by exchange. 1954.9

Jade discs with a central hole, generally called *bi,* were used by the ancient Chinese as ritual or ceremonial objects. Believed to have the power both to summon spirits from the dead and to preserve life, *bi* were associated with burials as early as Neolithic times and were also prized possessions for the living. Initially undecorated, *bi* reached their full ornamental development during the Eastern Zhou and Han dynasties. This example is carved on both sides with narrow rope bands that set off the outer border of four *taotie* (monster masks) and the inner area of raised spirals. It is similar in design to a number of *bi* found in Han dynasty tombs.

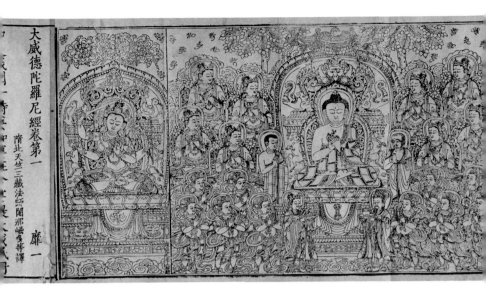

大威德陀羅尼經卷第一

靡一

隋北天竺三藏法師闍那崛多等譯

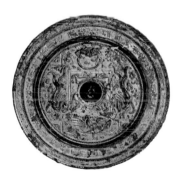
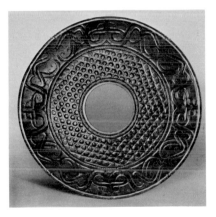

Ewer, China, Tang dynasty, 7th/8th century. Glazed
stoneware. 21.6 cm. h. Walter C. Mead Collection by
exchange. 1951.8

Spouted ewers like this belong to an early group of Tang
dynasty stoneware manufactured primarily in north central
China in Henan and southern Shaanxi provinces. Because
iron oxide was used as a colorant, this high-fired
stoneware has a subdued tone, in contrast to the
polychromed, lead-glazed ceramics of the period. White
slip covers part of the pale buff body of the vessel, which is
decorated with a rouletted chevron pattern. Applied by the
dipping method, a thin brownish glaze extends beyond the
slip but stops short of the base.

Hill jar, China, Han dynasty, 1st/2nd century. Green-glazed
pottery. 22.9 cm. h. with lid. Walter C. Mead Collection
by exchange. 1951.10

A large number of cylindrical vessels known as "hill jars"
have been recovered from Han dynasty tombs. Their name
derives from the lid, molded with a central five-peaked
mountain surrounded by hills, which symbolizes a Daoist
paradise of immortals. Perched on three feet shaped like
squatting bears, the body of this jar is decorated with a
low-relief band depicting a landscape with figures and
animals. Rows of zigzag lines, perhaps representing
mountains, encircle both the lid and the body, which
display the green glaze characteristic of Han ceramics.
The two ring handles with mask-shaped attachments are
a motif commonly found on bronze vessels. Although the
use of such jars is unknown, they presumably had a
ritual function.

Tomb figure, China, Tang dynasty, 8th century. Pottery with
polychrome lead glaze. 42.9 cm. h. Charles Bayly Jr.
Collection by exchange. 1954.38

The well-established practice of placing clay images of
humans and animals in burial chambers resulted in the
extensive production of tomb figures like this during the
Tang dynasty (618-906). Representations of riders on
horseback were especially numerous, reflecting the
popularity of equestrian activities such as polo, hunting,
and falconry. Because the cosmopolitan Tang trade
centers were in cultural and commercial contact with
Central Asia, Persia, and the Mediterranean world, foreign
influences, evident here in the rider's costume, often
appear in Tang art. The potter's skillful portrayal of the
falconer and his steed is enhanced by green, brown, and
cream glazes. The application of such three-color glazes
was a major technical achievement of Tang potters.

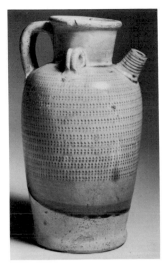

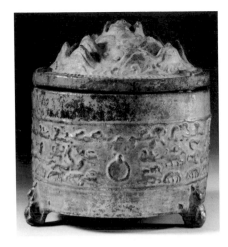

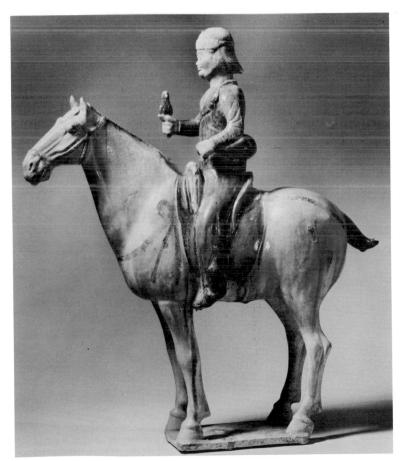

Document box, China, Ming dynasty, 16th century.
Lacquered wood inlaid with mother-of-pearl and gold,
metal fittings. 72.4 cm. l. Gift of Mr. and Mrs. John B.
Bunker. 1974.308

The technique of inlaying lacquer with mother-of-pearl and
precious metals originated as early as the Tang period
(618-906). During the Ming dynasty (1368-1644), the
practice was revived with a new elaboration of detail and
richness of color. Landscapes, gardens, and scenes of
people enjoying pleasant pastimes such as music, painting,
or calligraphy ornament this document box. Wave motifs
decorate the metal hinge and lock plates, and the hasp
takes the form of a *taotie* (monster mask), its eyes pierced
for the attachment of a lock. Curious in its shape, the box
was designed to rest on the arms of a sedan chair, an
arrangement which allowed the occupant to hold it
securely in front of himself.

Vase, China, mark and reign of Qianlong, 1736-1795.
Porcelain with celadon glaze. 33.1 cm. h. Mark on base.
Walter C. Mead Collection. 1933.4

Among the ceramic accomplishments of the Qing dynasty
(1644-1912) was the production of monochrome porcelains.
Artists developed an extensive range of glaze colors: some
were the result of new experiments while others, such as
celadon, were developed from earlier glaze types. The pale
green celadon color was achieved through the high firing
of a glaze containing a small amount of iron oxide in a
reducing atmosphere. Here, the celadon glaze covers a
gourd-shaped vase made of fine white porcelain. A product
of the kilns at Jing de zhen in Jiangxi province, it exemplifies
the combination of a sophisticated shape and a plain, but
exquisite, glaze.

Fahua jar, China, Ming dynasty, 16th/early 17th century.
Porcelaneous stoneware with polychrome glaze.
38.1 cm. h. Anonymous gift. 1974.23

The term *fahua* commonly refers to a type of ceramic
decorated in a technique similar to cloisonné enameling.
Clay threads are applied to create designs which control
different areas of color glazes. In examples such as this
one, additional elements modeled in relief and enhanced
with incised lines have been attached to the jar. A deep
blue exterior background sets off the motifs—fluttering
ribbons, peonies, lions, and butterflies—rendered in
various shades of turquoise, green, and white; the interior
is covered with a green glaze. In some instances *fahua*
jars were decorated with an outer layer of ceramic
openwork.

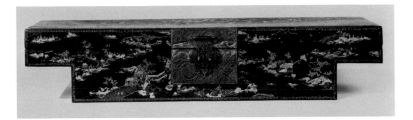

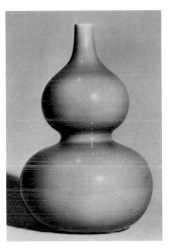

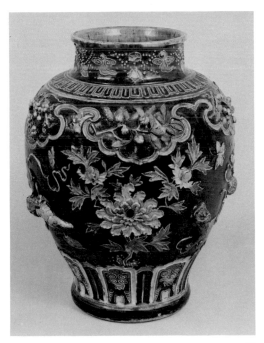

Stand, China, Ming dynasty, 17th century. Lacquer on fabric-covered wood. 89.9 cm. h. Gift of Mr. and Mrs. John B. Bunker. 1975.149.1

This tall red lacquer table, probably used to hold offerings, is one of a pair owned by the museum. The stands are decorated in the *jiazhu* technique, a method in which linen, silk, or hemp fabric is glued to a wooden form with lacquer. Incised and lacquered decorations, such as the floral motifs seen here, are then applied. Although these stands date from the late Ming dynasty (1368-1644), the coin pattern of the tabletop, side panels, and epaulettes is a design popularized during the first half of the 15th century.

Table screen, China, Qing dynasty, Kangxi period, late 17th/early 18th century. Lacquer inlaid with mother-of-pearl and gold, *zitan* wood frame. 66 x 101.6 cm. overall. Anonymous gift. 1978.130

The richness of the inlay work, which glimmers against the lacquer surfaces when struck by light, is appropriate to the scenes of palace life depicted on this ornate table screen. The back of each panel is inscribed with a poem inlaid with mother-of-pearl. Bearing auspicious symbols carved in delicate openwork, the frame uses the simple beauty of natural wood to complement the decorated panels.

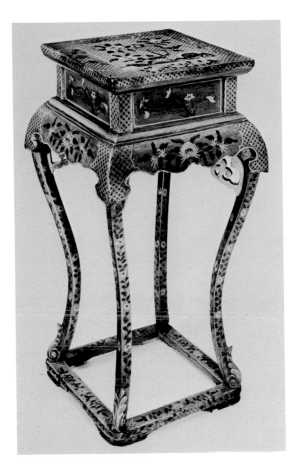

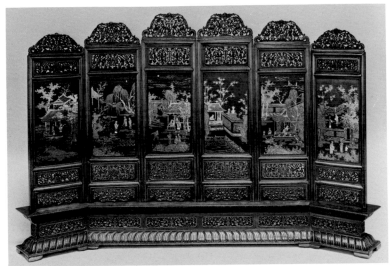

Ewer, Korea, Koryō period, 10th/11th century. Bronze. 25.4 cm. h. Gift of Mr. and Mrs. Emmett Heitler. 1979.103

This example of Korean metalwork is one of many bronze ewers and spouted flasks produced during the Koryō period (918-1392). Its distinctive shape, which originated in China, also appears in Koryō celadon-glazed ceramic wine pots. As early as the Kamakura period (1185-1333), the form was adopted in Japan, where Buddhist priests used similar bronze ceremonial vessels as containers for water to cleanse their hands.

Picnic and *Trial in the Street,* Korea, Yi dynasty, late 18th/early 19th century. Ink, light color on paper. Each painting 70.5 x 39 cm. Inscription and seals upper right of *Picnic.* 1972.65.1-2

Korean painters based their art predominantly on traditional Chinese themes until the second half of the 18th century, when they began to explore an entirely new subject—daily life in Korea. This increased awareness of common, everyday activities and pastimes was generated by *Sirhak* (practical learning), a contemporary Korean school of Confucian thought which flourished among influential scholars. Although artists continued to paint in the Chinese manner, scenes such as these are recognizably Korean in subject matter, costume, and details of landscape.

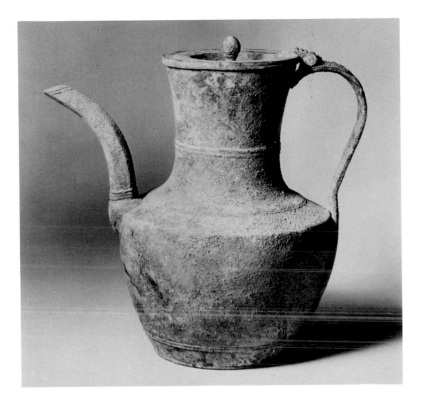

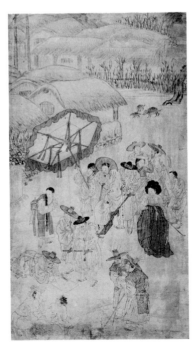

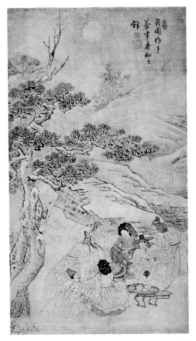

47

Shintō Deity, Japan, Heian period, 10th century. Zelkova wood. 85.1 cm. h. Purchased with bequest of Edith Trimble Zinn in memory of her husband, Comdr. Ralph Theodore Zinn. 1980.95

This monumental male figure represents a Shintō deity. Shintō, a religion native to Japan, changed dramatically under the growing influence of Buddhism during the 8th century, and for the first time Shintō deities were shown in anthropomorphic form. Among the earliest of such images, this figure is carved from a single block of wood in a manner which preserves the spiritual power and beauty of the natural material. Dressed in formal attire, the deity wears a stiff court cap and holds a *shaku,* a flat scepter indicating aristocratic status. In contrast to Buddhist sculpture, Shintō images were concealed in shrines, which intentionally hid them from the view of worshippers. Hence, this image provided a body in which the spirit of a particular deity could reside, to be venerated only in the minds of devotees.

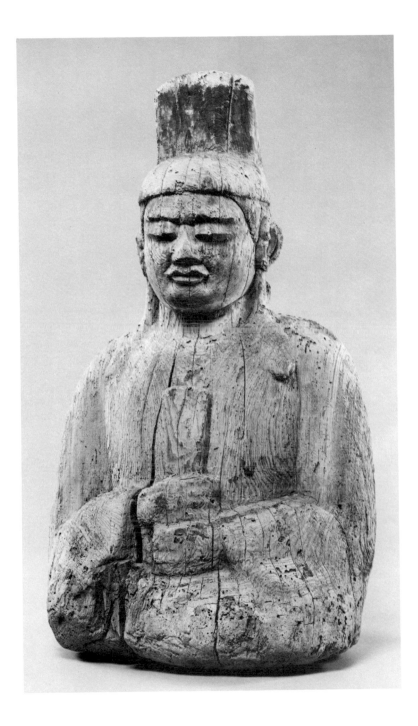

Negoro ware table, Japan, late Muromachi period, 16th century. Lacquered wood, metal fittings. 26.1 cm. h. Gift of the Pan-Asian Collection. 1966.6

In its metal fittings, decorative scroll-shaped panels, and delicately curved legs, this low table reflects a Chinese influence. Fashioned with an undulating profile of the leg panels, which became popular on Buddhist furnishings beginning in the 14th century, tables of this type were perhaps used to hold ritual objects in a temple or the monks' quarters. The deep cinnabar color, with areas worn away to reveal an underlying layer of black, is characteristic of Negoro lacquer wares. Although the true origin of these wares is obscure, tradition attributes their first production to Negoro-dera, a Buddhist temple founded in 1140 in Wakayama prefecture.

Shigaraki ware jar, Japan, Muromachi period, 15th century. Stoneware with natural ash glaze. 29.2 cm. h. Gift of Mr. and Mrs. William C. Kurtz Jr. 1972.248

From the 13th through the 16th centuries, large seed jars were produced at the Shigaraki kilns east of Kyoto. Primarily intended as utilitarian wares for farmers, they also appealed to masters of the tea ceremony, who used them as storage vessels for tea leaves. These unpretentious jars, with their uneven shapes, rough surfaces, accidental scorch marks, and ash glazes, particularly suited the esthetics of *wabi* (poverty) tea, as well as the spirit of humility common to all tea ceremonies. The shoulder of this jar is scored with a pattern resembling a latticework fence, a motif typically found on Shigaraki ware.

Haniwa, Japan, Tumulus period, 4th century. Pottery. 70.2 cm. h. 1961.3

Haniwa are hollow pottery cylinders, which were set in the ground around the large burial mounds of the Tumulus (Kofun) period (c. 250-552). It has been suggested that their original purpose was to inhibit erosion and permit drainage around the tombs. The cylinders were often surmounted with images of houses, men, and animals which reveal much about life in prehistoric Japan. The elaborate trappings on this partially restored *haniwa* suggest that horses were highly valued; bridle, saddle, and crupper are decorated with a random pattern of impressed circular markings, and bells adorn the breast collar.

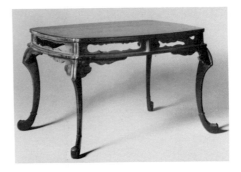

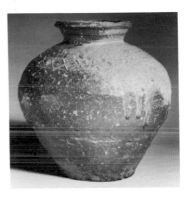

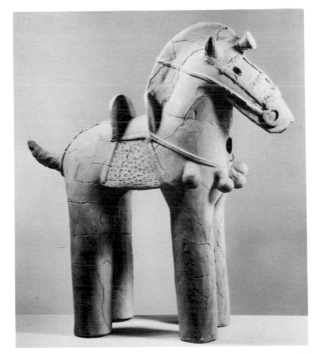

Sesson Shūkei (1504?-1589?), Japanese, *Landscape,* late Muromachi or early Momoyama period, 16th century. Ink on paper. 63.5 x 35 cm. Signed upper right. 1969.1

Sesson has taken the broken-ink (*haboku*) method of Chinese painting and transformed it into a highly personal mode of expression through the use of dynamic washes. Vivid strokes depict the individual motifs: figures crossing a bridge, fishermen in boats, travelers ascending a narrow path, a mountain village, and a descending flock of geese. Signed with two seals, this landscape most likely represents the mature style of Sesson, a Zen priest who spent most of his life in the provinces of northeastern Japan. The painting may have been one of a pair of hanging scrolls on the familiar Chinese theme *Eight Views of Xiao and Xiang.*

Yamada Dōan (d. 1573?), Japanese, *Hotei* (Chinese, *Budai*), Muromachi period, 16th century. Ink on paper. 69.6 x 45.8 cm. Partial seal lower left. Gift of Mary C. Lanius in memory of Paul Baxter Lanius. 1970.32

Hotei is a quasi-historical figure believed originally to have been the Chinese monk Qici. A favorite with Zen Buddhists, he became the center of many popular legends and was usually portrayed with a "big belly" and "hemp bag," a visual pun on the two meanings of his nickname. Hotei wandered around the country begging alms and carrying his belongings in a huge bag usually pictured suspended from a stick slung over his shoulder. Identification of Yamada Dōan, a painter in the Zen tradition, is complicated by the fact that there are three Japanese artists recorded by that name. The gourd-shaped seal found on this painting, however, can probably be attributed to Dōan II, who painted human figures.

Attributed to Hon'ami Kōetsu (1558-1637), Japanese, poem from *The New Collection of Ancient and Modern Poems (Shin Kokin Waka Shū),* late Momoyama or early Edo period, early 17th century. Ink, gold on colored paper. 21.1 x 16.2 cm. Anonymous gift. 1975.75

The arts of calligraphy, painting, and poetry are combined in this small album leaf, now mounted as a hanging scroll. Over the gold images of a pine tree and full moon on green-colored paper, the renowned calligrapher Hon'ami Kōetsu has inscribed a selection from an anthology of poems compiled under the Emperor Gotoba (1180-1239) and completed in 1205. Referring to the favored season of spring, the verse reads:

> Cherry blossoms are in full bloom over the
> white-cloud covered mountains.
> How I wish I were there to pluck a spray so I
> could distinguish the flowers from the clouds.

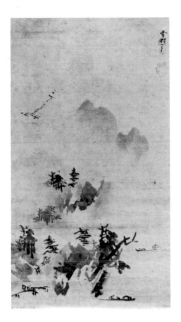

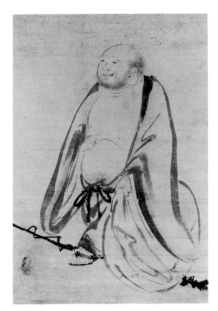

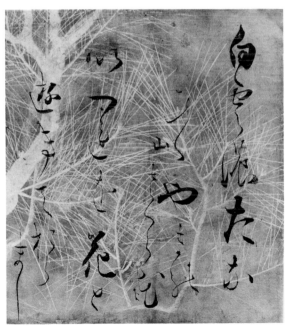

Isozaki (detail), pair of handscrolls, Japan, Momoyama period, late 16th century. Ink, color on paper. Each scroll 30.4 x approx. 732 cm. 1970.12.1-2

This pair of handscrolls, with eleven illustrated sections, tells the story of the warrior Isozaki. By marrying a second wife, Isozaki drives his first wife mad with jealousy, causing her to put on a demon mask and beat her young rival to death with a staff. The mask and staff become permanently affixed to the first wife until she is cured by practicing Zen meditation. This *Isozaki* is probably the earliest surviving text of the story preserved in handscroll form. The illustrations continue the indigenous *Yamato* style of painting developed during the Heian period (897-1185), and the one pictured here is rendered with Japanese aerial perspective: the roof is removed to give a bird's-eye view of interior scenes. Literary manuscripts of this type are often called *Nara Ehon* (Nara picture books).

Iizuka Tōyō, writing box (lid illustrated), Japan, Edo period, 18th century. Lacquered wood, bronze water container, inkstone. 23.3 x 21.6 cm. Signed "Kanshōsai-kakihan" lower left reverse of lid. Gift of Mr. and Mrs. George A. Argabrite. 1975.102a-g

Writing boxes (*suzuribako*), whose interiors were divided into separate compartments for holding an inkstone, water dropper, inksticks, and brushes, were customarily decorated on both the inner and outer surfaces by lacquer artists. Depicted on the exterior of this lid is a vivid scene of two armored warriors on horseback fording the Uji River, an episode in the Gempei Wars (1180-1185); a landscape with three herons adorns its interior. Kanshōsai is an artist-name used by Iizuka Tōyō and his pupils and followers.

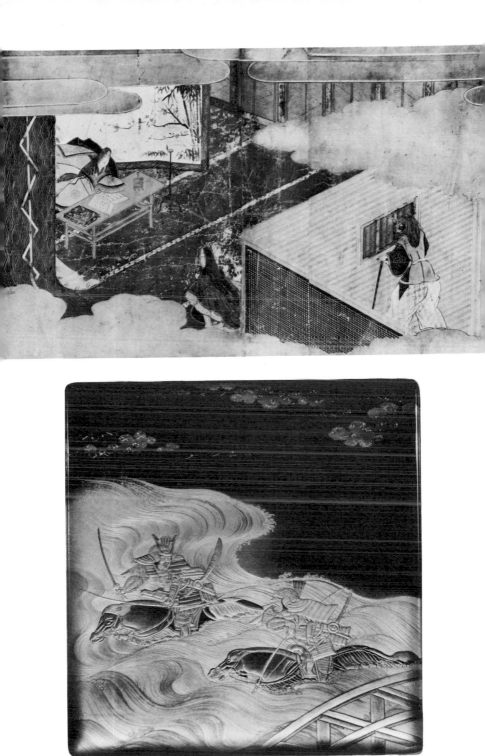

Chinese Sages in a Landscape, pair of eight-panel screens, Japan, Momoyama period, Kanō School, late 16th/early 17th century. Ink on paper. 160.8 cm. h., outer panels 56.6 cm. w., inner panels 63.6 cm. w. Gift of Dr. and Mrs. John A. Fleming. 1977.161.1-2

Remounted as an oversize pair of eight-panel screens, these paintings were originally intended as *fusuma,* the large sliding screen walls in a Japanese building. The two main scenes show a group gathered around a *go* board and three men examining a scroll with calligraphy. Perhaps they were originally part of a larger composition that also included scenes of music and painting, thus completing the traditional Chinese program of the Four Accomplishments. Since a snow-covered bank appears on one screen, the Four Seasons may also have been represented. The paintings are a product of the Kanō School, which favored Chinese subject matter and became the official academy of the Tokugawa shoguns.

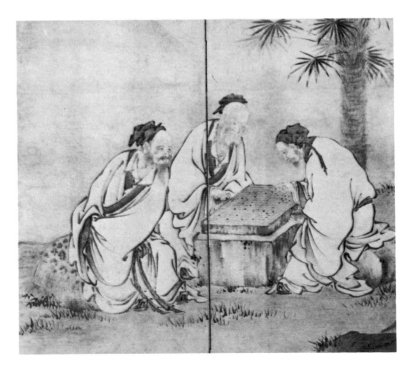

Maruyama Ōkyo (1733-1795), Japanese, *Peafowl with Tree Peonies,* Edo period, late 18th century. Ink, color on silk. 1.28 x 1.8 m. Signed middle right. Gift of Mr. and Mrs. John Davis Hatch in memory of Rev. Anson Phelps Stokes. 1971.63

Peafowl and tree peonies were a popular subject for Maruyama Ōkyo and his students. Perched on a garden rock, the two birds here are silhouetted against an undifferentiated background of gold wash; the brilliant plumage is rendered in precise detail. The founder of a school of painting based on the direct study of nature, Ōkyo developed a style influenced in part by realistically executed Chinese paintings and European art and perspective. This example of his work is closely related to two paintings in Japan belonging to the Emman-in and the Imperial Collection, dated respectively 1771 and 1776.

Okumura Masanobu (1686-1764), Japanese, *Potted Trees in the Snow,* Edo period, c. 1745. Hand-colored woodblock. 28.5 x 40.7 cm. Gift of Mrs. Frederic H. Douglas. 1960.19

Woodblocks were a favored medium in the art of *ukiyo-e* (the floating world), known for its representations of actors and beautiful women. In this early hand-colored print, Okumura Masanobu combines views of interior and exterior spaces through the innovative use of western perspective. Based on a subject popular in Japanese theater, the scene illustrates the story of Tsuneo, an unjustly banished warrior who sacrifices three prized potted trees to provide warmth for a monk seeking shelter during a storm. The monk, who is actually the powerful Prime Minister Tokiyori (1227-1263), restores Tsuneo's property and position to him. Tokiyori also grants Tsuneo three estates to compensate for the lost trees.

Tea caddy, Japan, 19th century. Bamboo with lacquered interior. 5.1 cm. h. Gift of the Lutz Bamboo Collection. 1980.17

The tea ceremony (*chanoyu*) pervades Japanese life and is unsurpassed in the manner in which it incorporates various arts into a harmonious relationship. Bamboo plays an integral role in the tea ceremony. As a natural material, it suits the spirit of *wabi* (poverty) tea, which was influenced by Zen Buddhism and its renunciation of worldly things. Carved from the underground portion of the plant to take advantage of the pattern of the root markings, this tea caddy, used when serving *usucha* (thin tea), elegantly reveals the inherent beauty of bamboo.

Itō Jakuchū (1716-1800), Japanese, *The Thirty-Six Immortal Poets,* pair of six-panel screens, Edo period, 1798. Ink on paper. Each painting 140.5 x 54.1 cm. Signed outer edge of first and last panels. Marion G. Hendrie Collection and Asian Art Department Acquisition Fund. 1977.35.1-2

Classified as one of the Three Eccentrics of the Edo period, Itō Jakuchū has created an unorthodox interpretation of a traditional pictorial theme—the Thirty-Six Immortal Poets. Customarily painted in staid poses, the poets are treated here with light-hearted humor. They are shown pursuing pastimes that include the familiar Four Accomplishments (music, the game of *go,* calligraphy, and painting), as well as more playful activities like blowing soap bubbles, juggling, and playing with a yo-yo. One of the most amusing scenes depicts a poet-calligrapher in court robes writing the exclamatory word *"Banzai"* (hurrah) with a brush held in his mouth in a gleeful display of virtuosity. To date, this is the only known treatment of the Thirty-Six Immortal Poets by Jakuchū, who is best known for his paintings of roosters.

Sakai Hōitsu (1761-1828), Japanese, *Autumn Grasses,* four-panel screen, Edo period, early 19th century. Ink, color, gold on paper. 1.65 x 2.61 m. overall. Signed lower right. Mr. and Mrs. Frederick R. Mayer, anonymous donor, and general acquisition funds. 1979.332

Sakai Hōitsu, son of a *daimyō* (feudal lord), progressed through an eclectic art training before finally turning to Rimpa, a school which exemplified native Japanese style and taste. He developed a particular interest in the earlier Rimpa artist Ogata Kōrin (1658-1716), many of whose paintings were in the Sakai family collection. Hōitsu selected themes from classical literature and poetry which he translated into compositions remarkable for their elegance of color and design. Here, the depiction of grasses and flowers associated with fall evokes the gentle melancholy of that season. Since this four-panel screen is signed "Uka Hōitsu," it can be dated after 1809, the year Hōitsu built a studio called "Uka-an" (Rain-Flower Hermitage) in Edo.

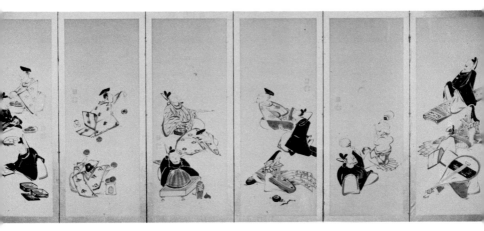

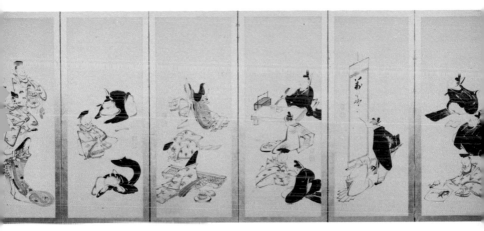

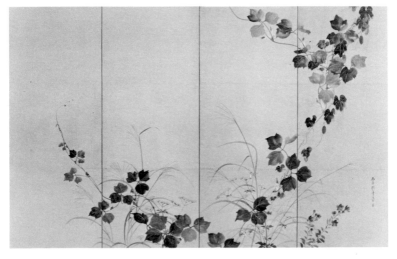

Descent of Amida (Amida Raigō), Japan, Kamakura period, early 14th century. Color, gold on silk. 106.2 x 37.9 cm. 1974.5

Japanese Buddhist painters frequently depict Amida, the Buddha of Infinite Light and Lord of the Western Paradise, descending to welcome to the Pure Land a newly deceased devotee. Toward the end of the Kamakura period (1185-1333), representations of Amida's descent were simplified from sumptuous, multifigured compositions to less complex paintings of Amida alone or with two attendant bodhisattvas. The change reflects the teaching of Hōnen (1133-1212) and Shinran (1173-1275), the two great leaders of the Pure Land sect of Buddhism in Japan. Here, Amida, painted in gold, with an intricate pattern of cut gold leaf (*kirikane*) applied to his robes, is shown as a solitary figure, floating down on a cloud.

Yamamoto Baiitsu (1783-1856), Japanese, *Early Summer Landscape,* Edo period, 1832. Ink on silk. 130 x 58.2 cm. Signed and dated upper left. Gift of Mr. and Mrs. George A. Argabrite. 1978.167

Although Yamamoto Baiitsu is better known for his colorful bird and flower paintings, he was also a talented landscape painter. In this majestic representation of mountain peaks and waterfalls, he demonstrates a full command of the styles and techniques derived from Chinese literati painting of the Ming and Qing dynasties. A native of Nagoya, Baiitsu traveled to both Kyoto and Edo, where he associated with members of the Nanga (southern painting) school, a group of Japanese artists who studied and interpreted the philosophy and style of Chinese scholar-painters.

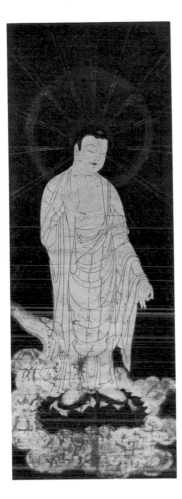
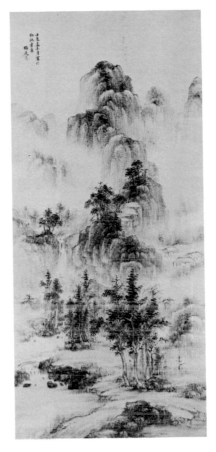

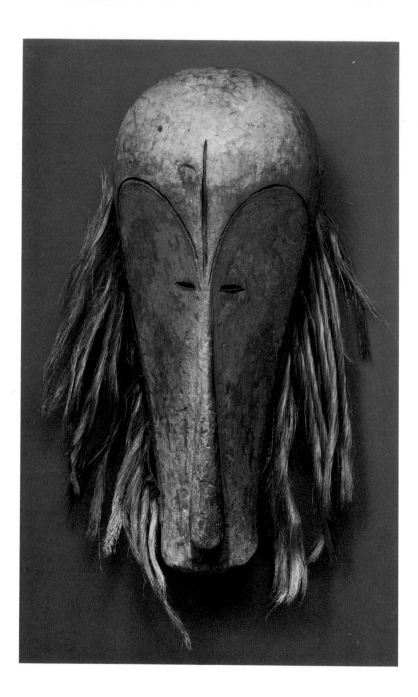

Native Arts

The museum is the repository of one of the world's foremost collections of Native American art, as well as significant examples of the art of Africa and Oceania. Although the Native American collection is not the largest in public hands, it was the first to be selected and displayed as art rather than anthropological artifact. Until relatively recently, most art museums virtually ignored the work of America's indigenous cultures, but the past few decades have witnessed a reappraisal of native arts which has emphasized their esthetic achievements and brought international attention to the Denver Art Museum's premier collection.

Although the museum's first directions paralleled those of other art institutions, its founders also decided to include in its collections a representation of southwestern Native American art—a radical idea in the early 1890s, when the activities of most art museums were strictly circumscribed by traditional notions of "fine art." Denver's most influential early champion of native art was Anne Evans, daughter of Colorado's second territorial governor. An enthusiastic collector of both Indian and Spanish colonial art, she not only provided the young museum with a nucleus collection in these fields, but also encouraged the support of her friends by her spirited patronage.

The aspirations of these early advocates were advanced in 1925 with the establishment of a Department of Indian Art. Edgar McMechan, the local man named as its first curator, undertook an active program of field collecting and devised a catalog system to bring the existing collection into order. Four years later the curatorship passed to Frederic Huntington Douglas, who was to gain national prominence as a pioneer in the study and appreciation of Native American art during his 27-year tenure. He was intimately involved with the first important exhibitions of

Native American art in this country—at the San Francisco World's Fair of 1939 and the Museum of Modern Art in 1941. Douglas, in fact, collaborated with René d'Harnoncourt in the conception and execution of the New York exhibition and provided the major part of the catalog text. Laboring tirelessly to promote the acceptance of the materials he loved, he taught courses at Harvard and elsewhere.

Both Douglas and his parents, Rev. and Mrs. Charles W. Douglas, donated many fine pieces to the collection, and Douglas bequeathed to the museum his anthropological library of over 50,000 volumes, now a major resource for students and scholars. His enthusiasm and pioneering fieldwork were matched by his discerning connoisseurship, which built the museum's collection of Native American art to a position of preeminence and proved to the world that such a collection had a valid place in an art museum.

Today, the Native American holdings account for well over half of the museum's inventory and offer examples of almost every style and medium produced in the United States and Canada. In its quality and depth, the Plains Indian collection is without peer, but masterpieces are a commonplace in other areas of the collection as well. Housed in a specially designed section of the mezzanine, the Northwest Coast display features two rare house partitions from the Alaskan Tlingit—a pair of superb Raven screens of fluid, dynamic design and the famous Shakes family Grizzly Bear screen, awesome in its size and symmetrical, massive image. In the 1950s the department's fine Southwest holdings were enriched by a large group of Navajo textiles from the collection of Alfred I. Barton of Miami Beach. This gift brought to Denver several of the world's foremost Classic blankets, including the well-known Sheridan blanket.

The extraordinary range of Native American art styles is reflected in such diverse objects as a prehistoric effigy pot, Naskapi painted leather garments, Winnebago twined weaving, Kiowa and Comanche peyote fans, Navajo silverwork, and Pueblo pottery. The growing collection of contemporary Indian art has been enlarged recently by a major gift from Henry G. Shearouse Jr., a knowledgeable collector of Eskimo prints and sculpture.

In 1979, the museum published a substantive catalog of 500 masterworks from the Native American collection. In it, Richard Conn explores the design concepts, techniques, and cultural values that inspired the complex array of styles and forms on view in the Native American galleries.

Although relatively small, the museum's collections of African and Oceanic art have steadily gained in size and stature since the 1940s, when Frederic Douglas's World

War II service first brought him into direct contact with the arts of the South Pacific. Encouraged by newly appointed Director Otto Karl Bach, whose own interests included the art of Africa, Douglas extended the collecting activities of the department and changed its name to reflect its new scope. In the years since then, both the African and Oceanic collections have received some of their finest examples, including a magnificent Yoruba door and several significant New Ireland pieces, from anonymous donors dedicated to preserving the swiftly vanishing arts of these native cultures.

Among major works in the African holdings are a hauntingly beautiful Fang mask and an Ekoi headdress thought to be one of the oldest extant examples. A handsome and unusual Tikar dance headdress from Mr. and Mrs. Peter Natan and a powerful Sherbro effigy figure given by Mr. and Mrs. Emmett Heitler are recent additions that have enlarged the collection's range. The Oceanic collection, too, has benefited from a growing interest in native arts and particularly from the continuing support of Mr. and Mrs. George Anderman, active collectors of Melanesian art. Prominent in the core collection assembled by Frederic Douglas are several pieces from New Guinea, including a fine ancestor mask from the Sepik River delta and a tortoise-shell mask from Torres Strait.

Effigy pot, Late Mississippian period, Missouri(?), early 15th century(?). Clay, ground shell. 23 cm. h. 1956.32

In the centuries before Columbus and for some time afterwards, a highly developed native society flourished along the lower Mississippi and Ohio rivers. Today we are just beginning to discover its accomplishments in social and political organization, architecture, and the arts. As was generally true in the eastern United States, the people of these early city-states preferred sculpture to painted pottery. They are particularly noted for their fine effigy ceramics. This example is a functional water jar carved as a seated woman. While the coiffure, which may have had tribal or social significance, is presented in some detail, the potter has subtly simplified the figure to form the jar's body.

Boogerman mask, Cherokee, Big Cove, North Carolina, 20th century. Buckeye wood, fur, native paint. 29.8 cm. h. 1936.205

The Cherokee held midwinter social dances which often included appearances of the Boogermen, bizarrely dressed clowns who carried on in a comic, sometimes obscene fashion. Reminding the community of the lighter side of the year's events, their dances and antics served as an example of unacceptable social behavior. Apparently associated with religious rituals, masking is an ancient tradition in the Southeast. The Cherokee masked clowns are the only historic survival of this tradition, which otherwise disappeared with the advent of the Europeans.

False Face mask, Seneca, New York, late 19th century. Basswood, horse tail, tin. 26.7 cm. h. excluding hair. 1932.126

The Six Nations of the Iroquois had a respected society of healers called the False Faces after the wooden masks they wore. Considered sacred objects by the Iroquois, these masks represented mighty spirits and were believed to contain the power the healers drew upon to treat both physical and mental illnesses. This example is typical in its use of repeated arching curves to emphasize the protruding mouth and staring eyes. Tin rings enhance the eyes' awesome appearance by firelight, and the long hair also adds to the mask's impressiveness.

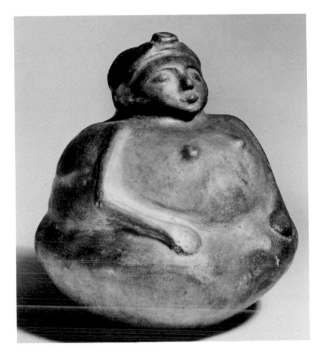

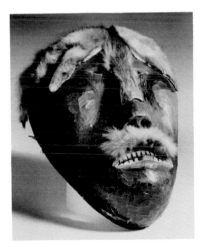

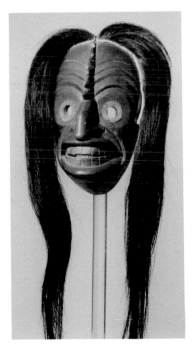

Embroidery, Huron, Quebec, mid-19th century. Broadcloth, moosehair. 51.4 x 44.5 cm. 1970.452

This unusual chair seat cover reflects the merging of cultural traditions that took place in 17th century Quebec: French designs are worked on a broadcloth background in the native medium of colored moosehair. Among the first French immigrants to Quebec were the Ursuline Sisters, whose mission was to instruct native girls in religion and domestic arts. They introduced as subjects for embroidery French floral design with its realistic blossoms and leaves and asymmetrical stem lines. Soon, Huron and Iroquois girls were combining the new motifs and materials with those of their mothers to create a distinctive hybrid North American floral design.

Container, Montagnais, Quebec, early 20th century. Birch bark. 26.5 cm. h. 1936.145

The native people of Quebec and Ontario had created their own plant designs, which emphasized simplified leaf and blossom shapes organized in bilateral compositions, long before the French introduced complex European versions. This design decorates a "mocock," a birch-bark container combining a rectangular base with an oval rim. After the fresh bark had been darkened with boiling water, the design was achieved by immediately scraping away the background to expose the paler, unscalded inner layers. Mococks were used for storing foods such as parched corn and maple sugar.

Quilled box, Micmac, Nova Scotia and New Brunswick, collected before 1840. Birch bark, porcupine quills, native dye. 10.5 cm. dia. 1943.27

Native American people have always shown great ingenuity in using unusual materials for practical purposes. The outer surface of this birch-bark container is completely overlaid with dyed porcupine quills. To form the design, sharp quill ends are pushed through the bark, and an inner bark lining is added to protect the container's contents. The use of long quills dictated straight-edged figures like these, but curvilinear designs could be achieved with finer quills. Quilled containers of this type are still made in Canada today.

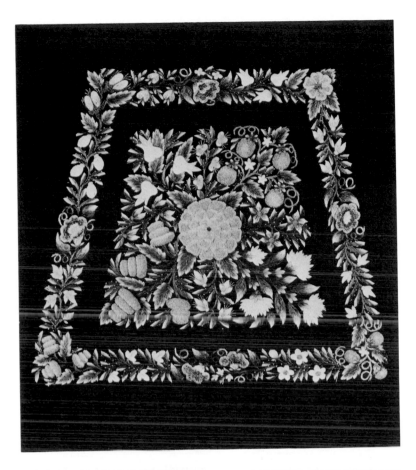

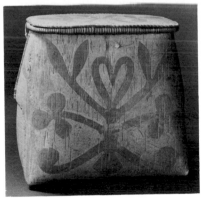

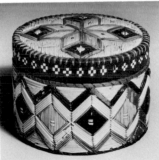

Spoon, Winnebago, Wisconsin, late 19th century. Curly maple. 23.7 cm. l. 1941.280

The deciduous forests of the Northeast and Great Lakes regions provided native carvers with a wealth of raw material. In both regions craftsmen tended to create functional forms with little decoration in order to emphasize the handsome textures of the hardwoods. Using only a stylized bird's head on the handle to balance the mass of the bowl, the carver of this spoon has concentrated on bringing out the beautiful grain of the curly maple.

Cradle and binder. Cradle: Ojibwa, Garden River Reserve, Ontario, c. 1860. Beechwood(?). 76.3 cm. l. 1940.184. Binder: Ottawa, Ontario, early 19th century. List cloth, silk ribbon. 1.36 m. l. 1939.9

The woodworking technology of the Great Lakes people included the ability to shape wood by boiling and steaming it. While the process was probably developed to make utilitarian canoe and snowshoe frames, it was also used in strictly decorative contexts like this cradle fender. Woodlands babies were bound to their cradles with ornamented wrappings. These binding strips have been embellished with silk ribbon appliqué in figures derived from the earlier woven quillwork and twined bags of the area. Midwestern tribes apparently invented this particular type of appliqué to take advantage of the new European material.

Rattle, Ojibwa, western Great Lakes, 19th century. Hardwood, deer toes. 25 cm. h. 1971.571

As in most of native North America, the Great Lakes people believed in individual spirit helpers who gave them directions for making personal sacred objects. Probably used to cure sickness or assure someone's well-being, this small rattle is crowned with a hawk, which may represent its owner's guardian spirit. The simple form is typical of Great Lakes wood carving and shows the carver's skill in creating graceful shapes which enhance the esthetic qualities of the raw material. When shaken, the bunch of polished deer toes tied just below the bird makes a gentle percussive sound to accompany sacred songs.

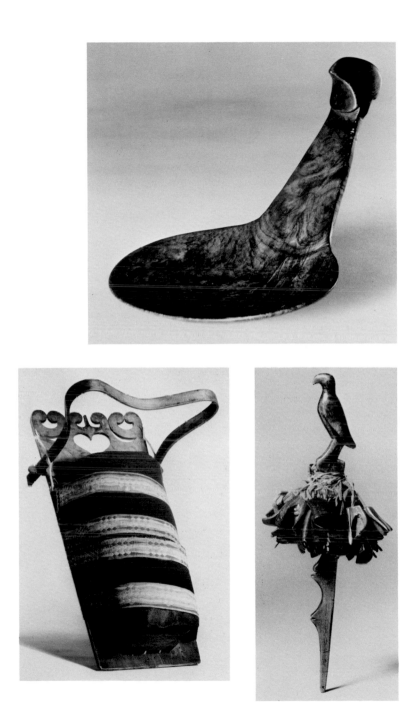

Twined bag, Menomini, Wisconsin, late 19th century. Linen, wool yarn. 33 x 47 cm. 1946.280

Small textiles can be produced without a loom by various twining processes. A weft twining technique apparently invented by the Woodlands people made it possible to work with two layers of colored warp strands and to bring either forward as desired, thus enabling the artist to create complex animal and human figures. When wool yarns became available in many colors, the capacity of the technique was expanded to produce attractive multicolored storage bags like this example.

Girl's boots, Cheyenne, Wyoming, 1870s. Native leather, beads. 23.5 cm. h. 1948.93

The earliest type of decoration used by the Plains tribes may have been painting on leather. Bison robes and clothing were often painted with groups of plain, narrow stripes, most likely a military motif recording the wearer's battlefield exploits. By using a lazy-stitch technique which allowed them to produce long, narrow lines, the Cheyenne were able to translate this design to the new medium of beading. The military symbolism was probably forgotten by the time these boots were made, but the stripes have been used to create a bold and dynamic beaded design.

Bandolier, Ojibwa, western Great Lakes, c. 1870. Cotton cloth, strouding, beads. Pouch 36 x 28 cm. 1970.417

When European traders appeared with new materials, their Native American customers often surprised them by using these goods in unexpected ways. For example, Europeans did not use glass beads in massed compositions like the decoration on this bandolier panel and strap. The figures, worked here in woven beadwork, are drawn from the traditional patterns used in twined bags and carrying straps of the Great Lakes region but have been expanded in complexity to take advantage of the wider palette of bead colors. The bandolier form itself was based on the European shoulder pouches in which a hunter or soldier kept his shot and powder.

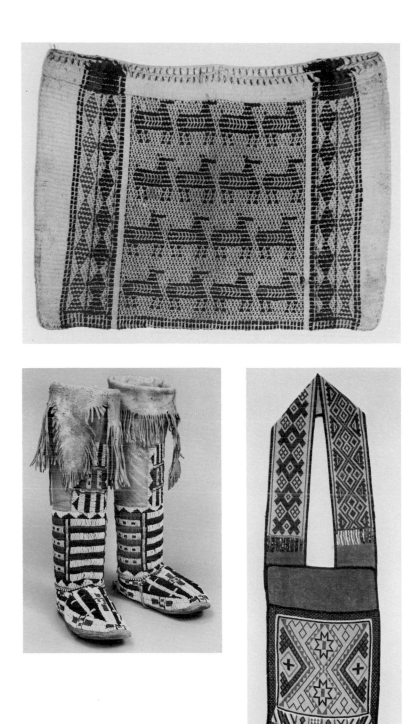

Man's long shirt, Seminole, Florida, 1940. Cotton cloth.
1.17 m. l. 1940.223

A persistent misconception about Native American art
is that all its manifestations are ancient and innovation
is minimal. This shirt pattern, based on an 18th century
European model, is proof to the contrary. Furthermore, the
patchwork method of decoration was not invented by the
Seminole until early in this century. Only the colored bands
on the shoulder yoke are traditional: they designate the
family to which the wearer belongs.

Woman's clothing, Menomini, Wisconsin, mid-19th century.
Skirt: broadcloth, ribbon, 1938.23. Moccasins: native
leather, beads, 1954.190. Blouse: sateen, ribbon, German
silver, 1948.192. Sash: beads, wool yarn, 1947.157. Earrings:
German silver, 1950.120. Brooch: German silver, 1949.113.

Native Americans frequently combined indigenous and
foreign elements to create striking ensembles like this,
which, except for the leather of the moccasins, is made
entirely of trade material. In its design the ruffled blouse
shows European influence, but, like the skirt and leggings,
it is cut according to earlier leather clothing patterns.
European ribbon and nickel silver were used to carry out
traditional native decorative motifs.

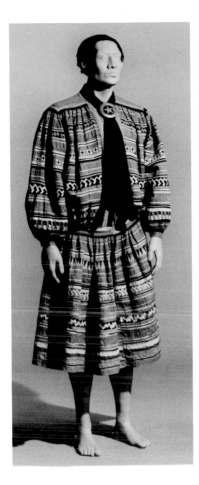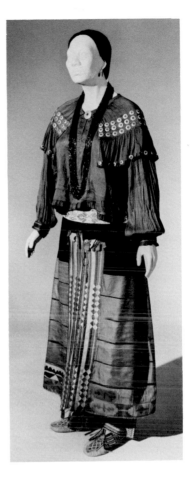

Beaded robe, Sioux, Dakotas and Minnesota, c. 1870.
Bison leather, beads. 1.78 x 2.37 m. 1948.144

Custom dictated that Plains women limit their designs to geometric patterns, which they applied with paint, quills, or beads to rawhide and leather. This robe shows a pattern called "box and border," one of several commonly used by most Plains tribes. Unique to decorated robes, the figures used here are probably among the oldest Plains designs. The whole composition is thought to symbolize the bison, with each part representing some useful portion of the animal. This robe is one of only two known examples of this pattern which are beaded rather than painted.

Necklace, Navajo, Arizona and New Mexico, early 20th century. Silver, turquoise. Gift of Rev. and Mrs. C.W. Douglas. 1935.79

Although the Navajo are famous for their silverwork, the craft was introduced to them by Mexican and Spanish metalworkers perhaps less than 200 years ago. The design of this squash-blossom necklace, one of the best-known forms of Navajo jewelry, originated as a Moorish magical guard against evil. The Spanish, who reinterpreted the central element as the hands of Our Lady of Fatima, also retained the Moorish pomegranate blossoms. Among the Navajo these were perceived as squash blossoms, and the crescent element became an abstract form known as a "naja." Like this example, early Navajo silverwork tended to be light and graceful and to make sparing use of turquoise or other gemstones.

Mrs. George Poolaw Sr., cradle, Kiowa, Oklahoma, 1897. Native leather, beads, Osage orange wood, various ornaments. 1.4 m. l. 1941.42

To protect their infants both during travel and the performance of camp chores, the women of equestrian Plains tribes devised cradles made by mounting reinforced leather sacks on wooden frames. Since cradles were usually made as gifts by loving aunts and grandmothers, full decoration is common. The Kiowa in Oklahoma evidently had no traditional cradle decorations of their own or else abandoned them in favor of curvilinear figures, which they may have borrowed from Midwestern tribes relocated in this region.

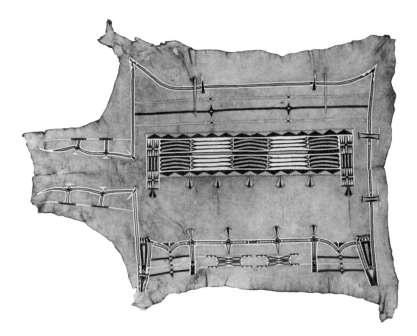

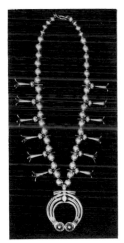

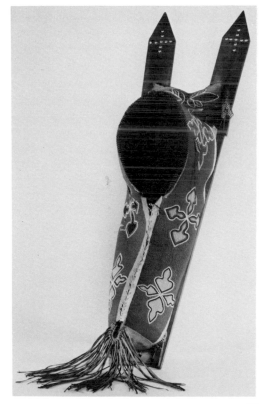

Pipe bowl, Sioux, Dakotas and Minnesota, mid-19th
century. Catlinite, lead. 23 cm. l. Gift of Miss Edith Thomas.
1941.196

Catlinite, a soft, reddish stone which occurs in deposits
throughout the Midwest, was used so extensively by the
Central Plains people to create pipe bowls that it has come
to be known as "pipestone." The Sioux were noted for their
sensitive handling of the basic "T" shape shown here and
for decorating it, if at all, with compatible designs and
materials. In this example, molten lead has been poured
into shallow, carved channels to form an elegant
decoration which reinforces the soft stone and enriches
the shape without detracting from its graceful simplicity.

Blanket, Navajo, Arizona and New Mexico, c. 1860.
Handspun and commercial yarns; indigo and cochineal
dyes. 1.78 x 1.4 m. Gift of Alfred I. Barton. 1955.248

Early Navajo weavers used compositions of horizontal
bands with few vertical elements. As Spanish and Mexican
settlers moved into the Southwest, they introduced new
concepts of plain and stepped diagonal lines which the
Navajo adopted. Dating from the Classic period, this
blanket represents a synthesis of native and foreign design
elements, as well as an amalgam of materials in
its use of New World dyes and Spanish wool. The blanket
once belonged to General Philip Sheridan, who acquired
it in Albuquerque shortly after the Civil War.

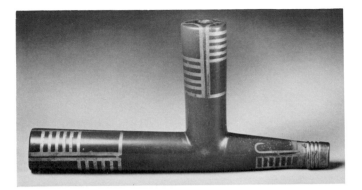

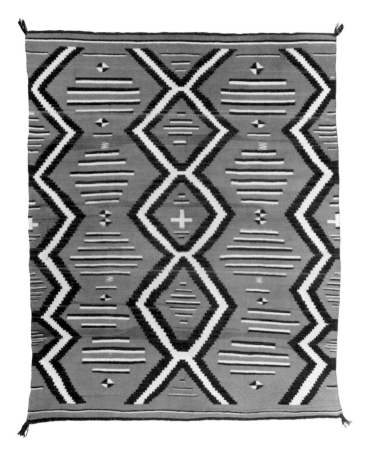

Incised parfleche, Crow, Montana, c. 1850. Bison hide.
73.7 x 30.5 cm. 1936.31

The designs on this parfleche were created by scraping
away the outer layer of rawhide, a tedious process rarely
used in native America. Most existing examples are
attributed to the Crow. Isosceles triangles used alone or in
pairs and a two-part division of the design field are elements
that became the hallmarks of Crow rawhide painting and
bead embroidery. Although sometimes used generically as
a synonym for *rawhide, parfleche* refers specifically to
envelopelike containers of this shape.

Basket, Pima, Arizona, early 20th century. Willow, martynia.
40.6 cm. dia. 1938.686

Of all the Native American arts, decorated basketry
has been least appreciated in proportion to its esthetic
accomplishment. While a potter or beadworker plans
compositions for an existing surface, a basket maker
creates both surface and decoration at the same time.
Pima baskets often show mastery of this difficult feat with
designs that fit their allotted space and relate perfectly to
the basket's form.

Pictorial bowl, Mimbres culture, Arizona and New Mexico,
10th/11th century. Tan clay, white slip, red paint.
19.5 cm. dia. 1972.384

About the time of Christ, a group of Southwestern
people known to us as the Mogollon culture developed
an advanced civilization, whose art culminated in the
Mimbres ceramic styles of the 10th and 11th centuries.
Keen observers of the natural world, Mimbres potters used
familiar life forms as subject matter and often went beyond
nature to create whimsical creatures like this New World
equivalent of the medieval cockatrice. Their superb
technical skill is illustrated by the evenness of the lines
painted inside the bowl's rim.

Santana Melchor, water jar, Santo Domingo Pueblo,
New Mexico, early 20th century. Red clay, cream slip,
black paint. 24.7 cm. h. 1963.333

Each pueblo in the Rio Grande valley of New Mexico
developed distinctive shapes and styles of decoration for
its pottery. Santo Domingo potters favored bold, large-scale
geometric decoration in black over a cream-colored base.
In this superb example, which shows the strength and
subtlety of their best work, the flowing curves of the ovoid
shapes temper the strong thrust of the verticals and
diagonals to create a graceful rhythmic relationship
between the surface painting and the pot's form.

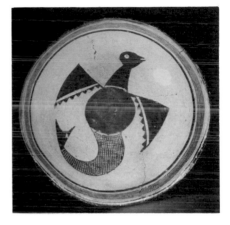

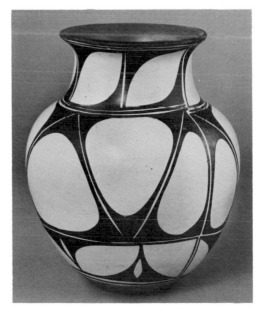

Covered hamper, Thompson River Salish, British Columbia, late 19th century. Cedar root, bear grass, wild cherry bark, native dye. 37 cm. h. 1938.753

While the technique of coiled basketry leads naturally to round bases, several tribes of the interior Northwest devised more difficult square and rectangular shapes. Another regional accomplishment is the attractive decorative technique called imbrication, in which strips of natural material such as wild cherry bark are caught into the stitches to form an "outer skin." Allover patterns like this were preferred by the Thompson River Salish, who also used them in twined and woven textiles.

Basket, Chemehuevi, California, early 20th century. Willow, martynia. 14 cm. h. Gift of Rev. C.W. Douglas. 1928.59

Compared to the more complexly decorated baskets of the neighboring Pima and Apache, Chemehuevi baskets seem rather plain. However, in this example, as in most Chemehuevi work, the design is a perfect complement to the beautifully simple shape; further decoration would have been excessive.

Twined bag, Wishram, Oregon and Washington, late 19th century. *Apocynum* sp., native dye. 30.5 cm. h. 1951.401

A distinctive art style, which was applied to several media, was developed long ago near the Dalles of the Columbia River, a region which has supported continuous native settlement for over 2,000 years. Among the characteristic motifs is a skeletal human figure with a hexagonal head. Here, the head alone is repeated in an elegantly stylized allover pattern. Because the Dalles area suffered several epidemics early in the 19th century, much of its traditional culture was lost. Thus, we do not know whether these remarkable figures had more than a decorative significance.

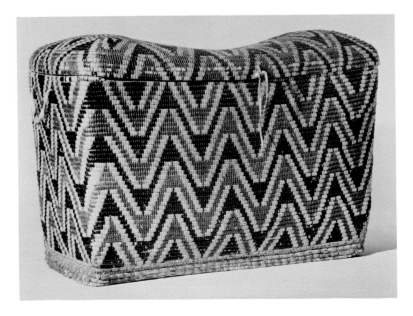

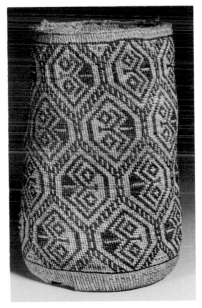

Bridal headdress, Yakima, Washington, late 19th century. Native shell, glass beads, Chinese coins. 32 cm. l. 1964.156

Like many Native American tribes, the Plateau people saw marriage as the inauguration of a new household and an enhancement of the community. Accordingly, a bride's family dressed and outfitted her as completely as possible. Part of her wedding costume was a traditional headdress incorporating highly valued *Dentalium* shells, which reflected her family's desire to "set her feet on the path of wealth." The coins used as ornaments on this headdress were introduced into the Northwest by Chinese laborers who came to work on the railroads.

Covered basket, Karok, California, c. 1890. Redwood root, maidenhair fern, bear grass. 19.7 cm. h. 1950.249

The workmanship and design of this basket establish it as a true masterpiece of the twining technique. To achieve the difficult convex/concave form, the basket maker normally would have added or removed warp strands in nearly every row of twining. Here, however, the maker has kept the number of warps constant, carefully preshaping each strand to form the complex shape, a feat which enabled her to execute the elaborate quail feather design without distortion. The pattern is typical of the northern California system of design organization: figures set alternately on either side of a horizontal axis.

Basket, Kitanemuk, California, late 19th century. Willow, yucca, martynia. 40.5 cm. dia. 1938.663

This example shows the flared shape customarily preferred by the central California tribes. The alternating plain and geometrically figured bands of decoration harmonize with the shape to give the basket a dynamic, expanding appearance. The Kitanemuk and their Kern River neighbors were noted both for their meticulous workmanship and for their skillful integration of shape and decoration.

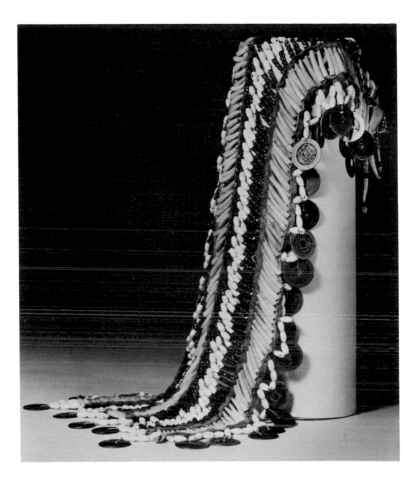

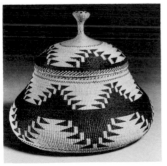

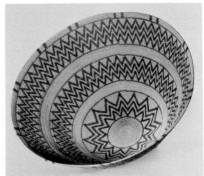

Harpooner's hat, Nootka, British Columbia, collected in 1794. Cedar bark, spruce root, surf grass. 23 cm. h. 1952.607

Nootka hunters periodically traveled far out to sea in pursuit of whales. Since the honored role of harpooner was usually awarded in recognition of personal wealth and prestige rather than skill, these privileged persons proclaimed their status by wearing special basketry hats on which whaling scenes were depicted. To accommodate the figures to the lin itations of the twining method, the basket maker had to simplify and stylize images of whales, canoes, and men. The harpooner's relative size has been exaggerated to emphasize his importance.

Basket, Yokuts, southern San Joaquin Valley, California, early 20th century. Willow, quail feathers, native dye. 21.5 cm. h. 1938.993

Unlike most California groups, the Yokuts of the San Joaquin Valley were organized into tribes with a central government and defined territories. On this basket the bands of figures with joined hands symbolize the sense of tribal community. Central California basketry often uses open, conical forms, but the squared shoulder and flat upper plane, a difficult technical feat, is unique to the Yokuts. Quail topknots have been used to decorate and emphasize the shoulder rim.

Totem pole, Haida, Kaigani Division, Sukkwan Village, Alaska, c. 1875. Cedar. 8.72 m. h. Gift of the University of Pennsylvania. 1946.251

Contrary to general belief, totem poles had nothing to do with Northwest Coast religion but instead depicted legends justifying family status and privileges. Each legend was personified by a particular crest animal, or totem, so that anyone looking at a totem pole would know immediately which legends were represented. In developing a monumental style consistent with the function of totem poles, carvers exaggerated facial features to make portraits more impressive.

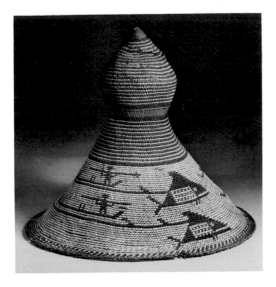

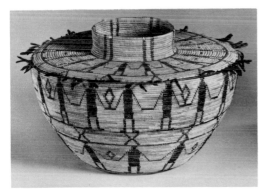

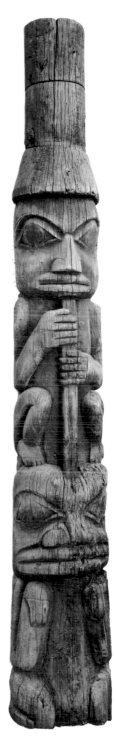

Chief's hat, Tlingit, Alaska, early 19th century. Yellow cedar, native paint, spruce root, copper, shells, various ornaments. 28 cm. h. 1938.369

The glorification of family crest symbols is an important part of Northwest Coast social organization. The crouching wolf surmounting this wooden hat indicates that it was carved for some dignitary of a Wolf clan, whose wealth and influence are proclaimed by various features such as the precious native copper appliqués and the painted basketry cylinders. The latter are a tally of paramount social occasions for which the wearer and his family may take credit. The conical shape was inspired by basketry hats of the region.

Carving, Haida, British Columbia, c. 1875. Carbonaceous shale. 18 x 20 cm. 1953.449

Carbonaceous shale is a soft stone found only in the Queen Charlotte Islands. Because it carves well and takes a high polish but is too brittle to use for tools or most functional objects, Haida carvers used the shale for decorative pieces like this. The figures represent events from a legend and differ from a totem pole only in having a lateral, rather than a vertical, composition. From the late 18th century, European traders called on Northwest Coast tribes to buy sea otter furs. Pieces like this were offered for sale to the traders and are still made as tourist wares today.

Rattle, Tlingit, Alaska, early 19th century. Hardwood, ivory, native paint. 28 cm. l. 1938.231

Northwest Coast rattles that fuse separate images into a coherent whole are an ancient art form that once probably referred to legends whose meanings are now lost. This rattle combines a fairly literal rendering of an oyster catcher with a stylized low-relief carving of another animal on its breast and a land otter suckling her litter. Since the Northwest Coast people considered the otter a malevolent, insanity-causing spirit, the doctor who used the rattle for curing may have specialized in psychotherapy.

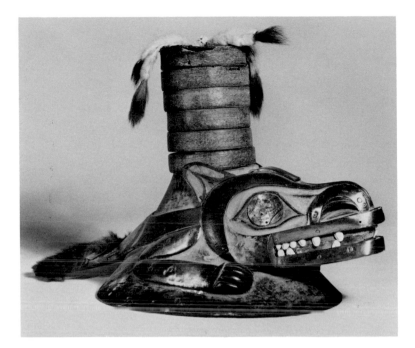

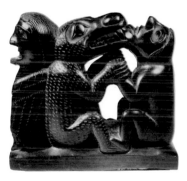

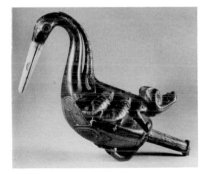

House partition, Tlingit, Wrangell Village, Alaska, c. 1840. Cedar, native paint, human hair. 4.57 x 2.74 m. 1951.315

A large, vertical type of interior house screen was placed parallel to the rear wall to separate an area where participants at a feast could dress for dancing and speeches. Painted with the principal crest of the Shakes family, the grizzly bear, this famous screen was originally part of the Grizzly Bear House at Wrangell Village, Alaska. The screen is somewhat unusual in its use of red paint for primary elements.

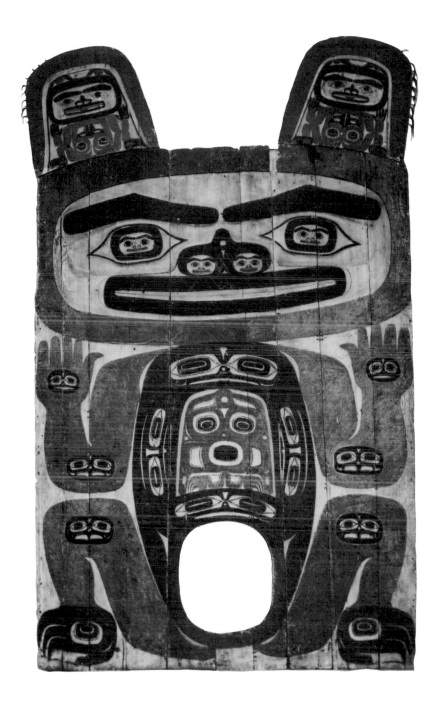

House partitions (one panel illustrated), Tlingit, Lituya Bay, Alaska, 1850s. Cedar, native paint. Each panel 1.7 x 2.27 m. 1939.140.1-2

In the large wooden houses of the Northwest Coast, interior dividers separated the space along the rear and side walls into individual sleeping areas. Those fronting the bedrooms of the nobility were painted with important crests. The Ravens decorating this pair are superb examples of Northwest Coast graphic design. The black primary lines hold the composition together and establish relative proportion; red secondary lines provide detail. The subtle variance in line width and the avoidance of straight lines and true circles achieve the strong rhythmic flow characteristic of Northwest Coast art.

George Walkus, Hamatsa Society mask, Kwakiutl, Blunden Harbour, British Columbia, 1938. Cedar, cedar bark, commercial paint and cord. 1.2 m. l. 1948.229

This fearsome mask represents a powerful cannibalistic spirit who initiated well-born people into the Hamatsa Society. To impersonate the spirit at the society's public ceremonies, multiple masks were made and worn by dancers. The Kwakiutl were particularly imaginative stage craftsmen and devised clever paraphernalia for these dramatic performances. Each of the beaks is movable to heighten the impression of voraciousness, and the eye regions have been painted white to increase their prominence by firelight. The rhythmic design adds to the mask's frightening impact by suggesting a sense of life pulsing through the eyes and mouth.

Basket, Haida, British Columbia, late 19th century. Spruce root, native paint. 34.2 cm. h. 1938.598

Although twined weaving could be modified to accommodate an approximation of Northwest Coast heraldic design, it was impossible to achieve these curvilinear shapes with the less flexible elements of twined basketry. By painting the design on the basket, the artist was able to use compositions identical to those painted on wooden surfaces. This Haida example is decorated with the crest of the mythical Sea Wolf. Northwest Coast families felt it necessary to embellish even utilitarian objects like this storage basket with crest symbols.

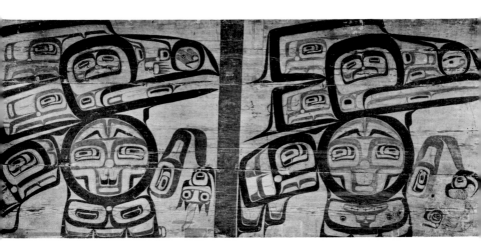

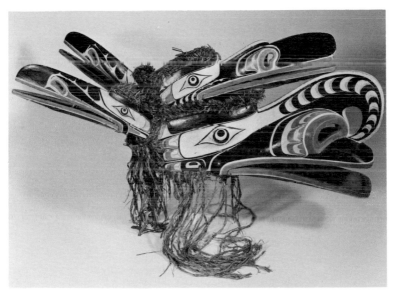

Wolf Society headdress, Kwakiutl(?), Vancouver Island, British Columbia, late 1870s. Cedar, native paint, vermilion, human hair. 51.5 cm. l. 1949.3642

For Kwakiutl and Nootka winter rituals, members of the prestigious Wolf Society dance in headdresses representing the mighty spirits who initiated them into the supernatural power and knowledge requisite for membership. The rows of fine parallel fluting covering most of its surface, the specific conformation of the wolf figure, and the combination of native paints with Chinese vermilion suggest that this mask was made on the northwestern coast of Vancouver Island. Although this example was carved in the 1870s, the design is somewhat archaic and suggests others collected a century earlier.

Dancing apron, Kwakiutl, British Columbia, c. 1880. Trade cloth, beads, thimbles. 74 cm. sq. 1969.406

Beaded decoration was never popular among the Northwest Coast people, perhaps because a less time-consuming painting tradition was already well established by the time glass beads were introduced. Here a traditional painting design has been worked out in beading whose atypical colors reflect the wide range of choice offered by the new medium. The two rows of brass thimbles made a musical sound during the dance.

Man's ceremonial shirt, Tlingit, Klukwan Village, Alaska, c. 1910. Mountain goat wool, cedar bark, native dye. 1.19 m. back length. 1936.297

The heraldic design of the Northwest Coast was developed for use in painting and sculpture. Given its flowing, curvilinear form, it did not adapt readily to fabric production. The Chilcat of Alaska stretched the basic twining technique to its limits and even developed special stitches in order to translate the designs into this medium. As with most other heraldic art, the figures represent the wearer's crest and are intended to impress all who see them with the majesty of his ancestry. Worn only by those of high status, long shirts of this type were reserved for ceremonial use.

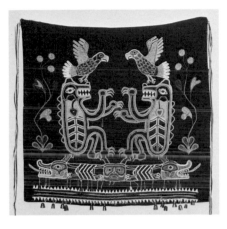

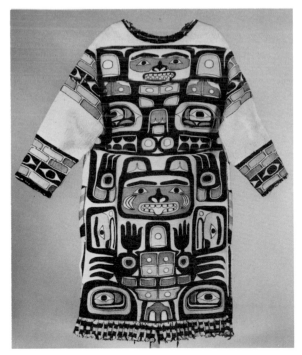

97

Carving, Eskimo, probably central Canadian Arctic, c. 1960.
Bone. 13 cm. h. 1965.394

Although there was considerable carving in the prehistoric central Arctic, the tradition was dormant for several centuries. In recent times, carving began anew and, with the encouragement of the Canadian government, has flourished. This carving of a ground-nesting arctic owl shows the expressiveness such works can attain. The hunched posture perfectly describes a bird defending its nest; the open mouth even suggests the warning cry.

Mask, Eskimo, Nunivak Island, Alaska, c. 1900. Wood, native paint, grass. 60 cm. h. 1953.396

Because wood is more plentiful along the southwest coast of Alaska than in the high Arctic, Eskimo people of the coast region have been able to carve ceremonial masks in this costly material. Composite images like this illustrate the Eskimo belief that every being has many souls. With its elements of fish, clams, a seal, and even three hunters in a boat, the mask probably represents a spirit that controls sea creatures useful to man.

Figurine, Eskimo, Alaska, late 19th century. Ivory. 9.5 cm. h. 1949.3894

This little figure probably represents a European whaling ship's officer, complete with top hat. However, the engraved dot-and-circle elements were favorite motifs of arctic carvers 1500 years ago. Since wood is scarce in most parts of the Eskimo world and not to be wasted on decorative carvings, ivory and bone, which are more plentiful, are preferred for pieces like this.

Covered basket, Eskimo, Point Barrow region, Alaska, c. 1950. Baleen, bird quill, ivory. 16.5 cm. h.
Gift of Mr. and Mrs. Gordon Ebbe. 1972.394

Baleen is a black, flexible material found in the mouths of certain whales. Split into thin strands, it can be used for cordage or basketry. Traditionally used to decorate grass basketry, ivory ornaments show to even better advantage on baleen baskets, which are frequently also embellished with small stitches of white bird quill.

Mask, Ekoi, Cameroon, c. 1860. Wood, antelope skin, natural fibers, human hair. 26 cm. h. 1949.4161

Recalling in their realism the bronze and terra-cotta portrait heads made between the 14th and 19th centuries at Ife and Benin, skin-covered cap masks were a common art form in a wide area of Nigeria and Cameroon. The Ekoi of the Cross River area are usually considered the originators of this type of mask, which was made by stretching fresh antelope skin over a wooden model onto which it shrank tightly, a process requiring remarkable skill and patience. This example has been decorated with human hair and a realistic pattern of scarification. The cap masks were worn by members of men's societies to commemorate victory in a battle or the death of a fellow member.

Fetish figure, Bena Lulua, Zaire, late 19th century. Hardwood, native paint. 20.5 cm. h. 1959.240

Among the Bena Lulua, who were noted for their beautiful figural sculpture, images of warriors and women holding infants were popular subjects for fetishes. Exhibiting trancelike expressions and relaxed poses, they convey a strong sense of peacefulness. Like this female figure, many carvings depict heavy scarification, a practice which was dying out by the 1880s. It is assumed that most known fetishes of this type were made prior to that time or shortly afterwards while carvings illustrating scarification still existed to serve as models. This figure is historically important because it was collected by the great German ethnologist Leo Frobenius on his expedition to the Kasai district of the Congo in 1906.

Mask, Tikar, Cameroon, 20th century. Wood, native paint, rattan, raffia. 51 cm. h. Gift of Mr. and Mrs. Peter Natan. 1976.145

The arts of Africa frequently are little known and poorly documented because they have not appealed to European esthetic taste. Such is the case with Tikar dance masks, which often are monochromatic, crudely carved, and grotesque. This example is a remarkable exception. The sharply protruding facial elements are traditional, but the use of red and white color and the rattan inlay in the coiffure may be either the innovation of an individual artist or typical of a still unidentified local style.

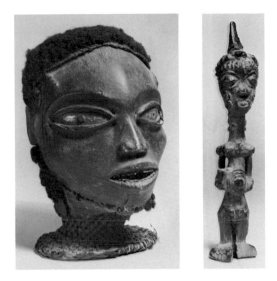

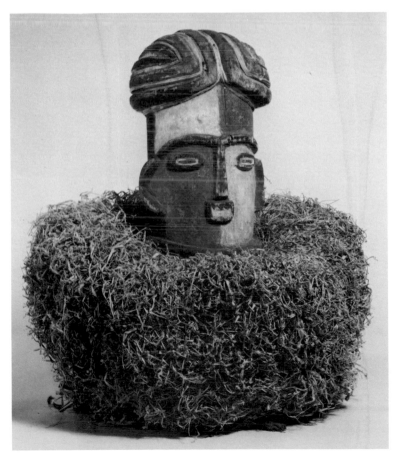

Mask, Makonde, Tanzania, 20th century. Wood, fur, native dyes, beeswax. 21.5 cm. h. 1960.102

Many Makonde masks are noted for their skillful and sensitive carving, as well as a naturalism unusual in East African art. In this example, the realism of the carved face has been heightened by staining the light-colored wood with red and brown dyes and by applying "eyebrows," small pieces of fur attached with beeswax. While these techniques are common to much of their carving, the Makonde also produce objects of a more abstract and crudely carved nature.

Fetish figure, Bateke, Zaire, 20th century. Hardwood. 20.4 cm. h. 1949.4185

The artists of several Congolese tribes carve fetish figures for clients to use as good luck charms. After a figure is purchased, it has to be activated by a sorcerer, who seals secret magical substances in a cavity in the figure, usually the stomach. This example, which was never activated, bears the striking cubistic head and arched headdress common to many Bateke fetish figures. As in almost all sub-Saharan art, the head is large in comparison to the body to signify its relative importance as the center of reason and wisdom.

Female figurine, Sherbro, Sierra Leone, 16th century. Steatite. 34 cm. h. Gift of Mr. and Mrs. Emmett Heitler. 1974.356

Hundreds of small figurines (*nomolis*) have been discovered in the rice fields of Sierra Leone and Sherbro Island. They vary considerably in subject matter but characteristically exhibit a flattened head with bulging eyes and exaggerated nose and mouth. The rhythmic flow of shapes makes this *nomoli* a particularly beautiful example. These figures duplicate the style of ivory carvings made by African artists during the 16th century for export by Portuguese traders. While the original meaning and use of the figures are uncertain, present-day Sherbro Island farmers place newly discovered *nomolis* in shrines and make sacrifices to them to ensure a good crop.

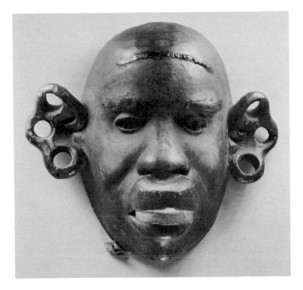

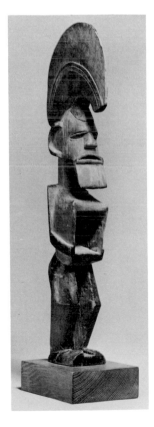

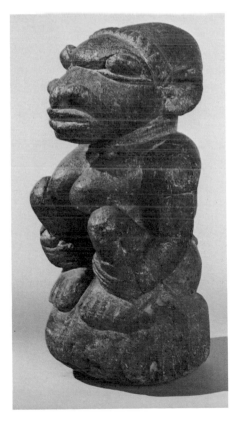

Tji-wara Society headdress, Bambara, Mali, c. 1860. Wood, Venetian glass beads, cowrie shells, feathers. 54.5 cm. h. 1949.4160

Probably the best-known Sudanese sculptural form is the antelope headdress of the agricultural Bambara tribe. These gracefully conceived and elegantly executed representations of antelopes are attached to basketry caps and worn in fertility dances prior to the clearing of new fields. The dancers always appear in pairs, one wearing a male and the other a female antelope mask. The name *tji-wara* means "the beast who labors" and refers to a legendary antelope who taught man how to cultivate his fields. In this beautiful old headdress, made in the Bougouni district, the artist has used delicately incised patterns to reinforce the rhythms of his abstract shapes.

Bundu Society mask, Mende, Sierra Leone, late 19th century. Bombax wood, dye. 42 cm. h. 1949.4178

The Mende are one of several Guinea Coast tribes having a separate secret society (Bundu) for the education and initiation of female adolescents into adult society. Helmet masks like this one are worn by high-ranking women in the society at the close of the initiation period in the hope that wealth, beauty, and social success—symbolized by the elaborate coiffure and rolls of neck fat—will be transferred to the initiates. The small, delicate face and high forehead, as well as the fat neck and complex hairstyle, are typical of all Bundu helmet masks, whose beauty stems in part from the contrast of plain and patterned surfaces.

Pipe bowl, Bali(?), Cameroon, c. 1860. Clay, paint. 21.7 cm. h. 1949.4165

Pipes of wood, clay, and metal are made throughout Cameroon. Although different tribal groups have developed distinctive ways of incorporating human figures into their pipe bowls, certain features which appear in this bowl from the Bamileke area are common: staring, deepset eyes, flared nostrils, open mouths revealing teeth, and headdresses displaying mythical spiders, chameleons, or lizards. Because pipes are considered status symbols, a man may also have his special totem incorporated into the design. Very large pipes like this one are usually owned by wealthy men, who hire guardians to keep them filled and lit.

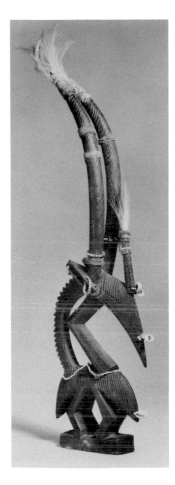

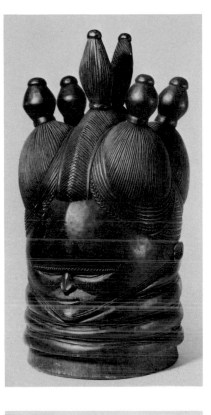

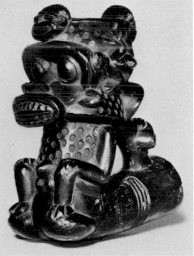

Osamuko of Osi, Epa mask, Yoruba, Kwara State, Nigeria, c. 1920. Wood, native paint. 1.12 m. h. 1970.802

Monumental helmet masks used in Epa masquerades are usually adorned with one or more figures representing culture heroes although in this example the main figure is probably a worshipper. Weighing 20 to 30 pounds, the masks are worn by dancers who perform their slow, deliberate movements for several days during the festival. While the helmet itself, as well as the faces and clothing of the superstructure figures, is highly stylized and abstract, the human forms are carved with a marked degree of idealized realism. This combination of harsh angularity and graceful naturalism makes Yoruba carving one of the most easily recognized traditions in African art.

Plaque, Benin, Nigeria, 17th century. Bronze. 51.5 x 36.3 cm. 1955.317

Some of the finest and most famous bronze sculpture in the world was produced by the artists of Benin. About 1400, Benin sculptors learned the lost-wax process, a technique known in Nigeria from at least AD 500. Two centuries later, they had made bronze casting a fine art. The bronzes are remarkable for their naturalism, as well as their superb technical quality. This plaque and many others depicting scenes of daily life in the city and court decorated the 17th century palace of the Oba (king) of Benin.

Master of Ikere, door, Yoruba, Nigeria, late 19th/early 20th century. African teak(?). 1.77 x 1.3 m. with posts. Marion G. Hendrie Collection, general acquisition funds, and anonymous donor. 1973.357, 1980.58

An important source of patronage for Yoruba artists is the architect, who hires sculptors to carve veranda posts and doors, which constitute the only decorated surfaces in many Yoruba buildings. Often painted in strong colors, these doors are traditionally made in two sections and carved in a planar, low-relief style. Here, however, the artist has carved his figures in high relief with the rounded forms typical of Yoruba sculpture. In 1973, the museum acquired the left half of the door. Publication of this piece led to the discovery of the missing half, which was purchased in 1980. Joined together, the two sections form a single door which originally pivoted on the posts at the right; a latch hole is visible at the left.

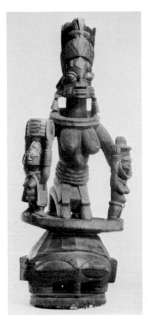

Mask, Melanesia, New Guinea, Torres Strait, late 19th century. Tortoise shell, cassowary feathers, fiber, pitch. 32.4 cm. h. 1965.501

This mask was made by using moist heat to shape pieces of tortoise shell to the required form. After shaping, designs were carved and incised on the fragments, which were then fitted together with fiber and pitch. Presumably representing mythical culture heroes, these masks were used at men's funerals. Arts of the Torres Strait region died out early under pressure from European settlers, who rapidly converted the natives to Christianity and put them to work as laborers, thus reducing both the need for ritual objects and the time necessary to produce them.

Mask, Melanesia, New Guinea, Sepik River delta, late 19th century. Wood. 36.5 cm. h. 1977.32

This mask represents a mythical ancestor, who is impersonated by its wearer during initiations and other ceremonies. As a man rose through the ranks of initiation, he would be allowed to see and handle objects which only other initiated men of that grade could touch. The rich patina was developed through generations of handling by initiates because the mask was considered a source of great power by virtue of its age. The small annular eyes, set in deep concavities, the projecting mouth, and the shape of the nose suggest the mask was carved in the coastal region to the east of the Sepik River delta.

Shield, Melanesia, New Guinea, Gulf of Papua, Elema or Uaripi tribe, late 19th century. Wood, coconut fiber, native paint. 84.7 cm. h. 1949.4463

In its highly imaginative arrangement of abstract human features, such as the hands dangling above the staring eyes, this dramatic shield is typical of art from the Papuan Gulf region. The use of relief carving and the geometric border patterns seen here are prevalent in objects produced by the Elema and Uaripi tribes although the uncrowded openness of the central design is quite unusual. The shield was considered important enough to be a part of the 1915 Panama-Pacific Exposition in San Francisco, long before the arts of New Guinea were generally included in exhibitions.

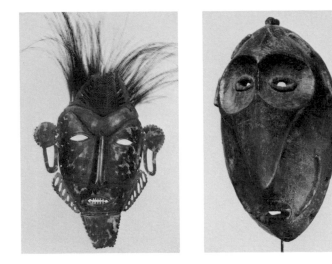

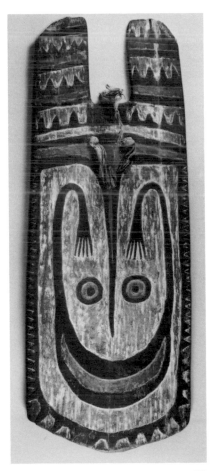

Mask, Melanesia, New Britain, Sulka tribe, late 19th or
early 20th century. Cane, wood pith, native paint. 1.07 m. h.
1949.4461

The Sulka are a small tribe who live in the coastal region
of Wide Bay in southeast New Britain. Little has been
recorded of their material culture, and examples of
their arts are rare in American collections. Like other
Melanesians, the Sulka created fantastic forms with
unusual raw materials. In this case, the mask is made of
a cane framework covered with strips of pith which have
been sewn together and painted before being attached
to the frame. This intricate technique has been used
to produce some of the most subdued color work in
Melanesian art. The Sulka probably used masks such
as this in secret society rituals.

Malanggan post, Melanesia, northern New Ireland, c. 1870.
Wood, native paint, bark, pitch, opercula. 1.18 m. h.
1950.561

The Malanggan ceremony of northern New Ireland
commemorates those who have recently died and
celebrates the reentry into society of an equal number of
juveniles who have been held in seclusion prior to puberty
rites and the assumption of adult responsibilities. The most
exuberant of all Melanesian art forms, Malanggan art
combines human and animal forms in rhythmically
graceful designs. Fashioned from a single piece of wood,
posts used in the ceremony are characterized by
intricately carved and painted openwork. This example is
one of a very few known pieces bearing comparatively
human faces modeled in pitch. The faces, with their
alarmingly realistic eyes, may have been intended as
portraits, possibly of the newly deceased.

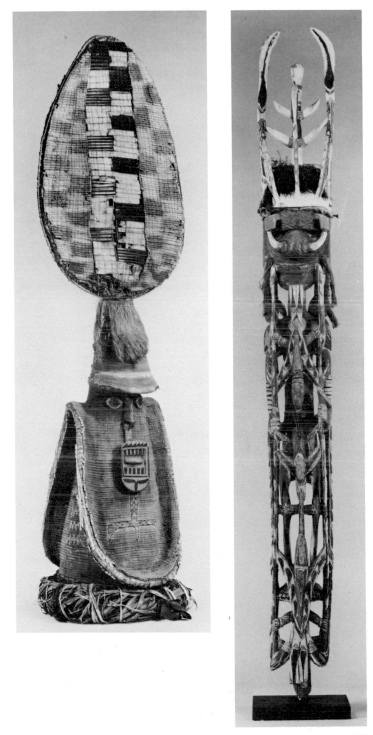

Breastplate, Polynesia, Society Islands or Cook Islands, Mangaia, early 19th century. Pearl oyster shell, sennit, human hair. 19.3 x 18.4 cm. 1953.977

This beautiful ornament was formed by cutting away part of the outer surface of the shell to reveal its iridescent interior. The fine lashing at the top is sennit and cord made from human hair, a popular decorative material in Polynesia. The lashing technique, used here for artistic effect, was adopted directly from that employed in shipbuilding. Since pearl oysters of this size are not found in Mangaian waters and nearly identical breastplates have been collected on Tahiti, where the shells are available, the origin of the ornaments is problematic. The Cook Islanders may have imported the shells from the Society Islands or the entire breastplates from Tahiti.

Ancestor figure, Melanesia, New Guinea, lower Sepik River, 19th century. Wood, native paint. 31.5 cm. h. 1949.4462

Figures such as this were once common in the Sepik River basin, where they were usually hung in the men's house as representatives of or receptacles for the spirits of ancestors. In the lower Sepik region, great care was given to the carving of the highly stylized and disproportionately large head, which in this instance resembles many masks from the area. Although smaller figurines, which are used as fetishes or amulets, are often erroneously called "ancestor figures," the term properly applies only to figures of this size.

Feast bowl, Polynesia, Marquesas Islands, 20th century. Hardwood. 72.5 cm. dia. 1949.4538

It is impossible to say whether this massive, elaborately carved bowl was made for potential tourist sale or for use by the Marquesans themselves because the islanders produced such objects for both purposes during the 19th and early 20th centuries. The decorative elements on the bowl are derived from glyphs which can be seen on many old carvings from the islands. Because the glyphs apparently once had individual names, it has been suggested that the Marquesans were on the verge of developing a written language at the time of their first contact with Europeans. At the beginning of the 20th century, old-timers recalled seeing feast bowls up to five feet in length, but none this large seems to have survived.

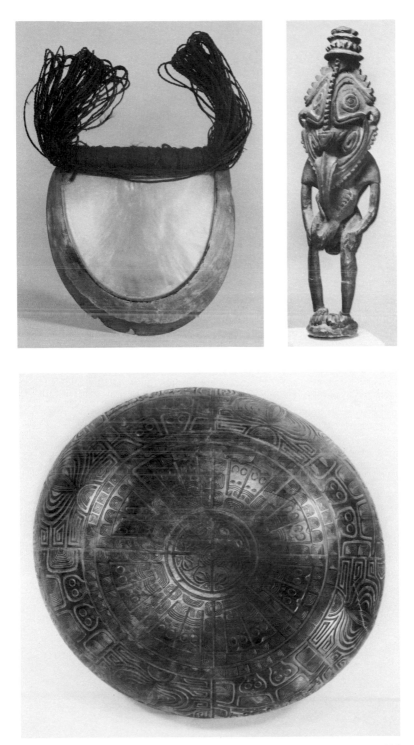

Headdress, Polynesia, Marquesas Islands, Fatu Hiva, 19th century. Tortoise and conch shell, buttons, coconut fiber. 47 cm. l. extended. Anonymous gift. 1952.732

On some islands of the Marquesas, crownlike headdresses made of alternating plaques of carved tortoise and conch shell attached to a coconut-fiber band were worn by anyone able to afford the purchase price, usually in the form of pigs. The geometric style of the human forms on the tortoise-shell plaques and the delicacy and fineness of the carvings are characteristic of Marquesan art. This example may have been assembled from pieces of several older crowns since many of the plaques were apparently carved by different artists.

Paddle club, Polynesia, Fiji, c. 1850. Wood. 1.24 m. l. 1948.646

Constant petty warfare played an important role in Fijian society. However, the shortened grip and massive blade of this club indicate that it was not intended for combat, but for ceremonial or decorative use. The club also suggests a close association between Fiji islanders and the neighboring Tongans: while the intricate carving on the grip is in a very old Fijian style, the shape of the club is more typically Tongan.

'Olalo(?), Melanesia, Solomon Islands, Ontong Java Atoll, early 20th century. Wood, shell. 1.1 m. h. Gift of the United States Navy Department. 1949.4495

An Ontong Javanese myth maintained that Ke luahinge, a mythical ancestor, threatened disease and famine if she and 'Olalo, her male counterpart, were not venerated regularly. Therefore, images of the pair were kept in a shrine, and once a year, as instructed by Ke luahinge, they were paraded in a festival called *sanga.* Figures of 'Olalo are extremely rare. The simplified, flattened forms in this example are reminiscent of the magnificent figures from Nukuoro Atoll and the Caroline Islands 600 miles to the north. Since Nukuoro and Ontong Java are both outlying Polynesian settlements, it is possible that the two traditions are related.

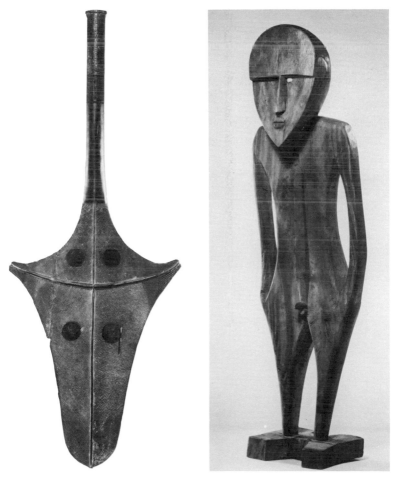

Suspension hook, Melanesia, New Guinea, middle Sepik River, Yamanum Village, c. 1900. Wood, native paint. 80 cm. h. 1959.269

Throughout New Guinea, food and valuables are stored out of the reach of rodents in netted bags, which hang from the rafters of houses on hooks like this. Carved with traditional tools of stone and shell, this fine old example exhibits design characteristics common in the middle Sepik River area in the second half of the 19th century. The heart shapes of the face, the snakes used as eyes, and the interlocking bird heads in the central diamond, as well as the clean lines of the carving, are elements no longer found in the art of the region.

Tapa, Polynesia, Fiji, Taveuni, early 20th century. Paper mulberry bark, native dyes. 390.1 x 67.3 cm. 1950.391

Tapa, or bark cloth, is used for clothing and floor covering throughout the Pacific. To make tapa, the inner bark of the paper mulberry, breadfruit, or certain species of fig is pounded out on a solid surface with a wooden beater. The thickness, texture, and evenness of the cloth depend on the raw material and the beating surface. Fijian tapa is noted for its evenness and consistently smooth texture, as well as the beauty of the designs painted on the finished cloth. The Fijians liked to incorporate bold areas of black into painted tapa decorations, but the strong geometric patterns shown here are typical of designs produced on Taveuni Island.

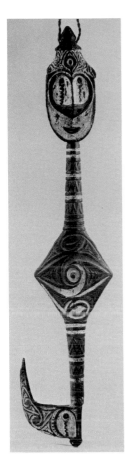

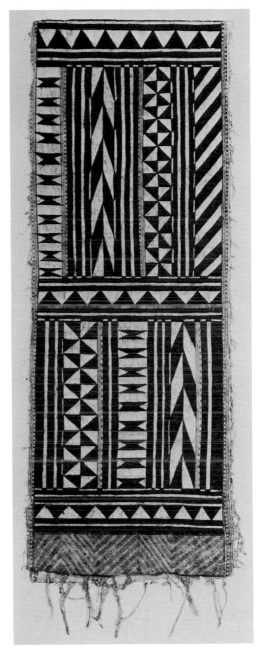

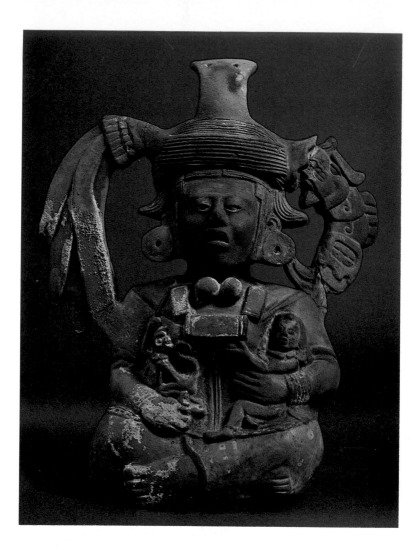

New World Art

Latin American art, from pre-Columbian times through 300 years of colonial experience, lies within the province of the New World Department. In seeking to acquire pre-Columbian objects of the highest quality, the museum has accumulated a collection that is neither comprehensive nor specialized; instead, it is a small, eclectic assembly of masterworks that epitomize centuries of technical and esthetic development in Mexico and Central and South America. The department's colonial holdings include works from Spanish and Portuguese colonies throughout the world, but their emphasis is on Spanish colonial art from the Americas. The Anne Evans Collection of santos from the southwestern United States and the unique Freyer Collection of Peruvian paintings, sculpture, and decorative arts have inspired the specialization of the colonial section in these and closely related areas.

Although the New World Department has only been in official existence since the late 1960s, its roots go as far back as the 19th century. The circle of artists who founded the museum shared an enthusiasm for regional "folk art" which assured the eventual place of Spanish colonial and pre-Columbian art in its collections. Anne Evans, one of the group's leading advocates for native art, began to collect santos in the 1920s, at a time when these religious images had fallen into disfavor and neglect and were being discarded by the churches they had once adorned. By 1936, when she presented her collection to the museum,

Ocarina, Maya culture, late Classic period, El Petén, Guatemala, c. 750. Ceramic, paint. 34.3 cm. h. Purchased with gifts from Mr. and Mrs. Frederick R. Mayer and Mr. and Mrs. Morris A. Long. 1979.3

Ocarinas and whistles, which probably served a ceremonial function connected with burial, were often created as images of deities. Sometimes Mayan artists portrayed these mythical beings as naturalistic figures of men and women performing domestic chores, and the lack of iconographic detail makes it difficult to identify them as specific deities or to relate them to Mayan oral or written history. This figure, however, has been executed in a stylized manner with enough symbolic detail to make identification possible. The headdress of fish glyph and quetzal plumes suggests that this is probably the moon goddess, Ixchel, in her role as Xkiq, mother of the hero twins, whose deeds are recorded in the *Popul Vuh,* the creation myth of the Quiche-Maya people.

sources of acquisition had declined, and the art of the santero was almost totally unavailable. The Evans Collection has continued to attract gifts from other collectors, however, and its holdings were significantly enlarged in 1968 with major purchases from the sale of the collection of Dr. Nolie Mumey of Denver.

The museum had begun to acquire pre-Columbian objects after the appointment of Otto K. Bach as director in 1944, and these were brought together with the santos collection under the designation of New World art in 1968, when a separate department was established with Robert Stroessner as curator. Soon afterwards, the pre-Columbian holdings were greatly augmented by a major gift from Mr. and Mrs. Frederick R. Mayer of more than 100 pieces from the internationally known Gaffron Collection of Peruvian art, formerly at the Art Institute of Chicago. Among the many Mochica ceramics that entered the collection at this time were three portrait vessels of unusually fine quality and state of preservation.

The widely published and exhibited Frank Barrows Freyer Memorial Collection of 17th and 18th century Peruvian colonial art created another collecting focus for the Spanish colonial section when it was presented to the museum by Engracia Freyer and her children in 1969. Assembled by Mrs. Freyer in Peru during the 1920s while her husband was Chief of the United States Naval Mission and Chief of Staff of the Peruvian Navy, the collection received special dispensation to leave Peru in recognition of Freyer's singular contribution to the nation. The Freyer paintings, furniture, woodcarvings, tooled leather objects, and silver illustrate the lavishly ornamented Cuzco style, considered one of the finest New World interpretations of Spanish baroque art. Among the best-known paintings of this influential school, *Our Lady of the Victory of Málaga* is only one of many outstanding examples included in the collection. Its dazzling overlay of silver and gold is typical of the sumptuous early colonial period. Installed in tile-floored rooms reminiscent of an 18th century Peruvian residence, the Cuzco paintings have been the nucleus of an expanding Spanish colonial painting collection that now includes works from Lima, Bolivia, Ecuador, and Colombia. A group of Washington, D.C., collectors has been particularly active in enriching this segment of the collection.

Among the department's most unusual holdings is a rare 18th century *troje,* or storehouse, from Mexico. Built about 1775 by Tarascan Indians, the reassembled building now provides exhibition space for some of the museum's most precious pre-Columbian objects—jade figurines, gold ornaments, jewelry, silver repoussé beakers, and unique ceramic pieces. Among these are the only complete known example of an Olmec "jaguar baby" and a remarkable

Popayán warrior figure, given by Mr. and Mrs. Edward M. Strauss in memory of Alan Lapiner. Like all native art in the museum's collection, the pre-Columbian objects have been selected primarily for their esthetic value. Ranging from the early Valdivia culture, which dates before 3000 BC, to late Aztec work of the 15th century, the holdings boast splendid examples of stone carvings from Teotihuacán and monumental ceramic figures from Veracruz. Illustrating the fine Mexican lapidary work of the Aztec period, a Mixtec mosaic mask inlaid with turquoise, shell, and silver became one of the pre-Columbian section's chief attractions when it entered the collection in 1979.

Ballplayer vessel, Zapotec culture, Monte Albán II, Oaxaca, Mexico, c. 300 BC. Burnished ceramic. 15.2 cm. h. 1971.350

One of the major social and religious events in ancient Mesoamerica was the ceremonial ball game. Played in a stone-walled rectangular court with a heavy rubber ball, the game was closely associated with ritual and augury and often ended in the sacrifice of one or more of the players. Holding an object shaped like a monkey's head, this ballplayer is portrayed in the traditional motion posture and wears a protective helmet, gloves, and a belt with a leather loincloth.

Hunchback figurine, Olmec culture, middle pre-Classic period, Guerrero, Mexico, 1100-900 BC. Serpentine. 8.2 cm. h. Gift of Mr. and Mrs. Frederick R. Mayer. 1973.181

Credited with magic powers, hunchbacks and dwarfs, as well as their images, played an important role in pre-Columbian society through the period of the conquest. The conquistadors noted that the Aztec emperor Moctezuma surrounded himself with these people, presumably for the power and protection he thought they afforded him. The fine detail of this early hunchback image is testimony to the skill with which the Olmecs were able to carve hard stone such as serpentine. Figures like this are commonly found as burial goods. To release its power and ensure its efficacy in the grave, the Olmecs customarily "sacrificed" the image by breaking it prior to burial.

Figure, Olmec culture, Zumpango del Río region, Guerrero, Mexico, 1100-900 BC. Ceramic, slip, paint. 35.5 cm. h. Purchased with gifts from various donors. 1975.50

Olmec ceramic style and technology reached its pinnacle in the production of hollow nude figures known as the "Jaguar's Children." Although the figures vary somewhat in posture and ornament, all display the open, down-turned Olmec mouth and evoke a strong sense of the mystery of that ancient civilization. One of the greatest expressions of the Olmec style, this figure is the only known intact example of its type. Traces of black and red paint over the flesh-colored slip give some idea of how such figures must have looked 3,000 years ago.

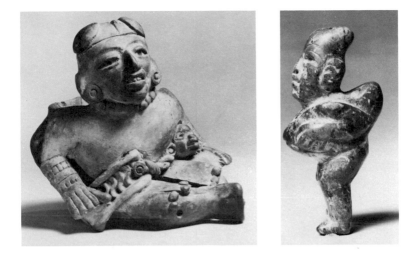

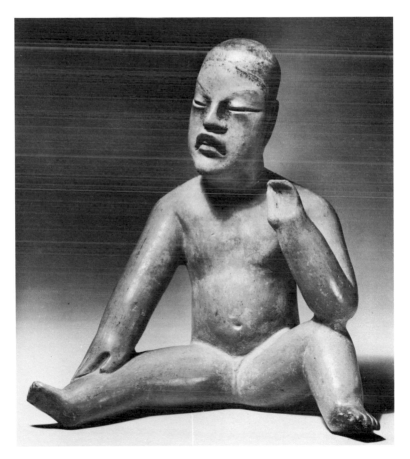

Burial urn, Zapotec culture, Monte Albán III-B, Oaxaca, Mexico, after 500. Ceramic. 61 cm. h. 1977.186

This burial urn depicts the great Zapotec rain god Cocijo, a deity of special significance to an agricultural society living in an arid climate. Shown here in his simplest form, Cocijo wears an elaborate headdress of feathers rising from a feline mouth representing the glyph C. The style of his mask, with its eye goggles and serpent-tongued mouth, reflects the influence of Teotihuacán which was prevalent in the Zapotec art of this period. Burial urns like this were placed over the tomb doors or within the tombs of Zapotec nobility.

Effigy vessel, Nayarit culture, Ixtlán del Río site, Nayarit, Mexico, c. 300. Ceramic, slip, paint. 47 cm. h. 1965.205

With its simplified forms and exaggerated abstraction of the human body, ancient ceramic sculpture from the west coast of Mexico has long influenced modern artists. The blocky, exuberant style of Nayarit ceramics is seen in this effigy vessel of a standing woman whose proportions have been distorted to maintain a structural balance. The highly burnished finish and complex polychromy are typical of works from Ixtlán del Río, but since many details were applied with a fugitive black paint, they are seldom seen as clearly as in this fine example.

Seated youth, Jalisco culture, Chinesco style, Los Cebollas site, Santiago de Compostela region, Nayarit, Mexico, c. 150. Ceramic, slip. 45 cm. h. 1970.301

The largest known ceramic figures from western Mexico come from the Santiago de Compostela region of Nayarit. Characterized by subtly curving, simplified forms which create a sense of vitality and naturalism, these rare figures are designated "Chinesco style" to distinguish them from the more static and abstract Nayarit style. Here the flowing movement of the body directs attention to the detailed head with its lightly incised hair and carefully modeled ear ornaments.

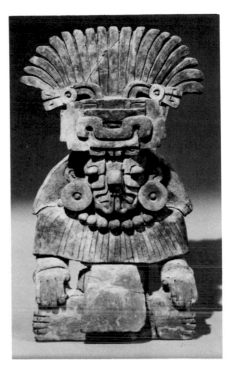

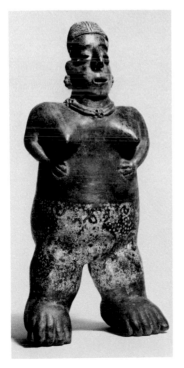

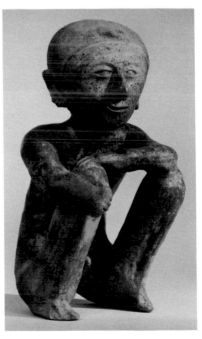

Fresco fragment, Teotihuacán IV, Tetitla site, San Juan Teotihuacán, Mexico, c. 650. Lime plaster, paint. 75.5 x 94 cm. 1965.202

During the Classic period, buildings in the great city of Teotihuacán were often covered inside and out with brilliantly colored frescoes. The most striking examples appeared on the walls of residential palace compounds such as Tetitla. Designs were strongly symmetrical with figures executed in profile, or, more rarely, frontal poses. Notable for its full range of hues, this image represents an agricultural deity, possibly Xochipilli, god of spring and flowers.

Effigy vessel, Colima culture, Classic period, Colima, Mexico, 300-500. Ceramic, slip. 30.5 cm. h. 1963.141

Because stylistic canons were very rigid in most pre-Columbian societies, it is rare to find artistic individuality among objects of a particular culture. This vessel in the form of a bound youth is one of the exceptions. Here the artist has adapted the figure to the vessel form with a flowing rhythm unusual in Colima art. The subject may represent the shaman's power to bind spiritually, as well as the physical binding of a prisoner.

Celt figure, Teotihuacán III, Puebla, Mexico, 250-650. Micaceous serpentine. 33 cm. h. Gift of Mr. and Mrs. Frederick R. Mayer in honor of Cile and Otto Bach. 1974.225

During the early Classic period in Mexico, the great city of Teotihuacán was the largest urban center in the world, its influence spreading as far south as Costa Rica. As exemplified by this superb figure, the hallmark of its art is an architectonic style emphasizing sharply angled, planar shapes. The sculpture, viewed in profile, conforms to the shape of a stone celt, or ax. In important tombs of this period, celt figures have often been found in male and female pairs.

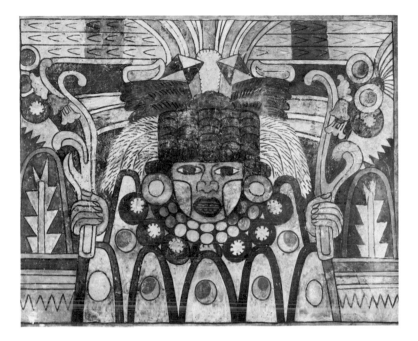

Head fragment, Veracruz culture, Classic period, Acatlán de Peréz Figueroa, Oaxaca, Mexico, c. 800. Ceramic. 46.3 cm. h. Women's Committee Fund and Charles Bayly Jr. Fund. 1959.122

This head from a larger-than-life-size figure of the old god Xiuhtecutli demonstrates the technical excellence reached by Veracruz ceramists during the Classic period, when hollow ceramic sculpture was made on a monumental scale. Under the elaborate headdress and facial ornaments, the sensitively modeled face is incised with wrinkle or scarification lines indicating that here Xiuhtecutli, or Two Tiger, is portrayed in his role of fire god.

Tripod vessel, Teotihuacán V, Tiquisate region, Escuintla, Guatemala, c. 500. Ceramic. 17.8 cm. h. 1971.417

This ceramic vessel comes from Teotihuacán's provincial center near Tiquisate. The relief design shows two ball players wearing elaborate headdresses, loincloths, and knee guards and kneeling before a game marker; speech scrolls project from their mouths. The ball-game marker consists of a stone sculpture representing a bundle of arrows surmounting a human skull which rests on a pair of serpent heads. Large, carved stone pieces resembling these components have been unearthed from the great plaza of the Sun Pyramid at Teotihuacán. The museum's collection includes a well-known pair of stone serpent heads which formed the base of such a ball-court monument.

Standing youth, Veracruz culture, Classic period, Tlacotalpan region, Veracruz, Mexico, c. 600. Ceramic. 83.3 cm. h. 1965.203

The artistic expression of ancient Mexico is most clearly seen in the magnificent ceramics found buried in tombs and caches. While the original meaning and use of this large figure may never be known, we can certainly appreciate its esthetic qualities and technical excellence. In contrast to the planar Teotihuacán style, Veracruz ceramics emphasize rounded shapes and deep modeling of details. In its exceptional size and quality, this figure typifies Veracruz ceramic sculpture of the Classic period. The young man wears a dancing belt made of seashells, which would rattle as the dancer moved.

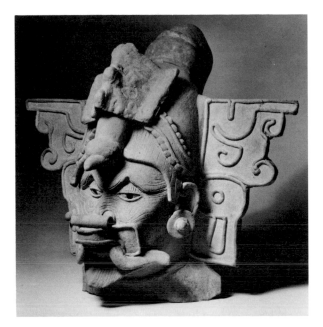

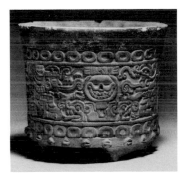

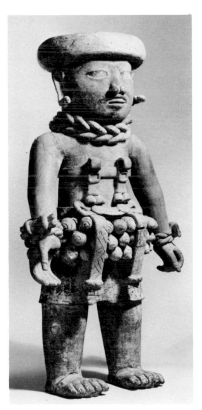

Mosaic mask, Mixtec culture, Mixteca Alta region, Puebla or Oaxaca, Mexico, 1100-1300. Cedar, turquoise, shell, silver. 19.7 cm. h. 1979 Collectors' Choice Benefit Fund and general acquisition funds. 1979.330

Deity masks were considered among the most sacred and valuable objects in the Aztec world. Describing these New World treasures, a 16th century historian wrote, "The superstructure is of wood, covered over with stones, so artistically and perfectly joined together that it is impossible to detect their lines of junction with the fingernail. They seem to the naked eye to be one single stone." (Peter Martyr, *De Orbe Novo,* as quoted in E. Carmichael, *Turquoise Mosaics from Mexico* [London: The British Museum, 1970], p. 10.) Mixtec artists produced much of the finest Mexican gold and lapidary work, which was acquired by the Aztecs through tribute or trade. Although many such masterpieces are listed in the conquistadors' inventories, few remain extant. This example of Aztec splendor is one of those rare pieces.

Vase, Maya culture, late Classic period, Ulúa Valley, Honduras, 10th century. Marble. 20.4 cm. h. Purchased with gifts from Mr. and Mrs. Frederick R. Mayer, Mr. and Mrs. Morris A. Long, and anonymous donors. 1979.329

A small group of marble vases from the Ulúa Valley represents a late and brief flowering of Mayan art. Although they vary in size, the vases bear a marked similarity in style and technique, as well as in certain design elements: elaborately carved handles representing serpents, often devouring felines, and bands of scrolls surrounding the principal motifs of faces and serpents. This exceptionally beautiful example clearly shows both the technical excellence and artistic elegance of late Mayan stone carving.

Vessel, Maya culture, late Classic period, Cholulá site, Yucatán, Mexico, c. 750. Ceramic. 15.7 cm. h. 1969.283

Nearly all our knowledge of the ancient Mayan civilization has come from the study of surviving stone, wood, and ceramic relief sculpture. Carved to commemorate great events, these objects are decorated with complicated scenes of ornately costumed figures and written texts which still defy translation. This ceramic vessel depicts a scene in which offerings are being made to a young lord wearing an elaborate bird headdress. The glyph blocks accompanying each figure are probably either an explanation of the scene or the names of the people involved. While figures on Mayan ceramic reliefs are generally carved as flat, raised shapes detailed with shallow incising, those on Cholulá vessels display a more sculptural form.

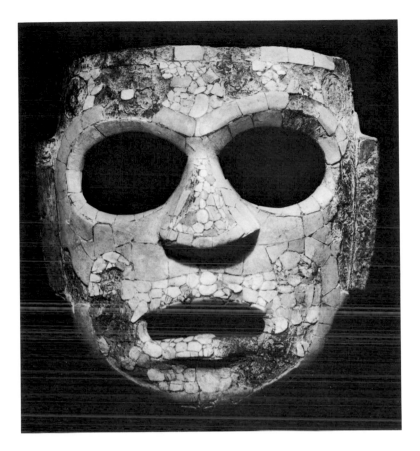

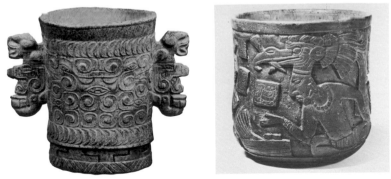

Incense burner lid (*xantil*), Mixtec culture, post-Classic period, Teotitlán del Camino, Oaxaca, Mexico, c. 1300. Ceramic. 59.7 cm. h. Charles Bayly Jr. Fund. 1963.145

Sculptured ceramic images of various deities were placed over low plates filled with hot coals and mixtures of rubber and incense so that the aromatic smoke filtered through the mouth, eyes, and other orifices of the figures. The deity represented is Xolotl, dog twin of the plumed serpent, Quetzalcóatl. According to the ancient Mexican creation myth, Xolotl went to the underworld to retrieve the bones of the first men. During this heroic feat, the Lord of the Underworld bit off the god's ears, the stubs of which can be seen on top of this head.

Goddess, Aztec culture, Valley of Mexico, c. 1500. Volcanic schist. 44 cm. h. 1957.31

One of the favorite Aztec deities was the maize goddess, Xilonen, patroness of corn and growth. Wearing a simple skirt, she holds in each hand her emblem, double ears of corn. Her elaborate "paper house" headdress represents a type made from a basketry framework covered with bark paper and worn by Aztec priests during rituals.

Goddess, Aztec culture, Valley of Mexico, c. 1500. Volcanic schist. 36.8 cm. h. 1965.204

The organic unity of subtly modeled forms creates a naturalism and radiant beauty typical of much Aztec stone sculpture, even when the subject is some terrifying mythical being. Here Chalchihuitlicue, goddess of flowing water and the female consort of the great rain god Tlaloc, is portrayed as a young Aztec maiden. She wears a simple headdress, three jade necklaces, earspools, and a typical Mexican shawl decorated with ball fringe. The frequency with which her image appears in Aztec art indicates that she was a highly venerated deity.

Chocolate-ware tripod vessel, Huetar culture, Turrialba, central highlands of Costa Rica, c. 800. Ceramic, slip. 37.5 cm. h. 1969.298

Chocolate ware takes its name from the rich, dark brown slip used to decorate many ceramics in the central highlands of Costa Rica. Because of their shape, tall tripod vessels like this have often been called *floreros* (flower pots). However, the heavy carbon deposits on the underside of many suggest that they were used to heat substances over a fire. This decorative example stands on "lizard legs," whose details were formed by applying separate coils and nubbins of clay.

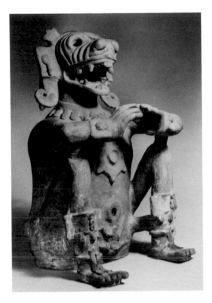
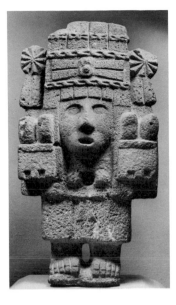
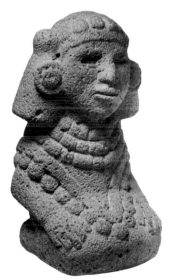
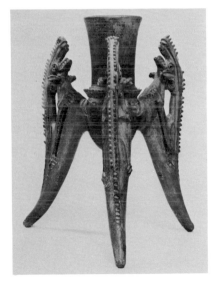

Pectoral, Coclé culture, Parita region, Península de Azuero, Panama, c. 1400. Gold/copper alloy, serpentine. 14 cm. l. 1966.201

The serpentine tusks of this pectoral are mounted in an ornament made from *tumbaga,* a gold/copper alloy favored by pre-Columbian metalsmiths because its low flow temperature facilitated the casting of elaborate pieces. The alloy was cast by the lost-wax method, a technique which had an independent development in the New World. Holding a club and fan in each hand, these figures represent twin insect deities which appear in the Mayan creation myth, the *Popol Vuh.* The projecting hooks originally supported polished gold reflectors, which would have sparkled in the sun as the wearer moved.

Pectoral, Coclé culture, Parita region. Península de Azuero, Panama, c. 1500. Gold. 13.4 cm. dia. 1965.196

Images of the Alligator God were frequent motifs in Coclé art. Although the style is basically geometric, the alligator face and the headdress of deer antlers and two hammerhead sharks have been rendered with some attempt at realism to enhance the awesome aspect of the deity. On his fourth voyage to the New World, Columbus noted that large gold plaques like this were worn as breast ornaments by Coclé chiefs. The four pairs of small holes enabled the wearer to attach the pectoral to a leather or cloth support.

Effigy urn, Popayán, Cauca, Colombia, c. 1000. Ceramic, paint. 38.1 cm. h. Gift of Mr. and Mrs. Edward M. Strauss in memory of Alan Lapiner. 1977.62

Known as the "Tower Warrior," this rare effigy figure is the largest and most complete extant ceramic sculpture from the Popayán region of Colombia, an area noted for its intricate gold jewelry. Thought to represent a tribal ancestor, the hollow-bodied warrior sits on a throne, his shield held before him, an animal, or alter ego figure, clinging to his back, his headdress forming the lid. Both the frontal pose and the pinched bands below the knees are elements adapted to the ceramic medium from Popayán goldwork. Collected during the 1920s by Arthur F. Tower, the figure was on loan to the American Museum of Natural History for over 30 years, during which time it was widely published.

135

Stirrup vessel, Chavín culture, Tembladera, Jequetepeque Valley, Peru, c. 500 BC. Ceramic, slip, paint. 30.5 cm. h. Gift of Mr. and Mrs. Frederick R. Mayer. 1972.187

Chavín potters established the technical and artistic standard for Peruvian ceramics for subsequent centuries. Their superb technology enabled them to mold and fire vessels with amazingly thin walls and the hollow stirrup handles typical of Peruvian ceramics. Favoring monochrome coloring, Chavín artists experimented with different styles of decoration, often combining incised and sculpted motifs. They were particularly skilled in adapting animal and human forms to the vessel shape, an art which reached its zenith during the Mochica period. The figure on this vase represents the Water Carrier, a deity often portrayed on early North Coast Peruvian vessels.

Drum, Proto-Nazca culture, south coastal Peru, c. 100. Ceramic, slip. 42.5 cm. h. 1972.189

Paracas artists used incised lines to separate the different colors of resin paint with which they decorated their ceramics. Later, when Nazca craftsmen learned to use brilliant polychrome slips, the incised lines were no longer necessary to keep the colors from merging. In this ceramic drum, representing an agricultural deity, the different areas of slip color are still defined by incised lines, an indication that the work is transitional between the two cultures. Originally the drum had a leather skin stretched tightly across its open end.

Seated figure, Bahía culture, Los Esteros site, Manabí, Ecuador, c. 300. Ceramic, slip, paint. 52.1 cm. h. 1968.186

Nearly 100 large, hollow figures like this were discovered buried with numerous small whistles and figurines and tons of skeletal fish remains in deep pits along the Manabí coast of Ecuador. In contrast to other Bahía pottery, these unique Los Esteros figures display a more complex decorative style and are particularly noted for the uncanny realism of the eyes, which often seem to follow passers-by. The figures are thought to be early, hand-built examples of Bahía ceramic art created before a mold technology was developed.

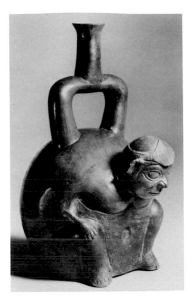

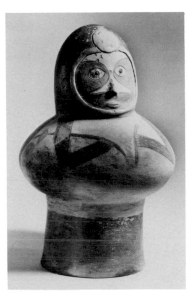

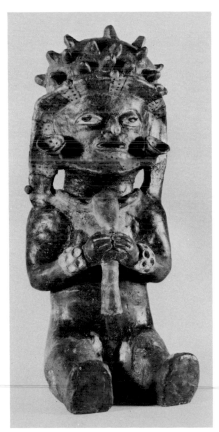

Effigy vessel, Huari culture, north coastal Peru, 800-1300. Ceramic, slip, paint. 19.1 cm. h. Gift of Dr. Rene A. Spitz. 1959.125

About the year 1000, much of Peru fell under the influence of a southern highland civilization known both as Huari, after its political center, and Tiahuanaco, after its religious center. Exemplifying the regional style of north coastal Peru during the Huari/Tiahuanaco period, this hunchback vessel combines the brilliant painted decoration of the south with the figural ceramic style of the Mochica, whose cultural development was interrupted by the invading southerners. The strong geometric patterns and a tendency toward abstraction anticipate the style of the later Chimú culture.

Effigy vessel, Recuay culture, Santa River drainage, Peru, 100-300. Ceramic, slip, paint. 21 cm. h. Gift of Rose Kushei. 1961.87

The most frequent motif in Recuay art is an important, godlike person wearing an elaborate animal-skin headdress and large earspools. In this example the great personage is shown drinking with three other figures (one on the back of the vessel), each holding a *kero,* or drinking cup. Details are painted in black negative outlines over a red and white ground, a decorative technique characteristic of Recuay ceramics. Another common feature of Recuay pottery is the double spout, here incorporated into the turban of the back figure and the *kero* of the figure to the left of the dignitary.

Portrait stirrup vessel, Mochica IV, Chimbote Valley, Peru, 300-500. Ceramic, slip, paint. 29.3 cm. h. Gift of Mr. and Mrs. Frederick R. Mayer. 1970.254

The portrait stirrup vessels of the Mochica are one of the most popular and appealing types of ancient Peruvian ceramics. They represent a high point in pre-Columbian ceramic art both for the psychological realism of the portraiture and for the extremely sculptural handling of the clay. Many of the accurately painted details of make-up and costume were applied in a fugitive black paint. This example is remarkable for the amount of painted decoration still remaining after centuries of burial in the earth.

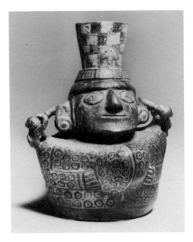

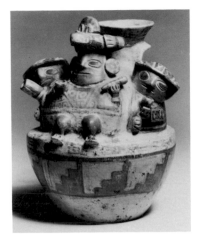

Vessel, Chincha-Ica culture, Inca period, Ica Valley, Peru, c. 1400. Ceramic, slip, paint. 33.6 cm. h. Gift of Mr. and Mrs. Frederick R. Mayer. 1970.230.1

Dating from the period of the Chincha federation just prior to its conquest by the Incas, large ceramic vessels like this have been found in the Ica Valley of south coastal Peru. Simplified human faces, modeled in relief, are a unique design feature whose symbolism is unknown. The decorative band of small birds is a motif often seen in textiles and wood carvings from this area.

Effigy vessel, Chancay culture, central coastal Peru, c. 1300. Ceramic, slip, paint. 48.3 cm. h. Gift of Dr. and Mrs. Otto Karl Bach. 1967.107

The Chancay culture is noted for its unusual textiles and ceramics. A particularly porous slip gives a distinctive texture to the pottery, which is often decorated with amusing images. Wearing a feathered turban and holding a small cup in his hands, the delightful character portrayed here may have been enjoying the vessel's probable contents—chicha, the ancient Peruvian beer.

Libation beaker, Chimú culture, Batán Grande site, north coastal Peru, 1200-1500. Silver. 17.8 cm. h. Gift of Mr. and Mrs. Frederick R. Mayer. 1969.303

The depredations of man and time have obliterated most of the vast treasure of gold and silver objects wrested from the Incas by the conquistadors. However, the enormous surviving treasure of the Chimú kings, which apparently was buried in a secret cache to protect it from invading Incas, gives us a glimpse of the richness and beauty of pre-Columbian metallurgical art. This elaborate repoussé libation beaker demonstrates both the superb technical skill of Chimú craftsmen and the artistic sensitivity with which they fashioned a complicated iconography into a beautiful design.

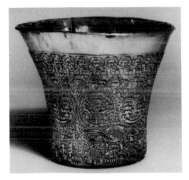

Standing Christ, New Mexico, early 19th century. Gessoed and polychromed cottonwood root, buckskin. 1.27 m. h. Gift of May-D&F. 1968.96

Holy Week was the focal point of both social and religious life in early New Mexico, where it was celebrated with community get-togethers, daily performances of High Mass, religious processions, and a reenactment of the Passion. Made with flexible arms for holding the various symbols associated with each station of the cross, life-size figures of Christ were carried in these rites. This figure wears a crown of thorns and a cotton robe and carries a cross. To reduce the weight of the sculpture, the head and torso rest on a hollow base covered by a tanned buckskin skirt.

Crucifix, Michoacán, Mexico, early 17th century. Figure: gessoed and polychromed *tzompantle* wood. Cross: hardwood. Figure 1.2 m. h. 1968.192

During the early colonial period in Mexico, as elsewhere in Latin America, native craftsmen were trained by Spanish teachers in religious houses such as the great Augustinian monastery at Yuriria. While learning European styles in art, the Indians often continued to use pre-Columbian materials and techniques. Made by an unknown Tarascan Indian, the figure in this rare crucifix was carved in European style from *tzompantle,* an extremely soft native wood. To form a hard protective finish for the wood, the artist mixed a special Tarascan paste made from ground orchids with the standard European gesso before applying it to the figure.

The Baptism of Christ, Philippines, c. 1750. Gessoed and polychromed *molave* wood. Christ: 82.6 cm. h. with base. St. John: 101.6 cm. h. with base. Marion G. Hendrie Collection. 1971.444.1-2

Carved by an unknown Jesuit artist from *molave,* an extremely hard Philippine wood, this sculptural group shows St. John in the act of baptizing the kneeling Christ. The deep carving of the hair and clothing, as well as many elongated physical proportions, brings to mind the style of statuary in the late 16th century church of Il Gesù in Rome, a style which influenced Jesuit missionary art from Paraguay to the Philippines.

Santo Niño santero, *Nazarene Christ,* New Mexico,
c. 1840. Gessoed and polychromed cottonwood root,
cloth. Figure 1.58 m. h. Gift of May-D&F. 1968.97

Santeros were folk artists, most of whom lived in northern
New Mexico, where they made santos, sculptures and
painted panels depicting Catholic religious images. While
later carvings became increasingly stylized and geometric
in appearance, this life-size figure of Christ exhibits the
sensitive and naturalistic character of mid-19th century
santos. The large, separately carved elements of the
sculpture are held together with wooden pegs, and the
joins are covered with gesso-soaked fabric, which was
also used to form the loincloth. The fine craftsmanship
and monumental scale of the figure suggest that it was
originally the focal point of a large altar screen.

José Inez Herrera (active 1890-1910), death cart, Colorado
or New Mexico, late 19th century. Gessoed and
polychromed cottonwood root, pine, metal, rawhide, horse
and dog hair. 1.4 m. h. Anne Evans Collection. 1948.22

The Spanish death cart was a prominent feature in the
Holy Week processions of the Penitentes, a self-flagellant
offshoot of a Franciscan lay order introduced into New
Mexico in 1598. This famous example shows a unique
colonial interpretation of Death as La Doña Sebastiana,
who symbolized the triumph of death during the time
between the Crucifixion and the Resurrection. Carved of
cottonwood root in a grotesque and stylized manner,
Death holds a bow and arrow rather than the traditional
European scythe.

Studio of Bernardo de Legardo (1706?-1773), *The Virgin of Quito,* Quito school, Ecuador, c. 1760. Gessoed and polychromed cedar, gold, silver. 44.5 cm. h. with base. Gift of Mr. and Mrs. John Pogzeba. 1974.265

Eighteenth-century Quito was internationally known for its fine polychromed wood sculpture. This beautiful example is characteristic of the delicate carving and elaborate polychromy produced in the studio of Bernardo de Legardo, who, together with Caspicara (Manuel Chili), was the most famous artist of the Quito school in his day. Statues of the Virgin of Quito were typically adorned with silver repoussé halo and wings.

Sebastian Salcedo, *Our Lady of Guadalupe,* Mexico City school, Mexico, c. 1779. Oil on copper panel. 63.5 x 48.3 cm. Purchased with gifts from Mr. and Mrs. George Anderman and an anonymous donor. 1976.56

The traditional Mexican Virgin of Guadalupe is shown here surrounded by prophets, saints, angels, and seven miniature scenes of her miracles, all identified by inscriptions. An early example of the colonial transition from the baroque to the neoclassic style, this superbly executed painting is one of five known works by Salcedo. Shortly after its completion in Mexico City, the painting was apparently brought north to Santa Fe, where it hung over the sacristy door of the Church of Our Lady of Guadalupe for over 100 years. The painting is typical of the detailed small-scale studies often made by Spanish colonial artists for their monumental works.

147

Luis Niño (active 1730-1760?), *Our Lady of the Victory of Málaga,* southern Cuzco school, Potosí, Bolivia, c. 1737. Oil on canvas overlaid with gold and silver. 1.51 x 1.11 m. Frank Barrows Freyer Memorial Collection. 1969.345

Although Lima became the political capital of colonial Peru, Cuzco remained its artistic center. Embellished with lavish gold and silver ornamentation, paintings of the Cuzco school influenced artists throughout the colonial Peruvian empire, which stretched far beyond the present geographical boundaries of Peru. This work, which represents a famous sculpture in Málaga cathedral given to commemorate the expulsion of the Moors from Spain, is one of the best-known paintings of the Cuzco circle. A history of Potosí from the 1730s mentions Niño as the talented creator of paintings, sculpture, fine metalwork, and possibly architecture. His two known signed paintings depict other statues of the Virgin and show similarly ornate architectural details, as well as an extraordinary use of overlaid gold and silver.

Joaquin Gutierrez (active 1780-1810), *The Virgin of the Apocalypse,* Bogotá school, Colombia, c. 1790. Oil on canvas with overlaid gold. 100 x 75.5 cm. Gift of Mr. and Mrs. Seymour Rubenfeld. 1978.180

Here, a surprisingly calm and beatific Virgin is presented in the violent scene vividly described in Revelation 12:19. Miniature pictures and inscriptions alluding to her virtues adorn the shields of St. Michael and his angels. The painting exhibits the linear style and smooth figural modeling characteristic of the French neoclassicism adopted by Joaquin Gutierrez, who established the last important colonial studio at a time when the Spanish baroque style was still mandated. Not until 1810, when the colony achieved independence from Spain, did the neoclassic style gain general acceptance.

Marcos Zapata and Cipriano Gutierrez y Toledo, *The Adoration of the Magi,* Cuzco school, Peru, c. 1750. Oil on canvas overlaid with gold. 1.88 x 1.26 m. Frank Barrows Freyer Memorial Collection. 1969.347

Because engraved reproductions of his work were readily available, Peter Paul Rubens had a profound influence on Spanish colonial art. In this painting, the composition is based on a 1631 engraving of an adoration scene painted by Rubens in 1628. Changes such as the outdoor setting, the substitution of llamas for camels, and the use of overlaid gold, however, are characteristic of Peruvian colonial work. The painting is like several produced by Zapata and his assistant Gutierrez for the Jesuit church in Cuzco. Based on evidence discovered during recent conservation work, it appears that Zapata blocked out the composition and did the underpainting and the canvas was then completed by Gutierrez. In 1755, Zapata agreed to paint 50 pictures of the life of the Virgin for the Cuzco cathedral. Among them was a nearly identical adoration scene which still hangs above the cathedral's El Triunfo entrance.

European Art

Richest in Renaissance and modern French paintings, the European collection includes treasures from the mainstream of western art from the time of its earliest beginnings in ancient Egypt and classical Greece. Although the museum had begun to assemble significant examples of European art as early as the 1920s and 1930s—notably two Monets, a Maillol bronze, and paintings by Corot and Millet—it was mid-century before the department received the major gifts that determined its present character.

In 1954, after five years of negotiations, the Denver Art Museum became the eleventh in a group of 21 regional museums to receive a substantial donation of paintings and sculpture from the Samuel H. Kress Foundation. The collection opened to the public in October of that year, simultaneously with the South Wing, the museum's first gallery built specifically to house art objects. Air-conditioned and fire-proof, as required by the terms of the Kress gift, the South Wing was incorporated into the architecture of the present museum building and is now designated as the Otto and Cile Bach Wing in honor of then-Director Otto Karl Bach and his wife, who secured the Kress donation for Denver. Officially deeded to the museum in a ceremony at the National Gallery of Art in 1961, the Kress Collection is now displayed in the European galleries of the new building opened in 1971.

The 32 pieces in the collection cover the period from 1350 to the mid-17th century and include examples from both the northern and the Italian Renaissance. From eastern Spain comes a delicate *Annuciation* by the Retascón

Edgar Degas (1834-1917), French, *The Dance Examination (Examen de danse),* c. 1880. Pastel on paper. 63.4 x 48.2 cm. Signed lower right. Anonymous gift. 1941.6

Japanese woodblock prints were a major influence on many late 19th century artists, particularly the French impressionists and postimpressionists. In this scene of ballet dancers, a favorite theme throughout his career, Degas has employed several Japanese compositional devices: the asymmetrical grouping of figures in the upper right-hand corner, the use of strong diagonals to create space, and a bird's-eye vantage point on his subject. He has gained a "stop-action" sense of spontaneity by cropping the composition in the manner of a snapshot— we are allowed to catch the young dancers and their mothers in a revealing and unguarded moment.

Master which, in its linear grace and choice of detail, is typical of the international style that flourished throughout Europe in the early 15th century. Other fine northern works include a 15th century German polychrome wood sculpture of *St. George and the Dragon,* a *Presentation* by the 16th century Flemish artist Jan Provost, and a full-length portrait by Murillo. The Kress Collection's Italian Renaissance paintings offer a balanced selection of periods and styles: a trecento panel by Pesellino, conservative late 15th century works from the Venetian painter Alvise Vivarini and the Sienese Girolamo di Benvenuto, and Zenale's superb High Renaissance *Madonna and Child with Saints,* once attributed to Leonardo himself.

Initiated by Olga Guggenheim in 1952 to honor her late husband, a former United States senator from Colorado, the Simon Guggenheim Memorial Collection complements the Kress holdings to give the museum a small, but significant, study collection of Renaissance paintings. The Guggenheim gift, which Mrs. Guggenheim continued to augment until her death in 1970, includes an early Riminese panel that reflects Byzantine influences and four panels by Crivelli in the exaggerated style of the late Gothic. An animated and vigorously carved sculpture depicting the Madonna and Child with St. Anne offers a fine example of late 15th century Netherlandish work.

Among post-Renaissance paintings in the Guggenheim Collection are d'Hondecoeter's *Still Life with Peacock, Birds, and Game* and Pannini's *Landscape with Classical Ruins,* each representative of an important period, national style, and genre. In 1961, Mrs. Guggenheim presented to the museum architectural elements from an early 17th century house in Bury St. Edmunds. The original hand-carved stone mantel and oak paneling and overmantel have been recontructed as a handsome English Tudor room and furnished with pieces from a fine collection of 16th and 17th century English furniture also donated by Mrs. Guggenheim.

Two other period rooms enhance the European collection. Assembled from different sources, a 17th century Spanish baroque study, the gift of Charles Bayly Jr., is notable for its wall covering of embossed, painted, and gilded hand-tooled leather, as well as its Moorish-style ceiling. Funds from the Dora Porter Mason Bequest enabled the museum to purchase late 15th century paneling and furniture from the Abbey at Marciac in southern France for its French Gothic room. Other important medieval works, including the stained glass roundel from Troyes Cathedral, were also acquired through the Mason Bequest.

The nucleus of impressionist works acquired with funds from the Helen Dill Bequest in the 1930s, together with major gifts from Horace O. Havemeyer and the Lawrence C. Phipps Foundation, established a firm basis for the

department's 19th century French collection. With the acquisition of the Charles Francis Hendrie Memorial Collection in the 1960s, this focus was extended to include the early 20th century. Given by Jennie, Edna, and Marion G. Hendrie in honor of their father, the collection contains significant works by Picasso, Gris, Braque, Rouault, Modigliani, Klee, and Mondrian. The modernist emphasis of the collection was further strengthened in 1974 with the addition of a large number of 19th century French works by such masters as Barye, Degas, Courbet, Toulouse-Lautrec, and Utrillo, part of an extensive gift from T. Edward and Tullah Hanley of Bradford, Pennsylvania, to "the people of Denver and the area."

Although relatively small in size, the ancient Mediterranean collection contains examples from Egypt, Greece, Etruria, and the far-flung Roman Empire. The most comprehensive segment of this area of the collection is a group of Greek vases illustrating most shapes and decorative techniques. The group was greatly enriched by gifts from Morton D. May and Ann Gregory Ritter in the 1960s.

Highlights of the department's print and drawing collection include several series of etchings by Callot, Goya's *Tauromaquia* and *Follies,* and Rouault's *Miserere et Guerre,* as well as drawings by Bertoia, G. D. Tiepolo, Fragonard, Fantin-Latour, and Derain.

Ibis coffin, Egypt, Tuna el-Gebel, 26th Dynasty, Saite period, c. 600 BC. Gessoed wood, bronze, gold leaf, rock crystal, paint. 33.5 cm. h. Charles Bayly Jr. Collection. 1949.8

This coffin from the sacred animal cemetery at Tuna el-Gebel is in the form of an ibis, the sacred bird associated with Thoth, the Egyptian god of wisdom, science, speech, hieroglyphics, and the arts. A typical coffin consisted of a wooden body with cast bronze head and legs. In this example, the body bears traces of white gesso originally overlaid with gold leaf upon which feathers were painted in red. Finely worked details decorate the legs, head, and neck, where bits of gold leaf are still visible on the incised necklace. Rock crystal eyes, outlined in gold, give the bird a lifelike mien. Like hundreds of similar coffins found in the seemingly endless underground passages of the necropolis, the hinged body once contained a mummified ibis.

Isis, Egypt, Ptolemaic period (332-20 BC). Palm wood, gold leaf, bronze. 38.1 cm. h. 1955.17

Shown in the rigid, frontal pose characteristic of ancient Egyptian sculpture, this small gold-leafed figure represents the great Egyptian mother goddess Isis, the personification of female creative powers, as well as the faithful wife and devoted mother. By the time this statue was made, Isis had assimilated the attributes of all the great primitive goddesses of Egypt. The cow horns holding a sun disc which surmount her headdress derive from her identification with Hathor, goddess of joy and motherhood.

Sunk relief (detail), Egypt, 5th Dynasty, c. 2400 BC. Limestone, paint. 42.5 x 165.7 cm. Marion G. Hendrie Collection. 1972.9

An outstanding example of ancient Egyptian craftsmanship, this Old Kingdom sunk-relief fragment of a text came from a nobleman's tomb in the necropolis at Saqqara. Although an outline would have been sufficient to identify a hieroglyph or determinative, the figures, especially the birds, are rendered in great detail. Typically placed in horizontal registers and read from right to left, the letters were originally filled with pigment, traces of which can still be seen. The text describes the funeral, with offerings of bread and beer, given by Pharaoh Unas to his deceased chamberlain and overseer of the royal gardens.

Winchester painter, Attic red-figure kylix, Greece, c. 520 BC. Painted terra cotta. 12.7 cm. h. Gift of Ann Gregory Ritter. 1968.4

During the last two decades of the sixth century BC, the kylix was the most popular shape among Attic red-figure vase painters. The typical interior decoration of these drinking cups was a central tondo encircling a single figure, such as a reveler, satyr, warrior, or, as in this example, an athlete. On each side of the cup's exterior, the artist has painted a pair of eyes and an athlete between palmettes. The elongation of the eyes and their short, nearly vertical tear ducts are characteristic of the Winchester painter's style.

Attic black-figure amphora, Greece, c. 525 BC. Painted terra cotta. 33 cm. h. Charles Bayly Jr. Collection. 1957.100

The decoration on this amphora, a vase shape particularly popular in the 6th century BC, illustrates two unrelated subjects traditional in black-figure vase painting. The main scene, which shows Dionysus riding a donkey and accompanied by two satyrs, is usually interpreted as the god's return to Olympus. On the opposite side, the lyre player flanked by two maidens probably represents Apollo with Muses. Although executed in the static black-figure style, the images show a fluidity of form and movement associated with the recently introduced red-figure style.

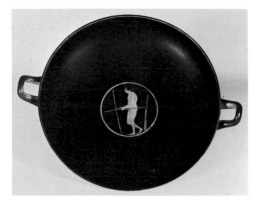

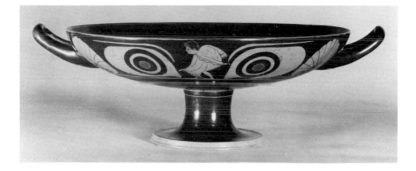

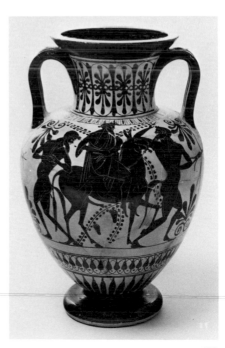

Mosaic floor fragment, Roman, House of the Ram's Head, Daphne, 450-500. Marble, limestone. 1.3 x 1.52 m. Charles Bayly Jr. Collection. 1951.27

Although tessellated floors originated in Hellenistic times, they flourished as a decorative art during the Roman Empire. Made from thousands of tesserae—tiny marble and limestone cubes—in carefully graduated colors, Roman mosaics usually depicted illusionistic scenes. However, late Roman pavements unearthed at Daphne, a suburb of the wealthy, sophisticated city of Antioch, show a preference for two-dimensional compositions. In this example, a flat outer border of circles and ellipses frames an inner design which creates the illusion of an undulating ribbon, a stylistic survival from earlier times. A vast grid of repeated heart and rosette motifs, which may have been taken from textile designs, originally formed the central field.

Portrait bust, Roman, mid-2nd century. Marble. 76.2 cm. h. 1965.22

In contrast to the Greek practice of idealizing the human form, Roman artists developed a realistic style of portraiture which vividly captured the personalities of Rome's leading citizens. Although the sitter's identity is unknown, this portrait can be dated on stylistic and technical grounds to the late Antonine period (138-161). The short, rough beard marks a change from the earlier clean-shaven style, while the eyebrows are modeled in relief and the eyes incised with pupils. Deep drilling gives a rich texture to the mass of curls. The garment draped over the subject's shoulder is probably a type of military cloak worn by certain officials, as well as officers.

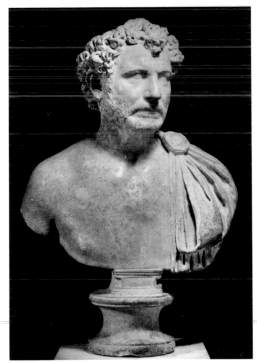

Master of the Retable of the Reyes Católicos (active late 15th century), Spanish, Valladolid, *The Adoration of the Magi,* c. 1497. Oil on pine panel. 153 x 93.2 cm. Samuel H. Kress Foundation Collection. 1961.177

During the second half of the 15th century, many Spanish painters went north to Flanders and Burgundy for training. Such was probably the case with this artist, who demonstrates a fine understanding of the Netherlandish style in this work, one of eight known panels from the *Retable of the Reyes Católicos.* Some compositional and figural elements have been borrowed from Rogier van der Weyden, while the meticulous rendering of texture and detail and the rich colors are characteristically northern. The emotional intensity and dour visages, however, confirm the painting's Spanish origins. It is thought that the retable was commissioned by Ferdinand and Isabella, the Catholic Kings, in celebration of the marriages of their children Joanna and John to the heirs of the Hapsburg Empire.

The Flagellation of Christ, France, Troyes Cathedral, 1220-1240. Stained glass, lead. 53.3 cm. dia. Dora Porter Mason Collection. 1947.33

In France, each great Gothic cathedral is distinguished by the character of its stained glass windows, which differ both in style and in the proportions of various colors. This rare and well-preserved roundel has been identified as a segment from the cathedral at Troyes partly on stylistic grounds but primarily because it includes a deep, golden yellow color peculiar to that cathedral. Since the subject would have been appropriate for the eastern end of a cathedral, the roundel was probably located originally in the apse or one of its radiating chapels.

Retascón Master (active 1400-1450), Spanish, Aragon, *The Annunciation,* 1425-1450. Tempera on pine panel. 117.5 x 64.2 cm. Samuel H. Kress Foundation Collection. 1961.176

Early in the 15th century, northern European influences began to appear in Spanish painting, which had followed for the most part the Italianate international style. Although strongly Italian in its architectural and decorative elements, as well as its composition, this *Annunciation* shows French influences in the animated drapery and the delicate features and curly hair of Gabriel and Mary. The curious attenuation of the figures and the hot, clear colors are characteristic of the Retascón Master.

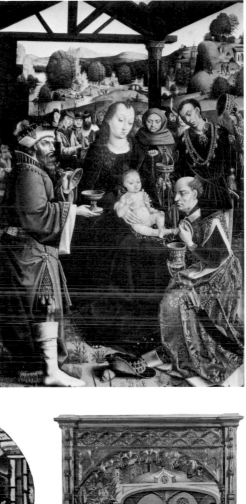

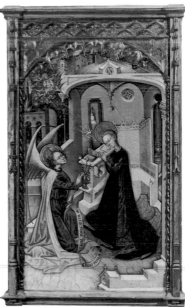

Albrecht Dürer (1471-1528), German, *The Prodigal Son,*
c. 1496. Engraving. 24.4 x 18.9 cm. Monogram on plate.
Gift of W. W. Grant in memory of his wife, Gertrude
Hendrie Grant. 1957.185

The Prodigal Son is among the earliest and best-known
prints by Albrecht Dürer, commonly acknowledged as the
greatest of all line engravers. Despite some problems with
spatial relationships and the awkward articulation of the
youth's figure, Dürer has integrated the setting and the
figures into a strongly unified composition. His treatment
of the subject was unprecedented in its time: by showing
the prodigal as a suppliant kneeling among his pigs in the
farmyard, Dürer achieved a graphically moving expression
of human degradation and repentance.

Madonna and Child with St. Anne, Netherlandish, late 15th
century. Oak. 65.4 cm. h. Simon Guggenheim Memorial
Collection. 1953.70

Coincident with the rise of prosperous middle-class art
patrons in the 15th century Netherlands, the group image
of the Virgin and Child with St. Anne replaced in popularity
the Gothic image of the Virgin as the sublime Queen of
Heaven. In this altarpiece the holy group is realistically
portrayed as typical members of the bourgeoisie, a
tradition already established in the paintings of Robert
Campin and Rogier van der Weyden. The somewhat
softened drapery folds, the gentle expressions, and the
pointed shoe style, which changed to a rounded toe about
1500, suggest a late 15th century date for this strongly
carved piece.

St. George and the Dragon, Germany, Bavaria, c. 1525.
Gilded and polychromed wood. 1.22 m. h. Samuel H. Kress
Foundation Collection. 1963.107

Images of St. George, the patron saint of soldiers and
armorers, were particularly favored in early 16th century
Germany, probably due in part to the influence of
Maximilian I, who revived the old Bavarian Order of St.
George. While much Bavarian sculpture of the early 16th
century displayed an animated, proto-baroque style,
exemplified in the works of Erasmus Grasser and Hans
Leinberger, a more restrained style of carving was favored
in some areas. This St. George stands firmly on the slain
dragon; the comparative stiffness of the figure is relieved
by the heavy, swinging folds of the deeply undercut
drapery.

Barthel Beham (1502-1540), German, *Portrait of a Woman,* 1529. Oil on panel. 96.3 x 74.2 cm. Dated upper left. Samuel H. Kress Foundation Collection. 1961.180

One of Dürer's prominent pupils, Beham was particularly noted for his portraits, which exemplify the decorous aristocratic style practiced by northern and Italian artists toward the middle of the 16th century. Bathed in an even light, figures were silhouetted against a plain background, and costumes were rendered in careful detail; the realistically executed fur collar might almost be considered the hallmark of the style. As this example shows, emphasis was placed on indications of social status and wealth rather than on character portrayal.

Ambrosius Benson (active 1519-1550), Flemish, *Portrait of Jean de Dinteville,* c. 1533. Oil on panel. 53.5 x 44.1 cm. Charles Bayly Jr. Collection. 1953.82

The subject of this fine portrait is Jean de Dinteville, who was sent by François I as French ambassador to the English court of Henry VIII in 1533, the same year Holbein painted his famous, life-size double portrait of the ambassador and his colleague Georges de Selve, Bishop of Lavour. The resemblance between the two likenesses of de Dinteville is striking, and since he wears a similar cap for each occasion, it is probable that the pictures were painted about the same time. The smooth surface, carefully rendered details, flat background, and realistic treatment of light and shade epitomize the eclectic Flemish style of Benson, a native of Lombardy and contemporary of Jan Provost in Bruges.

Jacopo di Cione, active 1368-1398 (or Andrea di Cione, called Orcagna, active 1344-1368), Italian, Florence, *Man of Sorrows,* c. 1370. Tempera on poplar panel. 31 x 66 cm. Samuel H. Kress Foundation Collection. 1961.154

Originally a predella panel, this compelling work portrays Christ in his sarcophagus flanked by St. John and the Virgin, who presents the kneeling donor of the painting to her son. The panel has been variously attributed to Andrea Orcagna, who dominated mid-trecento art in Florence, to his youngest brother, Jacopo di Cione, and to both artists as a collaborative work. The static composition and crisp outline of the figures, which emerge in bold relief from the flat, intricately stamped gold background, exemplify Orcagna's abstract style while the articulation of the Virgin's head and St. John's hands are characteristic of Jacopo's work.

Jan Provost (1465?-1529), Flemish, *Presentation of the Christ Child in the Temple,* c. 1521. Oil on fruitwood. 99.8 x 71.6 cm. Samuel H. Kress Foundation Collection. 1961.184

Although clearly working in the Flemish tradition of Gerard David, Jan Provost was receptive to new ideas and influences. The composition of this painting, for example, is taken directly from Dürer's treatment of the subject in his woodcut series *Life of the Virgin* while the stiff postures and crowding of the figures suggest 16th century mannerist techniques. The Flemish character of Provost's painting, however, emerges in the preoccupation with precise, naturalistic detail and the gemlike quality of the colors.

Christ and Procession of Martyrs with Saints, Italy, Rimini, 1300-1350. Tempera on wood panel. 48.3 x 71.1 cm. Simon Guggenheim Memorial Collection. 1958.98

This small panel, attributed to the Riminese school, is one of the earliest paintings in the European collection. In the upper register, Christ receives a procession of martyrs, probably St. Ursula and eleven of her 11,000 virgins, whose quiet, forward movement is suggested by the repetition of elongated forms and the rhythmic sweep of drapery. Executed in smaller scale, Saints George, Peter, Blaise, Anthony Abbot, and John are spaced across the lower register. The linear and insubstantial character of the figures, as well as the shallow, stagelike spaces in which they stand, derives from Byzantine influences, which strongly affected Riminese artists in the first half of the 14th century.

Niccolò di Pietro Gerini (active 1368-1415), Italian, Florence, *Madonna and Child Enthroned with Saints,* n. d. Tempera on wood panel. 104.2 x 50.8 cm. Simon Guggenheim Memorial Collection. 1955.109

Although he was trained in the Cione workshops and is known to have collaborated with Jacopo, Gerini was primarily an exponent of Giotto's more substantial style. Gerini's dignified Virgin, glancing tenderly at her son, echoes the Florentine master's monumentalism, and the saints and angels, while represented in a smaller scale, are equally solid physical presences. The artist has negated their substance, however, by flatly stacking these figures around the Virgin. Despite the spatial confusion of this arrangement, the configuration creates a mandorla of colorful robes and haloed heads which pulls the composition together.

Francesco di Stefano, called Pesellino (1422-1457), Italian, Florence, *Madonna and Child before a Marble Niche,* c. 1455. Oil on linden panel. 56.9 x 35.5 cm. Samuel H. Kress Foundation Collection. 1961.159

Pesellino was strongly influenced by his reputed teacher, Fra Filippo Lippi, to whom this painting was long attributed. A similarity of style exists in the figural types, particularly in the elongated proportions of the child, as well as in the diffused light, gentle modeling, and deeply cut folds of drapery. Pesellino's distinctive hand emerges in the softened outlines, the solemn naturalism, and the harmony of rich colors.

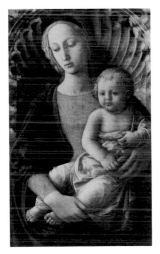

Alvise Vivarini (1457?-1505?), Italian, Venice, *St. John the* ·
Baptist and *St. Jerome,* c. 1480. Oil on fruitwood panel.
St. John: 117.2 x 38.7 cm. St. Jerome: 116.7 x 39 cm.
Samuel H. Kress Foundation Collection. 1961.161, 1961.162

Although late 15th century Venetian painting was
dominated by the influence of Antonello da Messina and
Giovanni Bellini, the work of the Vivarini family, including
that of Alvise, represents a conservative vein that
continued into the 16th century. While the images of these
two saints possess an imposing monumentality and grace,
Alvise has rejected the sense of volume and space found
in the works of Bellini and Antonello in favor of a style
which emphasizes broad areas of color, linear figures, and
narrow, stagelike spaces. The panels undoubtedly once
formed part of an altarpiece.

Girolamo di Benvenuto (1470-1524), Italian, Siena,
St. Catherine of Siena Exorcising a Possessed Woman,
1500-1510. Oil on wood panel. 31.4 x 55.8 cm. Samuel H.
Kress Foundation Collection. 1961.171

Sienese painting in the 15th century remained largely in
the Gothic tradition and was little affected by the
Florentine Renaissance. Elements such as perspective,
humanism, and interest in the antique made only sporadic
appearances. This predella panel exhibits one of the
intermediary styles practiced by Sienese artists before
they turned to mannerism in the 16th century. Despite the
stylized depiction of emotion and the stiff arrangement of
the figures against a flat interior background, there are
several compelling aspects to the painting, such as the
little flying demon and the individually characterized faces
of the group of maimed witnesses to the miracle and bald-
headed man supporting the possessed woman.

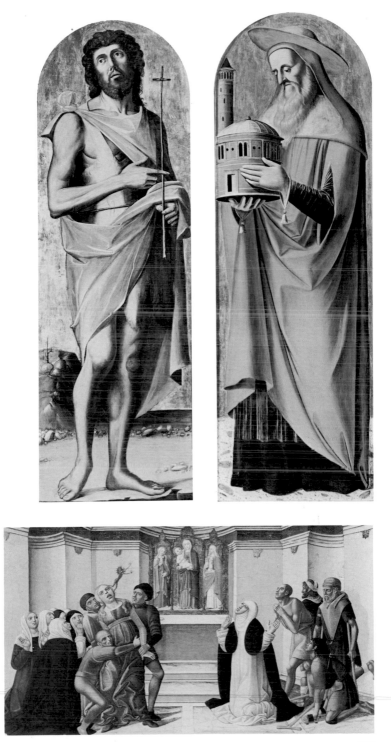

173

Jacopo Zanguidi, called Bertoia (1544-1574), Italian, Parma, *Holy Family with Saints Elizabeth and John the Baptist,* c. 1570. Ink, wash, chalk on paper. 30.7 x 25.5 cm. Purchased in honor of Diane DeGrazia Bohlin. 1973.160

An artist of the Parmesan school, Bertoia was strongly influenced by the works of Parmigianino, whose mannerist style was notable for the gracefully elongated proportions of his figures. While Parmigianino's influence is evident here in elements such as the slender elegance of the Virgin's foot, this drawing exhibits the full-bodied, sculpturesque quality which appears in Bertoia's work after 1568, a reflection of his contacts with Rome and the work of Taddeo and Federico Zuccaro.

Carlo Crivelli (active 1457-1495?), Italian, Venice, *Four Saints,* c. 1490. Oil on four wood panels. Each panel 43.5 x 8.6 cm. Simon Guggenheim Memorial Collection. 1956.92a-d

Although Crivelli painted these panels at the beginning of the High Renaissance, his style is essentially Gothic. He has modeled his sharply delineated figures with fine parallel hatching, a technique associated with the earlier egg tempera medium, and silhouetted them against an anachronistic flat gold background. The meticulous, exaggerated rendering of detail is also characteristic of the Gothic style. These four panels, depicting Saints Anthony Abbot, Christopher, Sebastian, and Thomas Aquinas, were part of a group of twelve thought to have flanked Crivelli's *Madonna della Candeletta* now in the Pinacoteca di Brera in Milan.

Bernardo Zenale (1450?-1526), Italian, Lombardy, *Madonna and Child with Saints,* c. 1511. Oil on poplar panel. 1.82 x 1.25 m. Samuel H. Kress Foundation Collection. 1961.173

The incomparable works of Leonardo da Vinci marked the advent of the High Renaissance style. His luminously modeled figures and masterful handling of atmospheric effects had a pronounced influence on many northern Italian painters, including the Lombard artist Bernardo Zenale. Attributed at one time to Leonardo himself, this painting by Zenale is obviously derived from the master's *Virgin of the Rocks* in its composition and in the treatment of the figures and drapery. Instead of using Leonardo's subdued palette, however, Zenale adopted the strong, enamellike hues favored by late quattrocento artists such as Ghirlandaio.

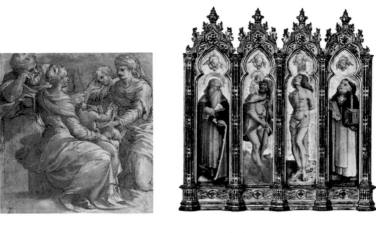

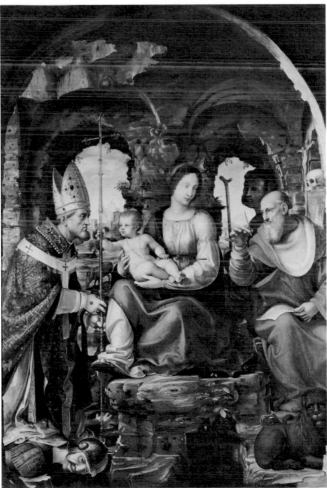

Giovanni Paolo Pannini (1691/92-1765), Italian, Rome, *Landscape with Classical Ruins,* c. 1753. Oil on canvas. 66.7 x 140 cm. Simon Guggenheim Memorial Collection. 1962.100

As tourism to Italy increased during the 18th century, so did the demand for topographical views, picturesque paintings of the Italian landscape. Roman view painters like Pannini often rearranged ancient and modern landmarks to achieve a pleasing composition. Here, Pannini has taken familiar monuments from the vicinity of the Roman Forum and composed them in a romantic, theatrical scene. The imposing scale and capricious juxtaposition of the ruins symbolize a typical 18th century concept: a single individual or moment in time is dwarfed by the scope of history and the power of nature.

Anne of Austria, Spain, early 17th century. Oil on panel. 54 x 44.7 cm. Helen Dill Collection. 1950.39

This adroitly executed work portrays Philip II's fourth wife, Anne of Austria, daughter of the Hapsburg emperor Maximilian II. Once attributed to Philip's court painter Alonso Sánchez Coello (1531?-1588?), the portrait is now thought to be an early 17th century copy of a Sánchez Coello painting of the Spanish queen. In its detached realism, the image continues the tradition of formal court portraiture established by Hans Holbein and Anthonis Mor. The number of known copies of the Sánchez Coello portrait made after Anne's death in 1580 suggests that images of royalty were in demand long after the sitter's decease.

Follower of Titian, Italian, Lombardy(?), *Portrait of an Architect,* 1550-1560. Oil on canvas. 93.3 x 81.7 cm. Charles Bayly Jr. Collection. 1951.85

Titian and Veronese were among the masters who dominated Venetian painting between 1470 and 1590. Although both artists are known as colorists, they often executed portraits in a monochromatic style which focused attention on the subject's face. Unlike the studied impersonality of the formal court style, these portraits convey a sense of character and spontaneity; the architect here seems about to speak. This portrait has been attributed to both Titian and Veronese, a confusion perhaps resulting from a similarity of style in their early work. Current scholarship, however, suggests that the artist was a follower of Titian, probably of the Lombard school.

Follower of Rembrandt (Willem de Poorter? 1608-after 1648), Dutch, *Minerva,* c. 1632. Oil on panel. 44.2 x 36 cm. Purchased with gift from Helen Bonfils and special subscription fund. 1959.114

An acknowledged master in his own lifetime, Rembrandt van Rijn dominated 17th century Dutch painting and attracted numerous students and followers. During his years in Leiden, the psychological realism, deft paint handling, and dramatic compositions that became the hallmark of his mature style were not yet fully developed. Characterized by intense contrasts of light and shade, overly detailed, and awkward in their spatial relationships, his paintings of this early period continued to influence Leiden followers like Willem de Poorter, whose works were similarly small in scale and scrupulously rendered. This painting also displays a facial type and the distinctive shades of red and teal blue found in much of de Poorter's work.

Melchior d'Hondecoeter (1636-1695), Dutch, *Still Life with Peacock, Birds, and Game,* after 1682. Oil on canvas. 1.53 x 1.34 m. Simon Guggenheim Memorial Collection. 1962.102

Among the specialized categories of 17th century Dutch painting were pictures of live animals or birds composed and rendered in the manner of still lifes. The foremost painter of bird still lifes was Melchior d'Hondecoeter, whose works are remarkable for their richness of texture and color, as well as their meticulous realism. In this example d'Hondecoeter took his theme from a proverb. The message under the owl's foot reads, "So beaked, so sung," a condensed version of the Dutch saying, "Every bird sings according to how it is beaked." The painting is a smaller version of a large composition executed by d'Hondecoeter in 1682.

George Romney (1734-1802), English, *Miss Holford,* 1781. Oil on canvas. 76.2 x 63.5 cm. Purchased with gift from Charles E. Stanton in memory of his mother, Mary Howie Stanton. 1979.335

George Romney's fame as a portrait painter in 18th century England was equaled only by that of Sir Joshua Reynolds and Thomas Gainsborough. His mature style combines a dramatic elegance in the 17th century tradition established by Sir Anthony Van Dyke and a classical simplicity which appeared in Romney's work following a two-year sojourn in Italy. In this portrait of Miss Holford, the aristocratic posture, the strong, clearly defined features, and the fashionable gown inspired by ancient Greek costumes give the figure a classical serenity which is enhanced by contrast with the brooding sky and swirl of red drapery.

Bartolomé Esteban Murillo (1617-1682), Spanish, *Portrait of Don Diego Felix de Esquivel y Aldama,* c. 1658. Oil on canvas. 2.06 x 1.09 m. Samuel H. Kress Foundation Collection. 1961.67

Although best known for his sensitive and sentimental religious paintings, Murillo was also a fine portraitist. While the impassive expression and realism of detail in this portrait hark back to the conventions established in the 16th century by Anthonis Mor, the painting exhibits distinctive 17th century characteristics, such as heightened chiaroscuro and a setting in the "unadorned style," in which minimal furnishings were used to establish perspectival relationships in a bare, stagelike space. The portrait was probably executed in 1658 when both Murillo, a lifelong resident of Seville, and Don Diego were in Madrid.

Francisco Goya y Lucientes (1746-1828), Spanish, *Folly of the Little Bulls* from *The Follies (Los Disparates)*, 1877. Etching, aquatint. Trial proof. 27.6 x 38.7 cm. Charles Bayly Jr. Collection. 1945.62

Conceived against a background of social and civil chaos in Spain, *The Follies* convey a profoundly pessimistic view of life. Like this image, which shows a cluster of normally formidable bulls floundering in space, they are perhaps the most enigmatic and ambiguous of Goya's prints. Even the title here is a puzzle: scholars have deciphered Goya's inscription on the working proof both as *toritos* (young bulls) and *tontos* (fools). Although Goya executed the plates for the 22 images which constitute *The Follies* about 1816, they were never published during his lifetime. Four images, including this one, were omitted from an edition published in 1848 as *The Proverbs (Los Proverbios)*. The museum's print is a trial proof from the first complete edition, published in 1877 in the French magazine *L'Art*.

Jean-Honoré Fragonard (1732-1806), French, *Pilgrim with a Staff,* 1756-1761. Sanguine chalk on paper. 40.6 x 25 cm. Gift of Mr. and Mrs. John B. Bunker. 1976.94

This early red chalk drawing is similar to others depicting male figures that probably date from Fragonard's student days at the French Academy in Rome. Although it lacks the subtle variation in line weight found in the artist's later works, the figure is delineated with a firm, sure hand. The energetic chalk strokes and the unsmudged, closely spaced parallel hatching are traits which become fully developed in Fragonard's mature style.

Honoré Daumier (1808-1879), French, *Podenas,* cast 1929/30 from clay original c. 1832. Bronze, edition 1/25. 21 cm. h. Purchased in honor of Charles F. Ramus. 1948.63

In 1832, Charles Philipon, editor of *La Caricature,* commissioned a series of comic portraits of influential men surrounding the new king Louis Philippe. Created by Daumier, the series consisted of at least 36 clay caricatures, including the bust of an obscure politician, Baron Joseph de Podenas. A lithographic version of the image, captioned with the unflatteringly punned name *"Pot-de-naz"* (Pot-nose), appeared in 1833 in Philipon's new journal *Charivari.* This bronze casting of the original clay figure was made by Philipon's grandson. The exaggerated features and surface textures have been skillfully arranged to emphasize the massive, pyramidal shape of the bust.

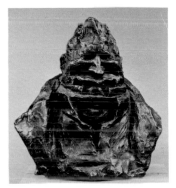

Jean-Baptiste Camille Corot (1796-1875), French, *Ville-d'Avray: Path by the Edge of the Pond,* 1865-1870. Oil on canvas. 55.5 x 80.8 cm. Signed lower left. Gift of the Lawrence Phipps Foundation. 1958.117

In his landscape paintings, Corot combined the balanced, classical structure of Claude Lorrain, whom he greatly admired, with a careful observation of nature and atmospheric effects. Like his Barbizon colleagues, he was a practitioner of plein-air painting whenever possible. This scene, one of many depicting the environs of Ville-d'Avray, a village near Paris where his family had a summer home, exhibits the cool palette, softened shapes, and shimmering atmosphere characteristic of his mature style. Like Claude, Corot often added picturesque groups of figures to his landscapes, but in the Ville-d'Avray paintings he has replaced the 17th century master's idyllic Arcadians with the indigenous French peasants favored by Barbizon artists like Millet.

Jean-Baptiste Camille Corot (1796-1875), French, *Woman in Thought (Femme à la pensée),* 1855-1858. Oil on canvas. 48.3 x 40.6 cm. Signed lower left. Gift of Horace Havemeyer in memory of William D. Lippitt. 1934.13

Although he is better known for his silvery, romantic landscapes, Corot also painted numerous studies of single female figures, the majority between 1860 and 1870. By dressing his models in peasant costumes and arranging them in static poses, Corot heightened the quality of poetic melancholy and nostalgia which pervades these studies. In this early example, the single-source lighting, which contributes to the pensive atmosphere, creates dramatic value contrasts reminiscent of 17th century Dutch painting, particularly the work of Vermeer.

Jean François Millet (1814-1875), *Mother and Child (Les Errants),* 1848/49. Oil on canvas. 50.8 x 40.5 cm. Signed lower right. Gift of Horace Havemeyer in memory of William D. Lippitt. 1934.14

Executed about the time of Millet's move from congested Paris to the peaceful village of Barbizon, this painting reflects the social and economic turmoil which drove thousands of peasants to the city. Following the depression of 1847, homeless wanderers like this mother and child were a common sight; frequent references to them appeared in contemporary writing and popular imagery. The firm draftsmanship and sculptural quality of Millet's portrayal endow the figures with a simple nobility which transcends their humble origins.

Claude Monet (1840-1926), French, *Waterloo Bridge,* 1903. Oil on canvas. 65.5 x 101 cm. Signed and dated lower left. Helen Dill Collection. 1935.15

Beginning with the haystack series in 1891, Monet examined the nuances of changing light by painting the same scenes under differing atmospheric conditions. The haystacks led to other series—poplars, the facade of Rouen Cathedral, and views of London, including Waterloo Bridge, seen from the window of the artist's hotel room on the Thames. In these paintings objects are barely differentiated by texture or color, and spatial relationships are less clearly defined than in Monet's earlier works, a result of his attempt to record accurately his visual perception of the scene.

Claude Monet (1840-1926), French, *The Water Lily Pond (Le Bassin des nymphéas),* 1904. Oil on canvas. 89.2 x 92.3 cm. Signed and dated lower right. Helen Dill Collection. 1935.14

In 1890 Monet purchased the house and grounds at Giverny where he was to live for the rest of his life. Three years later he acquired the famous water-lily pond, which became the subject of his most famous series. Over the next 20 years Monet altered the site to conform to his changing needs as a painter. By 1904 he was focusing on limited areas of the pond, capturing lily pads and blossoms floating on the mirrorlike surface of the water amid reflections of trees, clouds, and sky. Although this painting, like *Waterloo Bridge,* can be easily understood as a three-dimensional landscape, the lively brushwork and dabs of bright color dissolve the individual elements into an abstract surface pattern.

Henri de Toulouse-Lautrec (1864-1901), French, *Interlude during the Masked Ball (Repos pendant le bal masqué),* c. 1899. Oil, gouache on cardboard. 57.2 x 40.2 cm. Insignia lower left. T. Edward and Tullah Hanley Collection. 1974.359

Like Degas, whom he greatly admired, Toulouse-Lautrec was a consummate draftsman, and, like his fellow postimpressionists Van Gogh and Gauguin, he exploited the expressive potential of color. Combining these elements with the compositional devices of Japanese prints, Lautrec developed a unique style in which he captured the gaudy excitement of Parisian nightlife. The strong lines and garish colors of this painting accurately describe the psychological relationship between two revelers at a masked ball.

Edgar Degas (1834-1917), French, *Three Women at the Races (Trois Femmes aux courses),* c. 1885. Pastel on paper. 70 cm. sq. Signed lower left. Anonymous gift. 1973.234

Although he is usually considered an impressionist, Degas deplored the group's insistence on plein-air painting, a practice he reportedly dismissed with the remark, "...a painting is first of all a product of the artist's imagination, it ought never to be a copy....It is much better to draw only what remains in the memory." Accordingly, his racetrack scenes, like most of his work, were executed in the studio rather than "on location." Even so, the cropping of the figures, the masterful use of line, and the loose handling of the medium combine to create a strong sense of immediacy in this animated scene of women at the races.

Pablo Picasso (1881-1973), Spanish, *Landscape, Horta de Ebro*, 1909. Oil on canvas. 54 x 65 cm. Signed lower right. Charles Francis Hendrie Memorial Collection. 1966.175

During the summer of 1909 Picasso began to formalize the manner of pictorial expression which became known as cubism. Here, he has transformed the mountainous landscape near the Spanish town of Horta de Ebro into a kaleidoscopic surface of geometric planes. Unlike Cézanne, who experimented with the reduction of landscape into geometric components primarily by means of texture and color, Picasso used a combination of line and ambiguous shadows to create forms. His limited palette, restricted to shades of green and brown, helps to focus attention on the shifting planes and volumes, which lack a unified perspective.

Alexander Archipenko (1887-1964, b. Russia), American, *Walking Woman,* 1912. Bronze. 77.1 cm. h. Signed and dated lower right side. Charles Bayly Jr. Fund and 1958 Collectors' Choice Benefit Fund. 1958.43

Although Picasso experimented with the application of cubism to sculpture as early as 1909, Archipenko was the first artist who successfully incorporated cubist tenets in a three-dimensional work. In *Walking Woman,* he has used voids, as well as solids, to define volumes expressed through the dynamic interplay of convex and concave surfaces.

Aristide Maillol (1861-1944), French, *Summer,* 1910. Bronze. 1.61 m. h. Signed left edge of base. 1927.5

Maillol, who worked as a painter in his early years, turned to sculpture in the latter part of his career. Devoting himself almost exclusively to representations of the female nude, he used the medium to explore aspects of the figure as form. In a period still dominated by the dramatic style of Rodin, the smooth surfaces and graceful simplicity of Maillol's work, which was influenced by classical Greek traditions, offer a strong contrast to the exaggerated surface modeling and expressive romanticism of Rodin's sculpture. *Summer* is a superb example of Maillol's serene, monumental style.

Amedeo Modigliani (1884-1920), Italian, *Portrait of a Woman,* 1918. Oil on canvas. 61.3 x 46.4 cm. Signed upper right. Charles Francis Hendrie Memorial Collection. 1966.180

In this portrait, Modigliani has reduced the form and features of his subject to a study of line, texture, and color. The sweeping lines and echoing curves contrast with textured areas of color, cool grayish blues and warm terra cottas, recalling the tones of Cézanne. The painting is a variation of Modigliani's *Gypsy Woman with Baby* now in the National Gallery of Art, Washington, D.C.

Amedeo Modigliani (1884-1920), Italian, *Caryatid,* c. 1914. Watercolor, chalk, pastel on paper. 65.5 x 50.3 cm. Charles Francis Hendrie Memorial Collection. 1968.133

Modigliani's *Caryatids* were initially conceived as sculpture, a medium the artist was forced to abandon because stone dust aggravated his tubercular condition. As drawings, they exhibit a convincing solidarity achieved through rhythmically curving lines which define volume and heavy outlines which throw the figures into relief. The crisp abstraction of form and the long sweeping nose and elliptical eyes reflect influences from the sculptor Brancusi and from native African sculpture.

Juan Gris (1887-1927), Spanish, *Still Life with Bottle of Bordeaux,* 1919. Oil on canvas. 81.4 x 65.3 cm. Signed and dated lower left. Charles Francis Hendrie Memorial Collection. 1966.176

In the years between 1916 and 1919, Juan Gris synthesized the formal aspects of cubism into a new statement. Multifaceted images, ambiguities between solid and void, and collages of texture were replaced by what Gris called a "flat colored architecture," in which forms are defined by means of crisp lines and seemingly arbitrary, often acid, colors. In this example shapes are arranged on the flat surface of the picture plane with virtually no hint of spatial recession.

Henri Matisse (1869-1954), French, *Two Sisters,* c. 1916. Oil on canvas. 61 x 74 cm. Signed upper right. William D. Lippitt Memorial Collection by exchange. 1950.42

Matisse first gained public attention for the boldly colored paintings he exhibited in the Salons d'Automne of 1905 and 1906. In the following years, he developed his basic idea that form and light are a function of color. Increasingly, he emphasized line and eliminated modeling from his work so that shapes emerged as flat planes of color lacking perspective. This painting is one of a series done between 1913 and 1916 of his model Lorette and her sister. While Matisse has employed a greater delicacy of line and degree of modeling than in other works from this period, the vibrant areas of yellow and green confirm his supremacy as a colorist.

Henri Matisse (1869-1954), French, *Odalisque (Odalisque à la culotte bayadère),* 1925. Lithograph, edition 25/50. 71.1 x 57.2 cm. Signed lower right margin. 1928.12

Matisse used pattern, as well as color, to define form. Showing the odalisque draped in a languid pose favored by the artist at this time, this black and white lithograph is composed of scintillating juxtapositions of pattern. The strongly modeled figure, the boldly striped pants, and the lively floral design of the chair throw create a unified composition of curved shapes silhouetted against a plain background.

Georges Braque (1882-1963), French, *The Brown Table,* 1932. Oil on canvas. 50.2 x 65.5 cm. Signed lower right. Charles Francis Hendrie Memorial Collection. 1966.165

Georges Braque, like Juan Gris, developed a less complex and flatter geometry in his later cubist paintings. He also revived his interest in the tactile character of painting. In this still life, paint has been applied in thin, dull washes which bring out the texture of the canvas and in thick, glossy glazes decorated with incised patterns.

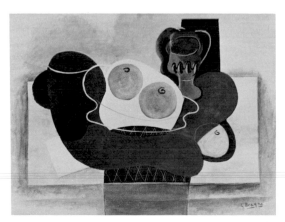

Paul Klee (1879-1940), Swiss, *Palace, Partially Destroyed (Palast, teilweise zerstört),* 1926. Watercolor, ink on paper. Sheet 65 x 50 cm. Signed upper right, dated lower left. Charles Francis Hendrie Memorial Collection. 1966.170

During his ten years at the Bauhaus, Klee experimented with the cognitive potential of vertical, horizontal, and curvilinear elements. He was concerned not only with their use in creating illusions of volume and space, but also with the perception of their instrinsic meanings. In the upper half of this painting, Klee has arranged these elements in evenly colored or textured units to suggest a solid architectural structure. The chaotic disruption of them in the lower portion prompts the viewer to imagine the partial collapse of the palace referred to in Klee's title. The painting may have been inspired by Sir Arthur Evans's archaeological description published in 1921 of the catastrophe that befell the ancient Minoan palace at Knossos on the island of Crete.

Ben Nicholson (b. 1894), English, *St. Ives,* 1951. Pencil drawing over casein on masonite. 41.6 x 43.8 cm. Signed and dated reverse. Gift of Miss Caroline Hunter. 1965.156

The harbor of St. Ives in Cornwall was a frequent theme in Nicholson's work in the early 1950s, a period when he was also producing the still lifes which brought him international recognition. In this view of St. Ives, as in the still lifes, Nicholson makes use of a very muted palette and a postcubist series of interlocking planes and lines.

Paul Klee (1879-1940), Swiss, *Specter of a Genius (Gespenst eines Genies),* 1923. Oil on gessoed paper. Sheet 53 x 34.4 cm. Signed lower right, dated bottom margin. Charles Francis Hendrie Memorial Collection. 1966.212

In 1921 at the invitation of Walter Gropius, Klee joined the Bauhaus as a painter. This wonderfully gnomelike self-portrait reflects his growing self-confidence as both a teacher and a creative artist. Rendered as an abstract caricature, the figure is a striking example of Klee's ability to express psychological and emotional attitudes. The frontal stance and tilted head convey a sense of cocky self-assurance, which is tempered by endearing whimsical touches, such as the wisps of hair and the starry eyes.

Piet Mondrian (1872-1944), Dutch, *Blue, White, and Yellow,*
c. 1930. Oil on canvas. 45.1 cm. sq. Signed and dated
lower right. Charles Francis Hendrie Memorial Collection.
1966.185

Early in his career, Piet Mondrian departed from the tenets
of cubism to develop a completely nonrepresentational
style which he called "neoplasticism." The series of
paintings produced between 1929 and 1932 is the simplest
statement of this style, which places total emphasis on the
tensions and balances between a limited set of visual
elements arranged in a two-dimensional pattern. Each
painting varies in its configuration of horizontal and vertical
components and in the relationship of the three primary
colors—red, yellow, and blue—plus black and white.

Max Ernst (1891-1976, b. Germany), French, *Time and
Duration,* 1948. Oil on canvas. 76.2 x 102 cm. Signed and
dated lower right. 1949.28

By emphasizing the exploration of subconscious
experience, the French surrealist movement gave artists
an increased freedom to develop new techniques, as well
as images, for making art. Max Ernst invented several
unusual techniques for releasing his subconscious
impulses and relaying them to canvas, including a rubbing
technique called *frottage* and a manipulative method of
paint application called *calcomanie.* These were among
the methods used by Ernst to realize the active organic
forms and otherworldly coloration in this imaginary
landscape painted during his postwar residence in Arizona.

American Art

Colonial decorative arts, displayed in handsome period rooms, and late 19th and early 20th century painting constitute the largest sections of this collection, which also contains paintings, sculpture, prints, and drawings representing all major periods in American art before 1945. Art of the American West, as well as paintings from the Taos and Santa Fe school, are other areas of concentration.

During the museum's formative years, its limited American holdings shared exhibition space with European works. In the 1930s, funds from the Helen Dill Bequest enabled the museum to purchase several significant paintings, among them Winslow Homer's powerful *Two Women by the Sea,* John Marin's *Sun and Gray Sea,* and Walt Kuhn's *Young Clown.* It was after World War II that the present strengths of the collection became firmly established.

In 1948 the National Society of Colonial Dames in the State of Colorado launched the colonial collection by presenting the museum with a suite of three rooms from the Georgian-style Russell House, built in 1772 in Providence, Rhode Island. Prior to installation, the woodwork of the suite—a parlor, dining room, and hall with stairwell—had to be painstakingly stripped of 28 layers of paint to reveal the crisp, elegant carving.

The rooms provide the setting for a large portion of the museum's decorative arts collection, notable for its examples of 18th century Newport and Providence

Arthur Fitzwilliam Tait (1819-1905, b. England), *Trappers at Fault, Looking for Trail,* 1852. Oil on canvas. Signed and dated lower right. 91.4 x 127.7 cm. Helen Dill Collection. 1955.86

Arthur F. Tait first encountered the American West when he assisted George Catlin with his Indian Gallery exhibition in London and Paris. In 1850, Tait immigrated to America, establishing studios in New York and the Adirondacks, where he painted the mountain scenery. Although he never journeyed beyond Chicago, his encounter with Catlin, his fascination with the West, and his own vivid imagination led Tait early in the 1850s to create a series of paintings of frontier life. Many of them were published by Currier and Ives under the title *Life on the Prairie.* The popularity of these colored lithographs, as well as his Adirondack scenes, made Tait one of the best-known artists of his time.

craftsmanship. Outstanding are a side chair and highboy in the graceful Queen Anne style, a finely proportioned and inlaid Hepplewhite sideboard, and a porringer made by Rhode Island silversmith Jonathan Clarke. The Mabel Y. Hughes Charitable Trust, like the Society, has made major contributions toward the development of this collection.

In 1952 the Society added authentic reproductions of a bedroom and kitchen of the period to the Russell House rooms. While the bedroom and its appointments reflect the economic prosperity of successful sea merchants like William and Joseph Russell, the kitchen is of the family-room type found in rural houses. Its informal furnishings suggest the variety of activities that would have taken place there—cooking, weaving, sewing, quilting, soap and candlemaking, bookkeeping, reading, and, on occasion, school teaching.

In 1963 the Society again made a substantial gift to the museum by donating the fireplace, floor, and woodwork from an early 18th century house, which has been set up as a cabinetmaker's sample room to display the small-scale furniture collection given by Mr. and Mrs. Wayne Stacey and other donors. The carefully executed miniatures were used as models by 18th century cabinetmakers to secure commissions for full-scale furniture.

The painting collection grew at a steady pace during the 1950s. Gifts from Charles Bayly Jr. added Mary Cassatt's *Mother and Child* and a *Peaceable Kingdom* by Quaker artist/preacher Edward Hicks to the holdings. Other significant contributions from private donors were William Bradford's luminist arctic landscape, Marsden Hartley's *Bright Breakfast of Minnie,* a cubistic-style still life, and a fine idyllic landscape by Thomas Cole, founder and leading painter of the Hudson River school.

By the 1950s, the collection had reached sufficient size and scope to warrant the establishment of a separate American Art Department. Major gifts from Marion G. Hendrie in that decade and T. Edward and Tullah Hanley in the 1970s brought particular richness to the late 19th and early 20th century holdings. In addition to works by Thomas Hart Benton and Georgia O'Keeffe, Miss Hendrie's gift included Yasuo Kuniyoshi's *Upstream,* which exhibits the soft colors and flattened shapes typical of his early work. Numbered among the Hanley Collection are Thomas Sully's *Lost Child,* a Martin Johnson Heade painting of red roses in a glass, and Homer's vibrant watercolor *Indian Boy with Canoe.* The American collection also boasts impressionist works by Willard Metcalf, J. Alden Weir, and John Twachtman.

Because of its location in the heart of the Rocky Mountain region, the museum takes special interest in art of the American West. The days of discovery and settlement

come to life in paintings by Peter Rindisbacher and Alfred Jacob Miller, one of the first professional artists to depict scenes of life in the Rockies. Works by Albert Bierstadt, William Jacob Hays, A.F. Tait, and James Walker, who vividly portrayed life among the Spanish vacqueros in California, offer other images of the Old West. Frederic Remington's *The Cheyenne*, probably the artist's first sculpture cast by the lost-wax method, is one of several bronzes in the collection.

Recent gifts have added watercolors by Edward Borein and an oil by Bert Phillips to the holdings. Paintings by Peter Hurd, Charles Graham, and Frank Mechau present more contemporary views of the western scene. Among paintings by artists of the Taos and Santa Fe school are several works by Andrew Dasburg. The museum has been fortunate to secure from numerous private and corporate collections long-term loans of western art, which are displayed with the permanent collection.

Hall, Russell House, Providence, Rhode Island, 1772.
9.76 x 2.44 m. Gift of the National Society of Colonial
Dames in the State of Colorado. 1948.28

This outstanding example of American colonial
architecture was built in the Georgian style for prosperous
sea merchants William and Joseph Russell. The original
house was the first three-story structure in Providence.
Although the architect is unknown, he probably used
Battey Langley's 1740 architectural handbook, *Builder's
Compleat Assistant,* as a guide for the decorative details,
including the Palladian window and hallway arch. The
Denver suite comprises the reassembled original
paneling, woodwork, and balustrade from the parlor, dining
room, hall and stairwell. Other rooms from the house are
preserved in the Brooklyn Museum and the Minneapolis
Institute of Arts. The appointments assembled by the
Society over several decades include furniture, silver, and
other decorative arts in the Queen Anne, Chippendale,
Sheraton, and Hepplewhite styles popular between 1770
and 1810. The Society has added a bedroom and country
kitchen of the period to the Russell House rooms.

Queen Anne side chair, Newport, Rhode Island, 1740-1750.
Mahogany. 1.04 m. h. Mabel Y. Hughes Charitable Trust
Fund. 1979.62

Furniture made in Colonial America often followed English
styles. First introduced in England during the reign of
Queen Anne (1702-1714), the style bearing her name was
popular in this country from 1725 to 1780. Its hallmark was
a simplicity derived from an elegant combination of curved
forms like those of the cabriole legs seen here. This
example displays the New England preference for circular
pad feet on the front legs although the flat stretcher is rare
in Rhode Island chairs.

Hepplewhite sideboard, Rhode Island, 1790-1800. Mahogany, satinwood. 1.01 m. h. Purchased in memory of Wayne Stacey: Estate of Maude A. Braiden, Mrs. Thomas Day, Mabel Y. Hughes Charitable Trust Fund, Walter C. Mead Collection, National Society of Colonial Dames in the State of Colorado, Mr. and Mrs. Alex Warner, and general acquisition funds. 1974.18

During the early Federal period, American cabinetmakers drew upon English pattern books for their designs. Among these was *The Cabinet-Maker and Upholsterer's Guide,* published by George Hepplewhite's widow in 1788, which introduced the sideboard, a new furniture form credited to Robert Adam. Standing on square, tapered legs characteristic of the Hepplewhite style, this sideboard exemplifies furniture made in Rhode Island during the 18th and early 19th centuries. The simple refinement of the decoration, a result of Quaker influence, contrasts with the elaborate ornamentation produced in Boston, another New England center of fine cabinetmaking.

Jonathan Clarke (1705?-1770), porringer, Rhode Island, c. 1760. Silver. 4.9 cm. h. Maker's mark on underside of handle. Mabel Y. Hughes Charitable Trust Fund. 1979.2

Because colonists regarded silver as visible evidence of status, the fine art of silversmithing advanced more rapidly in America than painting, sculpture, and architecture. For the most part, American silver closely followed contemporary English fashions. The porringer, a small bowl with a single handle traditionally decorated with an openwork design, was among the first silver objects commonly produced in the colonies. This beautiful example was made by Jonathan Clarke, one of the leading 18th century silversmiths working in Newport and Providence.

Samuel Hamlin (1746-1801), mug, Providence, Rhode Island, 1780-1795. Pewter. 15.3 cm. h. Maker's mark to left of handle at top. Wayne Stacey Memorial Fund and Mabel Y. Hughes Charitable Trust Fund. 1977.38

Pewter, an inexpensive metal alloy whose better grades could be polished to a high luster, was commonly used for utilitarian objects such as tableware, teapots, candle molds, and organ pipes. The finest New England pewter was produced in Boston and the Rhode Island centers of Newport and Providence. Unlike silver, whose styles it often imitated, pewter was not considered an investment or a status symbol. In fact, because it could be easily melted down and reused, old or damaged pewter was often turned in for replacement by objects in the newest style. Designed with classic simplicity, this mug was made by one of the finest pewterers in Providence.

Thomas Cole (1801-1848, b. England), *Dream of Arcadia,*
1838. Oil on canvas. 99.7 x 160.5 cm. Signed and dated
lower left. Gift of Mrs. Katherine H. Gentry. 1954.71

Although born in England, Thomas Cole became the
founder and foremost member of the Hudson River school
of American landscape painting. By 1825 he had become
an established landscape painter, creating sublimely
dramatic views of the Hudson River and the Catskill and
White mountains. A trip to Italy in the early 1830s exposed
him to the more open Italian countryside, the beauty of
classical ruins, and the romantic and ideal landscapes of
Salvator Rosa and Claude Lorrain. *Dream of Arcadia,*
which combines idyllic Olympian concepts of ancient
Greece with a vast picturesque landscape, is a superb
example of Cole's idealistic style. In the more realistic
paintings preferred by his patrons, Cole developed the
atmospheric effects which launched the mid-19th century
luminist movement.

Thomas Sully (1783-1872, b. England), *The Lost Child,* 1837.
Oil on panel. 69 x 54.1 cm. Signed and dated lower left.
T. Edward and Tullah Hanley Collection. 1974.412

Best known for his elegantly polished portraits of prominent
political and social figures, Sully was also the creator of
appealing genre paintings of children. Here, with dramatic
chiaroscuro, the artist has portrayed the child's plight with
affective sentimentality. Sully was brought up in
Charleston, South Carolina, and settled in Philadelphia in
1809. Like most young American painters of his time, he
went to study in London and visited Benjamin West. He
was most strongly influenced, however, by the romantic
portrait style of Sir Thomas Lawrence.

Edward Hicks (1780-1849, b. Pennsylvania), *The Peaceable
Kingdom,* 1847. Oil on canvas. 60.9 x 86.4 cm. Signed and
dated on stretcher. Charles Bayly Jr. Collection. 1954.236

In 1820 Quaker folk artist and preacher Edward Hicks
painted his first peaceable kingdom scene, a subject
which has become identified with his name and which
takes its theme from Isaiah 11:6, "And the wolf also shall
dwell with the lamb, and the leopard shall lie down with the
kid; and the calf and the young lion and the fatling together;
and a little child shall lead them." Hicks painted over 50
versions of this scene, a symbolic representation of
Quaker beliefs and of Hick's role of preacher. As he did
here, Hicks frequently included messages of historical
significance, particularly scenes of William Penn signing
his peace treaty with the Indians.

Peter Rindisbacher (1806-1834, b. Switzerland), *A Party of Indians,* 1822-1826. Watercolor on paper. 21.3 x 27.2 cm. Signed lower right. Gift of Mr. and Mrs. Samuel Gary. 1971.500

An important figure in the pictorial history of the American West, Peter Rindisbacher recorded life in Manitoba and the northern American plains at least ten years before Karl Bodmer, George Catlin, and Alfred Jacob Miller. Unlike his more famous counterparts, who visited the West for limited periods to paint native ways, Rindisbacher lived year round among the settlements, forts, and tribes which he depicted with vivid accuracy. Characterized by fine draftsmanship and precision, his work is all the more astonishing when one realizes that much of it, like this watercolor of Assiniboine Indians, was produced when he was between the ages of 15 and 20.

Alfred Jacob Miller (1810-1874, b. Maryland), *The Indian Guide,* n.d. Pen, ink, gray wash on paper. 22.6 x 27.6 cm. Gift of Mr. and Mrs. John B. Bunker and Lemon Saks. 1966.109

Alfred Jacob Miller was among the earliest professional artists to record the western scene and the first to visit the Rocky Mountains. He studied first with Thomas Sully and later at the Ecole des beaux-arts in Paris where he undoubtedly saw works by romantic painters such as Delacroix and Chassériau. In 1837 he accompanied the Scots nobleman Captain William Drummond Stewart on an expedition to the Rockies, following what later became the Oregon Trail. Miller's lively sketches of western life and mountain scenery, as well as his large dramatic paintings based on them, heralded the romantic western landscape tradition established later by Albert Bierstadt and Thomas Moran.

William Bradford (1823-1892, b. Massachusetts), *Whalers Working through the Ice on the Coast of Greenland under the Midnight Sun,* after 1860. Oil on canvas. 61 x 101.8 cm. Gift of Miss Louise Iliff. 1959.73

Luminist painter William Bradford was noted for his picturesque arctic seascapes, as well as his scenes of the New Bedford harbor. Like his contemporary Frederic Church, Bradford accompanied several expeditions to the Arctic. Rendered with characteristic precision of draftsmanship, this scene captures the rosy luminosity of sunlight reflected off the polar ice, an atmospheric effect which became increasingly common in Bradford's paintings of the 1870s and 1880s. A low horizon and an expanse of ice or water marked by a succession of flat, receding planes were devices frequently employed by luminist painters.

George Caleb Bingham (1811-1879, b.Virginia), *Portrait of Preston Roberts* and *Portrait of Agnes McGargill Roberts,* c. 1860. Oil on canvas. Mr. Roberts: 102.8 x 81.9 cm. Mrs. Roberts: 102 x 81 cm. Gift of Flaminia Odescalchi Kelly in memory of her grandparents Charles MacAllister Willcox and Marie dePazza Roberts Willcox. 1974.274, 1974.15

George Caleb Bingham is best known for his superb genre paintings of everyday life on the Missouri and Mississippi rivers. After trying his hand at portraiture in Missouri, Bingham studied briefly at the Pennsylvania Academy of the Fine Arts and then spent several years in Washington, D.C., painting well-known public figures. Returning to the frontier in 1844, he began producing genre scenes, such as *Fur Traders Descending the Missouri* and *The County Election,* in the monumental style which established his reputation. The luminist clarity of these works gradually gave way to a more painterly style probably enhanced by study at the Düsseldorf Academy in the late 1850s. These portraits display the directness and monumentality of Bingham's genre scenes, but the background setting suggests the influence of his European experience. Preston Roberts, a Missouri shipping magnate, was active in the staging business which carried mail to the West and Southwest. He established the first express lines to Pueblo and Canon City, Colorado.

Jasper Francis Cropsey (1823-1900, b. New York), *Chenango River, North of Sherburne,* 1858. Oil on canvas. 38.3 x 61.2 cm. Signed lower left. Thomas Barnes Knowles Memorial Fund and Volunteer Benefits Fund. 1977.83

Initially trained as an architect, Cropsey also studied painting and eventually became one of the most popular members of the Hudson River school. His favorite subjects were autumnal pastoral landscapes, whose rich colors indicate the influence of Thomas Cole. With the realism characteristic of his style, Cropsey has here depicted a late summer farm scene along the Chenango River in upstate New York.

Martin Johnson Heade (1819-1904, b. Pennsylvania), *Red Roses in a Glass,* 1880s. Oil on canvas. 41.9 x 26 cm. Signed lower right. T. Edward and Tullah Hanley Collection. 1974.419

One of the masters of luminism, Heade is the only major 19th century American painter known equally well for his landscapes and still lifes. His paintings of flowers ranged from romantic Victorian bouquets of the 1860s to the glowing magnolia series done around 1890. Red roses in a clear glass were a favorite subject for 30 years. In these paintings Heade combined luminist techniques with a naturalist's close observation to capture the essence of his subject.

Worthington Whittredge (1820-1910, b. Ohio), *The Foothills, Colorado,* 1870. Oil on paper. 29.8 x 50.2 cm. Signed lower left. Gift of the Houston Foundation in memory of M. Elliott Houston and by exchange. 1969.160

A prominent second-generation member of the Hudson River school, Whittredge is best known for his quiet landscapes depicting the dark, lush vegetation and sunlit pools of the Catskill Mountains. In 1870, accompanied by luminist painters J. F. Kensett and Sanford Gifford, Whittredge made the second of three journeys to the West. Influenced by the ideas of his companions, Whittredge adopted several of their techniques in his Colorado scenes. This horizontal composition of the Front Range foothills displays an atmospheric gradation of light and precision of texture characteristic of luminism.

James Walker (1819-1889, b. England), *Cowboys Roping a Bear,* 1877. Oil on canvas. 75.8 x 126.7 cm. Signed and dated lower right. Fred E. Gates Fund. 1955.87

James Walker is known for his dramatic battle scenes of the Mexican and Civil wars and his colorful depictions of the Spanish-American cowboys of California. An extended trip to South America and southern California provided Walker with material for his vivid paintings, which also display his particular interest in details of costume. Bear roping, a subject painted more than once by Walker, was a favorite pastime of the cowboys, who delighted in showing off their prowess against these formidable predators.

Albert Bierstadt (1830-1902, b. Germany), *Rocky Pool, New Hampshire,* c. 1860. Oil on canvas. 47.9 x 65.7 cm. Signed lower right. Gift of Albert J. Gould. 1974.301

In 1858 Albert Bierstadt, a Düsseldorf-trained landscape painter of the Hudson River school, joined an expedition to the Rocky Mountains. Following the same route taken 21 years earlier by Alfred Jacob Miller, he sketched and photographed the scenic wonders of the vast western landscape. Expanding his romantic Hudson River style to the huge scale he felt appropriate to the majesty of the West, Bierstadt painted panoramic canvases based on his on-the-spot sketches and photographs. Although his fame rested on these lofty vistas, Bierstadt's fine draftsmanship and careful observation of nature are perhaps more apparent in this eastern woodland scene.

John La Farge (1835-1910, b. New York), *Portrait of a Young Boy,* 1860-1862. Oil on canvas. 53.4 x 40.8 cm. Helen Dill Collection. 1937.3

The son of wealthy French émigrés, John La Farge had a cosmopolitan interest in art. Like his teacher, William Morris Hunt, he studied in Paris with Thomas Couture and was an admirer of the Barbizon school. During the 1860s, when this sensitive portrait was painted, La Farge was producing superb floral still lifes reminiscent of Fantin-Latour, as well as works in the Barbizon style. From 1876 to 1890, he concentrated on designing murals and stained glass, one of his first commissions being the interior decoration of Boston's Trinity Church in collaboration with architect H.H. Richardson and sculptor Augustus Saint-Gaudens.

Winslow Homer (1836-1910, b. Massachusetts), *Two Figures by the Sea,* 1882. Oil on canvas. Signed and dated lower right. 50.2 x 88.9 cm. Helen Dill Collection. 1935.8

In the early part of his career, Winslow Homer, one of America's most significant painters, created a colorful record of American country life. His artistic direction changed radically, however, in 1881 when a two-year sojourn in a North Sea village near Tynemouth brought him face to face with the reality of existence wrested from the sea. He spent the rest of his life at Prout's Neck on the rugged Maine Coast, where he painted, at first, the eternal struggle between man and the sea and, later, the primal relationships between the elements themselves. Instead of showing human beings as subordinate to nature, Homer endowed his figures, like these two Tynemouth fisherwomen, with a size and substance that makes them worthy antagonists of the forces of nature.

Winslow Homer (1836-1910, b. Massachusetts), *Indian Boy with Canoe,* 1895. Watercolor on paper. 29 x 50.7 cm. Signed "W. H." lower right, dated lower left. T. Edward and Tullah Hanley Collection. 1974.417

Even during his reclusive years in Prout's Neck, Homer took annual hunting and fishing trips to Quebec, the Adirondacks, and the Caribbean, where some of his freshest and most colorful paintings were made. One of the first American artists to use watercolor for finished pictures, as well as sketches, Homer also abandoned the pale, linear style of the English tradition. This sketch of an Indian boy in Quebec exemplifies the vibrant colors, free brushwork, and bold washes which have since dominated American watercolor painting.

William Harnett (1848-1892, b. Ireland), *Still Life with The Telegraph,* 1880. Oil on canvas. 36.2 x 50.9 cm. Signed and dated lower left. Gift of Roland G. Parvin. 1949.14

American *trompe-l'oeil* painting reached its high point in the art of William Harnett. The meticulous care and attention to detail which distinguishes Harnett's work undoubtedly derived in part from his early training as a silver engraver. This painting is one of a major series done between 1873 and 1880 depicting arrangements of pipes, stoneware jugs, and newspapers. Not widely appreciated in its own time, Harnett's work was rediscovered in the late 1930s and is now highly regarded as an important development in the history of illusionistic painting.

Willard L. Metcalf (1858-1925, b. Massachusetts), *The Ten Cent Breakfast,* 1887. Oil on canvas. 38.2 x 55.9 cm. Signed and dated lower right. T. Edward and Tullah Hanley Collection. 1974.18

Willard Metcalf was a member of the American impressionist group known as The Ten. Like fellow painters John Twachtman, Theodore Robinson, and Childe Hassam, he studied at the Académie Julian in Paris during the 1880s and was influenced by the French impressionist movement. In this picture, Metcalf has portrayed his friends sharing a breakfast with Scottish writer Robert Louis Stevenson at Giverny, site of Monet's famous home and gardens. Painted in dark, earthy tones, this fine example of his preimpressionist style shows an interest in interior light reminiscent of some of Van Gogh's work in the Dutch tradition.

J. Alden Weir (1852-1919, b. New York), *Danbury Hills,* 1908. Oil on canvas. 60.5 x 86.1 cm. Signed lower right. Charles Francis Hendrie Memorial Collection. 1928.1

J. Alden Weir received his early artistic training from his father, a drawing instructor at the United States Military Academy who numbered Whistler among his students in the early 1850s. He later studied in Europe with Jean-Léon Gérôme and Julien Bastien-Lepage, an early advocate of plein-air painting. He also came in contact with the impressionist painters and developed a particular admiration for Manet and Whistler. By the 1890s, Weir's experiments with impressionist techniques resulted in landscape paintings like this scene of the Connecticut countryside. With John Twachtman, Weir was one of the principal organizers of the first exhibition of The Ten in 1898.

Mary Cassatt (1845-1926, b. Pennsylvania), *Mother and Child,* n.d. Pastel on paper. 57.2 x 40.6 cm. Signed lower right. Charles Bayly Jr. Collection. 1953.36

Mary Cassatt is known for her portrayals of women in everyday life. The daughter of a well-to-do Pittsburgh businessman, she settled in Paris after several years of study at the Pennsylvania Academy of the Fine Arts and in Europe. Degas, who became her lifelong friend and mentor, invited Cassatt to exhibit with the impressionists in 1877. His influence is revealed in the fine draftsmanship and composition of her mature style, but her strong sense of pattern and use of flat areas of color derive from Japanese prints. Cassatt produced many rich pastels and prints in addition to her paintings.

Alfred Maurer (1868-1932, b. New York), *Head,* c. 1931. Watercolor on paper. 54.6 x 45.7 cm. Signed lower right. Purchased with gift from Mrs. Ethel H. Lundin in memory of Marilee Lundin Kitzrow. 1977.43

After studying briefly at the Académie Julian, Alfred Maurer remained in Paris, where he soon achieved success with his decorative, academic-style paintings. In 1904, as a friend of Gertrude and Leo Stein, he began to meet avant-garde artists and was particularly inspired by Matisse. His landscape paintings of the period, which used the vivid, arbitrary colors advocated by the fauves, were exhibited in New York by Stieglitz and included in the Armory Show. By the time he returned to the United States in 1914, he was experimenting with cubism. Fauvist color and cubist techniques are combined in this painting, one of many strong images of heads produced by Maurer between 1920 and 1931.

John Marin (1870-1953, b. New Jersey), *Sun and Gray Sea,* 1928. Watercolor on paper. 43.2 x 55.7 cm. Signed and dated lower right. Helen Dill Collection. 1938.16

A leading 20th century watercolorist, John Marin trained as an architect before entering the Pennsylvania Academy of the Fine Arts in his 28th year. During five years in Paris, he was little influenced by avant-garde movements, but in 1909 he came to the attention of Alfred Stieglitz, who exhibited his work at the famous gallery 291 and also introduced him to Cézanne's late watercolors and Picasso's early cubist work, influences reflected in Marin's Armory Show entries. His unique adaptation of cubist techniques is best seen in his Maine watercolors of the 1920s, paintings which capture the essence, as well as the structure, of the landscape.

Arthur B. Davies (1862-1928, b. New York), *Three Masks,* 1920/21. Oil on canvas. 71.2 x 58.5 cm. Museum Associates Purchase Fund. 1978.173

Arthur B. Davies is closer in style to the symbolists and pre-Raphaelites than to the European modernists although modernist influences, like the early expressionism of *Three Masks,* sometimes appear in his work. A member of The Eight, the first group of painters to rebel against the conservative taste of the National Academy of Design, Davies was also one of the organizers of the controversial 1913 International Exhibition of Modern Art, better known as the Armory Show.

Walt Kuhn (1877-1949, b. New York), *Young Clown*, 1932. Oil on canvas. 76.2 x 63.5 cm. Signed and dated lower right. Helen Dill Collection. 1935.12

Walt Kuhn played an active and influential role in the New York art world during one of its most exciting and turbulent periods. With Arthur B. Davies and painter-critic Walter Pach, Kuhn was a major organizer of the 1913 Armory Show, which had considerable impact on his own artistic development. Abandoning his early impressionist style, he experimented with cubist and expressionist techniques, gradually arriving at his mature style of the 1920s and 1930s. During this period he painted powerful images of circus figures in boldly outlined, monumental frontality. Kuhn regarded these clowns and acrobats, masked in their make-up, as symbols of man's fate, his bravado and essential loneliness.

Gaston Lachaise (1882-1935, b. France), *Portrait of Marie Pierce,* 1935. Nickel-plated bronze. 36.8 cm. h. Signed and dated lower left on back. T. Edward and Tullah Hanley Collection. 1974.423

A leader of the American avant-garde movement in the 1930s, Gaston Lachaise had emigrated to the United States in 1906 because he felt it was "the most favorable place to develop as an artist." Over the next 20 years he evolved his mature style, best exemplified by bronzes of lavishly proportioned, monumental female nudes. In this striking portrait head, Lachaise has made unusual use of nickel plating to create a masklike surface.

Marsden Hartley (1877-1943, b. Maine), *The Bright Breakfast of Minnie,* c. 1915. Oil on cardboard. 67 x 56 cm. Gift of Morton D. May. 1952.51

Hartley was one of the American painters most receptive to European modernism. In 1912, with the assistance of Stieglitz and Arthur B. Davies, he went to Paris where he studied cubism. A year later, attracted by the work of Kandinsky and the German expressionists, he moved to Germany, exhibiting with the Blue Rider group and in the New York Armory Show. During his German residency, which lasted until 1916, Hartley produced the paintings that many consider his most exciting work. The ship image in this cubistic painting recalls Hartley's Down East origins: the Maine landscape was a persistent theme in his art, particularly in the more naturalistic paintings of his later years.

Georgia O'Keeffe (b. 1887, Wisconsin), *Petunia and Glass Bottle*, 1924. Oil on canvas. 51.5 x 26 cm. Signed on back. Charles Francis Hendrie Memorial Collection. 1966.44

Georgia O'Keeffe's work exhibits a highly personal style characterized by a simplification and precision of forms, a flat, rhythmic patterning, and subtle gradations of color. Her first important works were exhibited in 1916 at 291 by Alfred Stieglitz. During the 1920s, she painted geometric New York scenes, landscapes, and a series of magnified, sensuous flower forms. This painting is typical of her approach to form and color. In 1929 O'Keeffe visited Taos, New Mexico, and returned each summer until 1949 when she settled permanently near the village of Abiquiu. The southwestern landscape, with its mountains, canyons, bleached bones, and vast spaces, has been the inspiration for much of her art.

Andrew Dasburg (1887-1979, b. France), *Portrait of Cecil,* c. 1926. Oil on canvas. 101.4 x 65.7 cm. Signed lower center. Art Americana Purchase Fund. 1975.5

Although he has long been associated with New Mexico and contemporary southwestern American art, Andrew Dasburg was in every sense an international artist. Strongly influenced during his Paris years by Cézanne and Matisse, he developed the unique linear cubistic style evident in the paintings he created between 1918 and 1937. Unable to work for several years because of illness, he resumed an active career in 1944 and produced numerous paintings, drawings, and lithographs until the time of his death. The subject of this portrait, Cecil Clark Wolman, was a sculptor who lived and worked in Santa Fe.

Yasuo Kuniyoshi (1893-1953, b. Japan), *Upstream,* 1922. Oil on canvas. 76.7 x 60.8 cm. Signed and dated lower left. Charles Francis Hendrie Memorial Collection. 1973.56

Emigrating from Japan to Seattle in 1906, Yasuo Kuniyoshi first studied art in Los Angeles. In 1916 he moved to New York, where he attended the Art Students League as a pupil of social realist painter Kenneth Hayes Miller. *Upstream* is typical of Kuniyoshi's paintings from the 1920s, which humorously depict flattened images of people, landscape, animals, and flowers.

Frank Mechau (1904-1946, b. Kansas), *Saturday P.M.,*
c. 1942. Tempera on board. 76.8 x 91.6 cm. Signed lower
left. Gift of the Allied Arts. 1952.52

Frank Mechau's work is a striking modern documentation
of the Old West. Growing up in Glenwood Springs,
Colorado, Mechau absorbed legends of prospectors,
cowboys, and pioneers and fell deeply in love with the
landscape. His mature style represents a distinctive blend
of cubist and surrealist influences, acquired during a 1929
visit to Paris, and a strong graphic line and sense of
composition derived from Chinese and Japanese painting.
Some of Mechau's best-known works are panoramic
murals executed for the WPA's Federal Art Program during
the 1930s. In *Saturday P.M.,* he has imaginatively captured
the excitement of the big night in a small western town.

Thomas Hart Benton (1889-1975, b. Missouri), *Retribution,*
1923/24. Oil on paper. 45.7 x 30.5 cm. Charles Francis
Hendrie Memorial Collection. 1973.223

Although he studied at the Académie Julian in Paris for
three years, Thomas Hart Benton ultimately rejected
European modernism in favor of American rural realism.
In 1919 he embarked on a ten-year project entitled *The
American Historical Epic,* a series of paintings which
depicted the history, folklore, and daily life of rural
America. This small oil sketch is a study for one of Benton's
large paintings in the series.

Edward Borein (1872-1945, b. California), *Indian Warriors,*
1920-1930. Watercolor on paper. 24.4 x 37.5 cm. Signed
lower right. Gift of Michael B. Howard. 1977.58

Edward Borein, like his close friend Charles M. Russell,
was a working cowboy and a self-taught artist who created
a rich visual record of the Old West. He sold his first
sketches to a Los Angeles publisher in 1896 and by 1909
was a successful illustrator for magazines such as
Harper's, Collier's, and *Western World.* Borein is
particularly well known for his watercolors of horses,
cowboys, cattle, and Indians. Some of his finest work in
this medium was produced in the 1920s and 1930s.

Contemporary Art

The first permanent gallery for display of the museum's collection of contemporary art was not opened until April 1980 although works by living artists were central to the museum's role from its first days. The eleven charter members of the Artists' Club, forerunner of the Denver Art Museum, were all professional artists, and their earliest official activity was the inauguration of an annual juried exhibition limited to entries "not before publicly exhibited in Denver." Between 1894 and 1973, despite limited funds and exhibition space, the museum sponsored a series of 74 juried and invitational exhibitions open primarily to artists working west of the Mississippi. Many of these *Western Annuals,* as they came to be called, included purchase awards which brought to the museum a small nucleus of contemporary American works. In 1950, the museum organized the first of 22 *Denver Metropolitan* exhibitions to provide an annual showcase for local artists, and, beginning in 1973, a series of *Colorado Annual* exhibitions offered recognition to artists throughout the state.

With the opening of the new building in 1971, the museum began to collect contemporary art actively, thanks in large part to the encouragement and support of major collectors like Kimiko and John Powers, Carol Schwartz, and Mr. and Mrs. Edward M. Strauss. Through private gifts and government grants, including the first of four National Endowment for the Arts purchase grants, the department

Jim Dine (b. 1935), American, *Colour of the Month of August (Painting Pleasures),* 1969. Acrylic on canvas with mixed media collage. 2.19 x 2.52 m. National Endowment for the Arts Purchase Fund, Hilton Hotel Corporation, Albert A. List Foundation, Inc., Alliance for Contemporary Art, and anonymous donors. 1979.334a-h

Although Jim Dine played a major role in the reaction against abstract expressionism that led to the pop art movement, his concerns shifted in the mid-1960s from dehumanized and commercial pop imagery to a painterly expression of personal and poetic feelings associated with objects. Following the lead of Johns and Rauschenberg, Dine has thoroughly explored the esthetic possibilities of combining objects and painting into a single entity. In this work, one of Dine's finest, he has succeeded in uniting a luscious surface, which recalls the energy and spirit of abstract expressionism, with a collage of articles related to his feelings about the process of making art.

acquired important works by Larry Bell, Vance Kirkland, Frank Stella, and George Rickey, whose kinetic sculpture *Two Lines Oblique Down, Variation III* was the first object installed in the outdoor sculpture garden. The graphics collection received a boost with the addition of prints by other artists of national stature like Jasper Johns, Robert Motherwell, Claes Oldenburg, Fritz Scholder, and Robert Rauschenberg.

In 1976, the Board of Trustees adopted a resolution to "expressly dedicate a specific and substantial percentage of . . . accession funds for the next five years to the acquisition of contemporary American art." While a search began for a full-time curator, the museum's associate director, Lewis Story, continued to pursue an increasingly fruitful acquisition program: William Wiley's *Hound Harbor Series* and Sam Gilliam's *Abacus Sliding* were among the major purchases of the next two years. During this period, through a grant from the General Services Foundation, works by such "old masters" of photography as Ansel Adams, Edward Weston, and Imogen Cunningham established the basis for a strong photography collection. Meanwhile, the burgeoning collection continued to be displayed only when gallery or wall space was temporarily available.

With the financial assistance of the Albert A. List Foundation, Inc., the museum appointed Dianne Perry Vanderlip as its first full-time curator of contemporary art in 1978, and the acquisition program was accelerated. Through the continued support of the NEA, private and corporate donors, and special support groups, important works by Red Grooms, Lucas Samaras, Ann McCoy, Larry Poons, Charles Fahlen, Chuck Forsman, Katherine Porter, Jim Dine, and Christopher Wilmarth joined the collection. The department expanded its photographic holdings with examples of new directions in photography, particularly color work by such artists as John Baldessari, Jan Groover, David Haxton, Harry Callahan, and JoAnn Callis.

The increased generosity of private collectors accounted for a host of other acquisitions: paintings by Allan D'Arcangelo, Willard Midgette, and Ben Schonzeit; sculpture by Jack Zajac and Tony Delap; an important ceramic vessel by Richard DeVore; portfolios of photographs by Gary Winogrand, Robert Adams, and Manuel Bravo; and prints and multiples by Richard Lindner, George Segal, Sam Francis, Adolf Gottlieb, Lee Krasner, and others.

The inauguration of the Herbert Bayer Archive in 1980 made accessible to scholars and the general public paintings, sculpture, drawings, prints, and photographs by the versatile Bayer, as well as memorabilia and general archival material. Currently on long-term loan to the

museum, the archive will eventually become part of the permanent holdings.

Because the explosive growth of the collection demanded a permanent exhibition space, the museum assigned the Schleier Gallery of the Bach Wing to the exclusive use of the Contemporary Art Department in April 1980. Objects on view are periodically changed to give as much exposure as possible to the collection and to display new works as they are acquired. Long-term loans of recent major works by nationally prominent artists often supplement the exhibition. A separate gallery, made possible by a grant from Jesse and Nellie Shwayder, Inc., is devoted entirely to exhibiting the photography collection, with works on view changing at scheduled intervals.

Kay Sage (1898-1963), American, *A Little Later,* 1938. Oil on canvas. 91.6 x 71.3. Signed and dated lower right. Estate of Kay Sage Tanguy. 1964.80

Painted by Sage during a brief stay in Paris, this work typifies avant-garde sensibilities of the period immediately prior to World War II. While the clarity of form and precise rendering recall the hard-edge machine esthetic prevalent in the 1920s, the enigmatic juxtaposition of egg-like shapes and machine or architectural elements derives from surrealist delight in visual ambiguities of form and meaning. The title, too, is typically surrealist in its mystery. An American by birth, Sage was married to the French surrealist painter Yves Tanguy.

Herbert Bayer (b. 1900, Austria), American, *Chromatic Gate,* 1969. Oil on canvas. 2.03 x 1.52 m. Signed lower left. Gift of Marcor Housing Systems, Inc., Denver. 1971.96

Herbert Bayer has explored and mastered virtually every field in the visual arts. After studying architecture for two years, he entered the Bauhaus in 1921, first as a student and then as a teacher of typography and graphic design. By the time he left Germany in 1938, he had introduced one of the first sans-serif typefaces and produced an important body of paintings and photographs. In 1946, he was chosen by Walter Paepke to develop a complete architectural and graphic scheme for converting the old mining town of Aspen, Colorado, into a center for humanistic studies. Over his long career, Bayer's work has evolved from strong surrealist images to clear statements of form and color. This painting is one of a series of chromatic works inspired by a trip to Morocco.

Rico Lebrun (1900-1964, b. Italy), American, *Figures on the Cross with Lantern,* 1950. Oil on masonite. 2.44 x 1.23 m. Signed and dated lower left. Charles Bayly Jr. Fund. 1957.111

Painter, sculptor, and printmaker Rico Lebrun was born in Italy and moved to the United States in 1924. After working several years in New York as an advertising artist, Lebrun joined the Walt Disney studios as an expert on animal anatomy, an experience which greatly influenced the development of his mature style. Begun in 1947, the Crucifixion series, which eventually numbered more than 200 paintings and drawings, was conceived as a succession of cinematographic frames. Like this example, the paintings are basically monochromatic and possess a baroque sense of drama, as well as an almost morbid surrealism.

Robert Beauchamp (b. 1923), American, untitled, 1967. Oil on canvas. 1.73 x 2.22 m. Signed lower right. Gift of Lawrence Shainberg. 1972.23

A second-generation member of the New York school, Denver-born Robert Beauchamp studied under abstract expressionist painter Hans Hofmann. Although he worked in an abstract period, Beauchamp is one of America's most talented figurative artists, a creator of highly disturbing but fascinating images. As in this painting, his work often blends nightmarish surrealist images with gaudy expressionist color and abstract expressionist techniques of paint application.

Vance Kirkland (1904-1981), American, *Vibrations of Cadmium Scarlet on Rose Red,* 1967. Oil on canvas. 1.88 x 3.51 m. Signed and dated lower left. Gift of Carol Schwartz. 1974.71

Images of energy in outer space have been a continuing theme in the work of Vance Kirkland, a seminal figure in the development of painting in the Denver area. This painting is part of a series, produced between 1964 and 1973, of vibrations of color in outer space. Sensations of intergalactic or subatomic energy are achieved through dots of vivid color; moreover, the large scale and absence of perspectival references liberate the image from any sense of physical gravity or substance. The result is a chromatic dance of charged particles, a constantly undulating optical space, suggesting quantum forces existing beyond our immediate world.

Morris Graves (b. 1910), American, *Coonemara Pooka (Life Size)*, 1955. Oil on masonite. 86.4 x 121.9 cm. Signed and dated lower right. Gift of Mr. and Mrs. Richard S. Shannon Jr. 1972.70

Morris Graves is one of the great mystical artists of our time. Primarily self-taught, he studied briefly with Mark Tobey after several years of working on mail ships bound for the Orient. Tobey's work and his own interest in oriental painting and Zen Buddhism led Graves to evolve a style unique for its blend of precise draftsmanship, deft calligraphic strokes, and misty washes, as well as its mythological, often mysterious content. In this fanciful painting, realism and fantasy are fused in a highly personal manner to create the image of the pooka, a mythical bison of Irish origin, noted for its intelligence and stamina. In Irish folklore, the pooka is a mischievous, but not malevolent, goblin that haunts bogs and marshes.

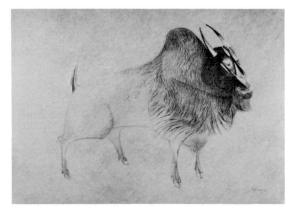

Sam Gilliam (b. 1933), American, *Abacus Sliding,* 1977.
Polymer pigment on canvas. 2.29 x 3.05 m. Signed and
dated upper left reverse. National Endowment for the Arts
Purchase Fund and United Bank of Denver. 1978.10

Sam Gilliam was first recognized for his large, brilliantly
colored, draped canvases which, though obviously
sculptural, were related to the color-field painting of Morris
Louis and Kenneth Noland. This painting is among the first
of a new group of stretched canvas works by Gilliam which
emphasize an even more extravagant use of color and
texture. Building up the painted surface with thick dapples
of black over an intensely colored ground, Gilliam forms
compact geometric areas within the painting by applying
strips of similarly treated canvas. These nearly obscured
rectangles create a focal point for the complex surface.

Larry Poons (b. 1937), American, *Pablo Creek,* 1979.
Acrylic on canvas. 2.83 x 2.95 m. National Endowment for
the Arts Purchase Fund, Hilton Hotel Corporation, Alliance
for Contemporary Art, and anonymous donors. 1979.333

A leading second-generation color-field painter, Larry
Poons studied music before turning to art. A subsequent
class with avant-garde musician John Cage introduced
him to methods of random composition that had a lasting
influence on his later painting. During the 1960s, Poons
created optical paintings with round or elliptical spots
placed on grids over a field of pure saturated color. As he
gradually abandoned the use of grids, the spots took on
the appearance of blurs speeding across the canvas. Early
in the 1970s, Poons began a remarkable series of poured-
paint canvases, including *Pablo Creek.* In addition to using
traditional methods of color application, the artist has
spattered, poured, and flung paint onto the canvas. This
element of flowing paint links Poons with artists like
Pollock, Frankenthaler, Louis, and Olitski.

Allan D'Arcangelo (b. 1930), American, *Constellation #15,*
1970. Acrylic on canvas. 1.53 m. sq. Signed and dated
middle reverse. Gift of Mr. and Mrs. Edward M. Strauss.
1979.70

As a major figure in the pop art movement of the 1960s,
Allan D'Arcangelo was known for his flat, hard-edge
paintings of highways and highway symbols. Toward the
end of the decade, he began to select specific elements
from this imagery—a dotted highway line, a striped
construction barrier—and abstract them into highly
geometric forms which, though still flat and hard-edge,
focus on perspective and the creation of of illusionistic
space. This painting is a superb example of the precise
and articulate pictorial style on which D'Arcangelo's
continuing reputation as an important painter rests.

Chuck Forsman (b. 1944), American, *On Lookout Mountain*, 1976. Oil on masonite. 1.07 x 1.57 m. Signed and dated lower left reverse. National Endowment for the Arts Purchase Fund, Hilton Hotel Corporation, and Colorado Dye and Chemical Corporation. 1979.44

Colorado resident Chuck Forsman examines the nature and nuances of the western landscape by reducing it to its essential character. Focusing on light, scale, and texture, he captures his environment in a pointillistic impasto. When viewed from a distance, the small bits of saturated color, which flicker across this canvas in a mosaic pattern, heighten the intensity of the motorcycle's shadow. Forsman, like many contemporary artists, incorporates in his work devices of perspective and paint application traditionally used by landscape and still life painters.

Dan Christensen (b. 1942), American, *Mira,* 1969. Acrylic on canvas. 2.66 x 2.07 m. Gift of Steve Schapiro. 1976.173

Color-field painting, in which the viewer experiences the optical sensation of flat areas, or fields, of pure color, originated in the early 1950s with artists such as Barnett Newman and Mark Rothko. Exploring this mode in the late sixties, Dan Christensen sprayed looping lines of subtly modulated color against vaporous washes to create the effect of glowing ribbons of light.

Katherine Porter (b. 1941), American, *When Alexander the Great Wept by the Riverbank Because There Were No More Worlds to Conquer, His Distress Rested on Nothing More Substantial Than the Ignorance of His Mapmaker,* 1977. Oil on canvas. 2.13 x 2.35 m. National Endowment for the Arts Purchase Fund, Dayton Hudson Foundation, and Target Stores. 1978.115

Although gridlike structures derived from the hard-edge abstraction of the 1960s are common in Katherine Porter's early work, even then she employed a brushy application of lush, thick paint. In this example of her current painting, Porter uses the grid as an unseen device to unify the geometric shapes and grafittilike strokes which float independently of each other within the picture plane. At the same time, she both confines and enhances the central composition with a richly colored pattern border. Porter was one of the first contemporary painters to use this decorative technique.

Willard Midgette (1937-1976), American, *Red Dawn Princess,* 1976. Oil on canvas. 2.75 x 3.2 m. Gift of Donald B. Anderson. 1979.226

Until his untimely death, East Coast artist Willard Midgette pursued a painting style well outside the mainstream of contemporary art by investigating an esthetic that would allow him to combine a representational expression of the human situation with a formal expression of the spatial problems of painting. Midgette successfully achieves this in *Red Dawn Princess,* part of a Bicentennial suite of paintings about American Indians completed after a visit to Arizona and New Mexico. Midgette provocatively conveys the psychological distance between the Indian culture and ours by placing the realistic figures of self-conscious Navajo girls with their veiled expressions against an artificial, two-dimensional scrim of Monument Valley.

Jerry Kunkel (b. 1944), American, *II-VIII,* 1975. Acrylic on unstretched canvas. 2.13 x 2.44 m. National Endowment for the Arts Purchase Fund, Dayton Hudson Foundation, and Target Stores. 1978.81

Jerry Kunkel, whose work embraces a variety of styles and media, has been an influential artist and teacher in Colorado ever since his arrival in 1969. In this painting he has imposed a personal sensibility on a purely formal structure. The rough, often sketchy quality of the brush strokes gives a feeling of spontaneity to their calculated repetition.

Ben Schonzeit (b. 1942), American, *Continental Divide,* 1975. Two panels, acrylic on canvas. Each panel 2.14 m. sq. Gift of Robert Mulholland. 1979.282ab

Working from photographs taken on a trip to the Rocky Mountains, New York painter Ben Schonzeit created this remarkable superrealistic panorama for *America 1976,* a Bicentennial exhibition organized by the Department of the Interior. Although he renders the rugged terrain of each side of the continental divide with clinical detachment and accuracy, Schonzeit also manages to convey a feeling for and of the landscape.

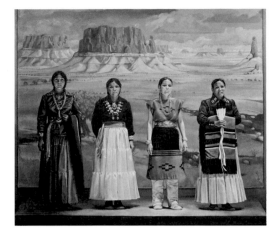

Lucas Samaras (b. 1936, Greece), American, *Reconstruction #20,* 1977. Sewn fabric. 2.21 x 2.16 m. National Endowment for the Arts Purchase Fund, Dayton Hudson Foundation, Alliance for Contemporary Art, Mr. and Mrs. Edward M. Strauss, Mr. and Mrs. Donald S. Graham, and anonymous donors. 1979.1

Born in Greece, Lucas Samaras spent his first eleven years in a world colored by the art, ritual, and Byzantine splendor of the Greek Orthodox Church. This extraordinary fabric painting is from a series of *Reconstructions,* begun in 1977, which recall childhood images and were created in homage to his mother. Employing quilt-making techniques, Samaras has assembled strips and bits of brightly colored fabrics to form a dazzling image that includes references to cubism, action painting, grids, patterns, and pop art.

Charles Fahlen (b. 1939), American, *Easy On,* 1978. Wood, paint, masonite. 268.2 x 225 x 12.7 cm. Signed and dated on reverse. National Endowment for the Arts Purchase Fund, Dayton Hudson Foundation, and Target Stores. 1978.109a-c

In the early part of his career, San Francisco-born Charles Fahlen concentrated on printmaking, studying with Stanley William Hayter in Paris and at the Slade School in London. By 1967, however, he had turned his creative energies toward sculpture, often playfully satirizing artistic theories of earlier generations. While *Easy On* appears to have the precision and logic of a constructivist work, a closer glance reveals a geometry consciously thrown off balance and fine, tasteful craftsmanship lavished on materials more often found in a hardware store than in an artist's studio.

Frank Stella (b. 1936), American, *Warka I,* 1973. Mixed media construction. 2.34 x 2.43 m. National Endowment for the Arts Purchase Fund and anonymous donors. 1974.77

Prior to 1970, Frank Stella was noted primarily for the total abstraction of his black paintings, the introduction of shaped canvases, and his explosively colored Protractor series. Since then, he has created a distinctive new body of work in three major series which explore abstraction through the creation of relief constructions. *Warka I* is from the first series, called Polish Village constructions. Named after small villages in Russia and Poland, these works pay homage to the Russian constructivists, particularly Malevich and Tatlin. They rely on tight, dynamic planar reliefs to probe the intellectual nature of abstraction while incorporating all the eccentricities of color, shape, and material that characterize Stella's development in the 1970s.

William T. Wiley (b. 1937), American, *The Hound Harbor Series,* 1977. Four-part mixed media construction. Pastel painting on unstretched canvas, 107.3 x 46.9 cm.; acrylic and ink painting on stretched canvas, 200.1 x 292.2 cm.; charcoal drawing on parchment, 76.2 x 104.1 cm.; triangular floor construction with found objects, 63.5 x 243.9 x 236.3 cm. Signed and dated in journal; canvases and drawing signed. National Endowment for the Arts Purchase Fund and Volunteer Benefits Fund. 1978.22.1-47

Since the 1960s, William Wiley has been the leader of northern California's Bay Area school, a group which focuses on autobiographical art and delights in creating enigmatic layers of meaning. Here, Wiley has ingeniously combined three-dimensional objects with stretched and unstretched canvas paintings and a traditional drawing to achieve a work rich in personal humor and iconography. Included are references to friends and familiar locations, as well as tapes of the wind and old sea chanteys, all of which visually and aurally describe the artist's relationship to Hound Harbor.

Red Grooms (b. 1937), American, *William Penn Shaking Hands with the Indians,* 1967. Enamel on plywood. 205.7 x 292.1 x 45.7 cm. Signed and dated lower left. National Endowment for the Arts Purchase Fund, Mr. and Mrs. Edward M. Strauss, Mr. and Mrs. Donald S. Graham, William Copley, and anonymous donors. 1979.9ab

Among the finest artists associated with pop art and happenings, Red Grooms typically creates environmentlike works from brightly painted plywood cutouts. Combining fantasy and broad humor, his art most often deals with images of contemporary culture and society. One of Grooms's early plywood constructions is this wonderfully irreverent take-off on Benjamin West's famous painting of William Penn solemnizing his treaty with Indians. It was especially created for an exhibition held in Philadelphia, the city Penn founded in the 1680s.

247

Suzanne Anker (b. 1946), American, *Alluvial Number Seven,* 1977. Cast paper. 1.07 x 1.63 m. National Endowment for the Arts Purchase Fund and Volunteer Benefits Fund. 1978.12

Handmade paper as object, as well as process, has been a growing concern of contemporary artists like Suzanne Anker, a Colorado artist who has been working in this medium for several years. With its reference to the sediment deposited by flowing water, the title evokes the actual process Anker uses in casting paper works. The effect created in this three-dimensional wall hanging—that of layers torn away to reveal a corrugated texture— suggests plaster peeling from a wall. Anker has achieved remarkably subtle color gradations ranging from white to warm beige with occasional hints of pink.

Richard DeVore (b. 1933), American, vessel, 1977. Ceramic. 41.1 cm. h. Gift of Exhibit A Gallery, Chicago. 1979.10

Colorado artist Richard DeVore has been instrumental in establishing contemporary pottery as a valid means of formal esthetic expression. A master of understatement with clay, DeVore creates vessels that are deceptively simple at first glance. Closer viewing reveals that what appears to be a casually expressed form is, in fact, carefully calculated to create a specific focus. An edge, a curve, a line, a subtle yet definite change in surface combine to give his objects a perfection that is deeply moving without ever being obvious or overbearing.

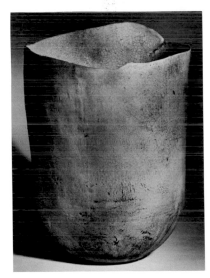

Donald Judd (b. 1928), American, untitled, eight-part sculpture, 1968. Stainless steel. Each unit 1.21 x 1.21 x 1.21 m. Gift of Kimiko and John Powers. 1976.205a-h

Critic and sculptor Donald Judd is a leading figure in the development of minimal art, an esthetic position which this work exemplifies. Using basic geometric forms and industrial materials and techniques, Judd aims for a totally objective art free of personal expression and involvement. Although the entire work spans 39 feet, it does not overwhelm the viewer because each unit is physically comprehensible on a human scale. Despite the severity of form, the impeccable manufacture of the cubes and the wavering patterns of reflected light create a sensuosness that eliminates any impression of harshness in the work.

Jack Zajac (b. 1929), American, *Big Skull and Horn in Two Parts III,* 1962. Cast bronze. 92.7 cm. h. Anonymous gift. 1978.154

This beautifully patinated bronze is Zajac's third work in the *Big Skull and Horn in Two Parts* series. Influenced by visits to the Southwest, Zajac frequently draws on skeletal organic themes for his images, which gain an essential vitality through his skillful handling of material.

George Rickey (b. 1907), American, *Two Lines Oblique Down, Variation III,* 1970. Stainless steel, edition 2/8. 6.4 m. h. 1972.66.

A leader in the field of kinetic sculpture, George Rickey began his career as a painter, studying with cubists André Lhote and Fernand Léger and purist Amédée Ozenfant. He made his first mobile in 1945. Drawing on the esthetic traditions of the constructivists, Rickey utilizes spare, reduced forms, light-reflecting metal strips, and small rotors in his sculpture. Activated by the slightest current of air, the delicately balanced "arms" in this example continually create new forms in space.

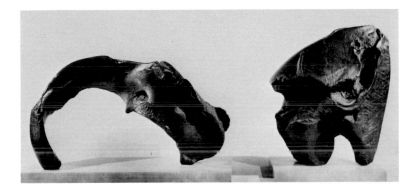

Arshile Gorky (1905-1948, b. Turkish Armenia), American, *Nighttime Enigma and Nostalgia,* 1931-34. Ink and crayon on paper board. 69.3 x 101.6 cm. Gift of Mr. and Mrs. Samuel Gary. 1968.26

Gorky came to the United States in 1920, where he became known as a pioneer of abstract expressionism and as the primary translator of European movements into the new American modernism. *Nighttime Enigma and Nostalgia* is from a series of 20 drawings produced during the lean depression years. Each drawing consists of an interlocking complex of abstract biomorphic figures whose psychologically compelling shapes defy identification.

John Altoon (1925-1969), American, *ABS-78,* 1963. Pastel and ink on construction board. 1.54 x 1.01 m. Purchased with gift from Alliance for Contemporary Art. 1980.66

Much admired in Los Angeles as an eccentric underground artist, John Altoon achieved national recognition shortly before his death at age 44. He is now best known for those works produced between 1962 and 1968 in which he transcended the dictates of abstract expressionism to establish a vigorous personal style. While the biomorphic shapes in this beautifully colored abstract scheme recall Gorky, the work possesses a spontaneity and energy that is pure Altoon. With delightful lyricism, he manipulates his figures into the appearance of human confrontations.

Andy Warhol (b. 1931), American, *Electric Chair,* 1971. Silkscreen, edition of 250. 90.2 x 122 cm. Signed lower right reverse. 1978.11.1

Pop artist Andy Warhol is a master at creating images which compel us to consider the social, political, economic, and religious aspects of our society. Using the commercial silkscreen process to produce multiples of famous personalities or products sold in supermarkets, Warhol emphasizes the impersonal, unfeeling, machine-made quality of our culture in an anonymous manner that often cloaks the basic morbidity of many of his subjects. Here, he forces the viewer to look beyond the abstract presentation of the object and contemplate the full range of meanings associated with it.

Tom Wesselmann (b. 1931), American, *Great American Nude,* 1976. Color lithograph, edition 70/75. 57.2 x 76.2 cm. Signed and dated center bottom. Volunteer Benefits Fund. 1977.86

Like Andy Warhol and other pop artists in the 1960s, Wesselmann produced images of supermarket products executed in the manner of commercial billboard still lifes although he maintained a traditional structure in his compositions. During the late sixties, Wesselmann began to concentrate on the erotic subjects which have become his best-known and most-admired works. The idea for the series of prints, drawings, and paintings of the *Great American Nude* came to him following a dream about the colors of the American flag. In recent years Wesselmann has focused on the social implications of modern technology as he continues to illustrate the ills, as well as the pleasures, of our society.

Claes Oldenburg (b. 1929, Sweden), American, *Alphabet Good Humor Bar,* 1970. Lithograph, edition 92/250. 73.7 x 50.8 cm. Signed and dated lower right. Gift of Kimiko and John Powers. 1975.10

A pivotal figure in the development of happenings and pop art in the 1950s and 1960s, Oldenburg is best known for his amazing ability to transform everyday objects, such as a Good Humor bar, into metaphors for power. Consistent with his habit of creatively examining each possible permutation of a single concept, he further developed this theme into an *Alphabet Good Humor Bar,* which he produced in various media—drawings, watercolors, prints, and both studio and monumental sculpture. This version, the poster image for an Oldenburg exhibition at London's Tate Gallery, was reproduced as a signed, limited-edition lithograph at that time.

Robert Motherwell (b. 1915), American, *Pauillac #1,* 1973. Embossed color lithograph with paper collage, edition 2/92. 91.8 x 60.7 cm. Signed lower right. General acquisition funds and Dale Mathis. 1976.37

The acknowledged American master of collage, Robert Motherwell was the youngest member of the original New York abstract expressionists. Best known for his monumental *Elegy to the Spanish Republic* series, Motherwell combines painterly elements and pure geometry rendered in a palette of "natural" colors—ocher, black, white, and an exquisite range of blues. In *Pauillac #1* he has used a single line of "Motherwell blue," an azure hue that has become as identifiable as "Matisse pink." The real French wine label evokes good times and discerning tastes, while the work itself suggests a world of reserved sensualism and dignified elegance.

Ann McCoy (b. 1946), American, *Sea Serpents: Tractatus Aristoteles* (one part illustrated), 1978. Three-part, hand-colored lithograph, printer's proof. Each part 75 x 104.2 cm. Signed and dated lower right. National Endowment for the Arts Purchase Fund, Hilton Hotel Corporation, and Alliance for Contemporary Art. 1979.89.1-3

Ann McCoy's art is both a reflection and a function of the human psyche. Influenced by the Jungian concept of archetypes, McCoy endeavors to strike a responsive chord in the viewer through an imagery based on the dreams and myths of shared subconscious experience. Because the sea merges with the heavens in these prints, it is sometimes difficult to distinguish one from the other, as wondrous creatures and symbols float around in a fairy-tale world.

Jasper Johns (b. 1930), American, *Decoy II,* 1971-1973. Color lithograph, edition 29/31. 105.1 x 74.9 cm. Signed and dated lower right; publisher's seal lower left. National Endowment for the Arts Purchase Fund, Albert A. List Foundation, Inc., Mr. and Mrs. Thomas E. Congdon, Mr. and Mrs. Samuel Gary, and William M. White. 1974.19

Jasper Johns is considered among the most important contemporary printmakers, as well as a significant painter. *Decoy II,* published by Tatyana Grosman, is not only a landmark in the use of offset lithography, but also Johns's most complicated print in terms of technique and imagery. Printed on a hand-fed press using one stone and twenty-five plates, the image presents common objects and words in such a dematerialized fashion that the viewer is provoked to draw on memory, as well as perceived reality, in trying to determine its meaning.

Fritz Scholder (b. 1937), American, *Indian at the Bar,* 1970, from *Indians Forever,* 1970/71. Lithograph, edition 34/75. 76.2 x 55.9 cm. Signed lower right. 1973.53h

Native American Fritz Scholder is noted for his unromantic, nontraditional portrayal of the American Indian. After studying with Wayne Thiebaud, Scholder participated in the Rockefeller Foundation's Southwest Indian Art Project, a program designed to train young Indian artists, and later taught at the Institute of American Indian Arts in Santa Fe. During his years at the Art Project, Scholder began to introduce into his completely abstract paintings images reflecting his Indian heritage. Printed by the Tamarind Institute, this lithograph from a suite of eight entitled *Indians Forever* is one of his strongest images. In its grotesque vitality, it is the antithesis of the many idealized ''noble savage'' representations produced in the past few decades.

Man Ray (1890-1976), American, untitled, 1943. Rayogram. 35.6 x 28 cm. Signed and dated lower left. Gift of Mr. and Mrs. Walter Maitland. 1976.13

A member of the dadaist circle and particular friend of Marcel Duchamp, Man Ray began experimenting in the early 1900s with lensless photographic methods. In typical dadaist fashion, he accidentally discovered that objects placed directly on unexposed photographic plates created an immediate photographic image when exposed to light. These images became known as "rayograms." In this 1943 example, Ray uses strong contrasts and abstract patterns of shadowy gray tones to achieve a dramatic three-dimensional effect.

Edward Weston (1886-1958), American, *Shell,* 1927. Black and white photograph. 23.6 x 18.6 cm. General Service Foundation Purchase Fund. 1976.5

As a leading proponent of "pure" photography, Edward Weston insisted upon realism of subject and purity of technique to arrive at a photograph which would capture "the very substance and quintessence of the thing itself." His uncanny talent for obtaining the maximum impact from the simplest elements is typified in his classic images of shells, nudes, vegetables, and commonplace objects. *Shell* is an important illustration of Weston's sharp and penetrating comprehension of form.

Imogen Cunningham (1883-1976), American, *Magnolia Flower,* 1925. Black and white photograph. 25.1 x 32.5 cm. Signed and dated lower right. 1975.16

After studying chemistry at the University of Washington, Imogen Cunningham mastered the techniques of photography by working for two years as an apprentice to the noted photographer Edward S. Curtis. A member of the influential f/64 group in San Francisco, she shared with Edward Weston and Ansel Adams an interest in simple, straightforward photographic techniques. *Magnolia Flower,* one of Cunningham's most admired photographs, exemplifies her concern with the study of forms and her direct, honest approach to the spiritual essence of her subject.

Ansel Adams (b. 1902), American, *Moonrise, Hernandez, New Mexico,* 1944. Black and white photograph. 39.8 x 48.7 cm. Signed lower right. General Service Foundation Purchase Fund. 1975.20

Ansel Adams, a founding member of the f/64 photographic group and an influential writer on the techniques and esthetics of photography, established his reputation as an artist with the dramatic and architectonic vision of the natural environment recorded in his superb photographs. Desiring to make the perfect photograph through an absolute control of the process, Adams developed the zone system, a method of analyzing exposure and development so that the final print is conceived before the film is exposed. The system creates a predetermined structure of tones produced with ultimate clarity of detail.

Harry Callahan (b. 1912), American, *Untitled (Providence, R.I.),* 1977. Color photograph. 28 x 35.6 cm. Signed lower left. General Service Foundation Purchase Fund. 1978.42

Long recognized as a leader in the development of photography as an art form, Harry Callahan is particularly noted for his innovative work with high-contrast images and his exploration of time and space concepts by means of multiple exposures. Most recently he has turned his camera to the study of urban architectural forms. *Untitled (Providence, R.I.)* is part of a serial portrayal of the typical New England frame house; the series is Callahan's first color photography work.

Diane Arbus (1923-1971), American, *Identical Twins, Cathleen and Colleen, Members of a Twin Club in New Jersey,* 1966, from *Diane Arbus: A Box of Ten Photographs,* published 1971. Black and white photograph, edition of 50. 36.9 x 37.5 cm. Signed reverse "Doon Arbus" (artist's daughter). 1975.13.10

Diane Arbus is noted for her acutely observed photographs of ordinary and bizarre subjects—twins, midgets, nudists, circus people, transvestites—which invite comparison between what is considered unusual and what is accepted as normal. At first glance the photograph reproduced here presents a typical family album image of two appealing little girls. Closer examination suggests that, far from relishing their "darling twins" status, the girls perhaps are contemplating devilish acts of mischief, an unsettling realization which makes the viewer question the reality of appearances.

Jan Groover (b. 1943), American, untitled, 1977. Three-part color photograph. Each part 48.3 x 33 cm. General Service Foundation Purchase Fund. 1978.45

This photographic triptych is part of the Georgetown series Groover began in 1974. Influenced by minimalist artists like Sol Lewitt, Robert Mangold, and Jennifer Bartlett, she combines their reductive style of composition with a shifting focus on reality. In this work she depends on serial pictures of trees and lawns, houses and columns, porches, stairs, and architectural ornaments to explore complex spaces and images. Unlike the straightforward approach of Weston or Ansel Adams, Groover takes the viewer on a tour of her subject, sometimes showing a panorama, sometimes changing scale to focus on a peculiar shadow within the panorama, but always maintaining the context of reality.

Robert Adams (b. 1937), American, *Enjoying the Wind, East of Keota,* 1969. Black and white photograph. 19 cm. sq. Gift of the artist. 1980.76.11

Over a ten-year period, Robert Adams produced a group of 50 photographs which create a compelling visual essay on the Colorado prairie. His starkly beautiful images in the Prairie series convey his deep empathy for the lonely, challenging life of prairie dwellers, the hope and vulnerability symbolized by spare, isolated buildings, and the empty expanse of the rural landscape vanishing into the horizon. This work is one of the few from the series to include the human figure—in this instance Adams's wife, Kerstin, obviously enjoying the sensuous wonder and eloquent mystery of the prairie.

264

Textiles and Costumes

The Textiles and Costumes Department, which includes approximately 8,000 objects, is the museum's second largest. With the exception of material that falls under the custody of the Native Arts Department, its holdings come from all areas of the world and range from pre-Columbian and Coptic fragments to contemporary costumes. Nationally recognized for its superb American quilts and coverlets dating from the late 18th to the 20th century, the department also boasts significant examples of Chinese and Peruvian textiles and embroidery. The costume collection is particularly rich in American clothing after 1850.

A fine Kashmir shawl and a Saltillo serape, given to the museum in 1927, were the first textiles to enter the collection. Since that time, a continuing flow of gifts, bequests, and purchases has brought the department to its present prominence. Much of the credit for its scope and quality belongs to Lydia Roberts Dunham, its first curator, who served from 1951 to 1965. Mrs. Dunham convinced the museum of the importance of preserving textiles as an art form years before many museums considered collecting them.

During the 1950s and 1960s the museum received major donations of quilts and coverlets from Charlotte Jane Whitehill, S. Effie Parkhill, and Mrs. Frederic H. Douglas. These gifts included fine examples of pieced, appliquéd, and crazy quilts, as well as woven coverlets. One of the most widely exhibited objects in the collection is a pieced

Dragon robe, China, Qing dynasty, 1875-1900. Silk and gold threads on silk tapestry. 1.37 m. l. at center back. Gift of James P. Grant and Betty Grant Austin and museum purchase. 1977.196

The production of dragon robes, long embroidered silk garments worn by Chinese royalty, courtiers, and officials, reached its high point during the Qing dynasty (1644-1912). The embroidery was designed to enhance the beauty of the silk, a highly valued fabric which originated in China over 4,000 years ago. *Kesi,* the tapestry weave used in this fabric, was the most precious of all silk weaves. The yellow color and nine embroidered, five-clawed dragons—traditional requisites for imperial robes—indicate that this sumptuous garment was created for the emperor. The 12 symbols placed across the back, front, and shoulders of the robe proclaim the emperor's role as Ruler of the Universe.

quilt depicting a scenic view of the Matterhorn. Among recent acquisitions are a rare stenciled quilt and a Hawaiian quilt with an unusual two-color design. A catalog published in 1974 illustrates 80 representative examples from the collection.

The Julia Wolf Glasser Collection of over 100 samplers, donated by Mr. and Mrs. Raymond L. Grimes in memory of Mrs. Grimes's mother, came to the museum in 1965. Outstanding among them is a late 18th century English sampler stitched by 10-year-old Sarah Webb. The museum also holds an extensive collection of laces documenting all the major lace-making centers of Europe.

Chinese silks and embroideries constitute an important area of the collection. In 1977 its scope was significantly enlarged by the acquisition of the Charlotte Hill Grant Collection of Chinese Court Costumes, a group of over 500 objects from the Qing dynasty. Assembled by Mrs. Grant during her 16-year residency in Peking after World War I, the collection includes magnificent Imperial Court robes and accessories, as well as lengths of embroidered, uncut yardage. In part a gift from Mrs. Grant's children, James P. Grant and Betty Grant Austin, the collection is featured in a catalog published in 1981.

The museum takes pride in its Peruvian holdings, which illustrate all Peruvian techniques of textile manufacture and decoration and include an ancient embroidered Paracas burial mantle and Tiahuanaco plush caps, as well as colonial tapestries. The collection also contains examples of featherwork and a rare Chancay fabric tree.

Major strengths of the costume collection are English and American bridal dresses spanning 150 years from 1830 to the present and a large group of elegant American gowns from the last quarter of the 19th century. Fashioned from rich velvets and brocades and lavishly trimmed, these costumes reflect the influence of European design and the growing opulence of American taste. Accessories form a significant part of the collection; selections of lingerie, gloves, millinery, fans, shoes, shawls, lorgnettes, and opera glasses are usually on view.

In 1962 Meyer, Bernita, and Myron Neusteter made a substantial gift to the museum to be used for sponsoring exhibitions, furthering research and publication, increasing library facilities, and acquiring important examples of costumes and textiles. These funds, together with additional gifts from the Neusteter family, enabled the museum to purchase some of the finest pieces in the collection, including a Persian silk fragment of the Buyid dynasty, 16th and 17th century Chinese embroideries, important Peruvian fabrics, and 18th century English, French, and Italian costumes.

Another resource of the department is its excellent slide and reference library, available to students and scholars. Generous donations from The Fashion Group, Inc., Denver Regional Group, have increased its holdings in recent years.

In order to protect fragile fabrics and to give as much exposure as possible to the extensive collection, exhibits are changed on a regular basis. A representative selection of quilts and coverlets is always on view, and other areas of the collection are featured in a continuing series of exhibitions. Certain textiles and costumes related to other curatorial divisions are displayed in those departments. Thus, many Peruvian examples can be found in the New World Art Department; tapestries are on view on the European floor; and oriental rugs, Persian fabrics, and Chinese embroideries are exhibited with the Asian collection.

Inscribed shroud fragment, Egypt, c. 1500 BC. Ink on linen. 33.2 cm. I. Gift of the Denver Public Library. 1962.121b

This piece of inscribed linen dating from the time of Thutmose I is one of three fragments in the museum's collection believed to have come from a mummy shroud. During this period the Egyptians abandoned their earlier practice of writing important chapters from the *Book of the Dead* on burial chamber walls and began inscribing such texts on shrouds. The earliest known fabrics are linen, a material woven for thousands of years by the Egyptians, who considered its source, flax, to be the cleanest cultivated plant and therefore an appropriate raw material for burial goods.

Woven fragment, Iran, Buyid dynasty, late 10th/11th century. Silk. 20.4 cm. sq. Neusteter Institute Fund. 1964.7

Because they represent major technical and stylistic changes, textiles from the Buyid period (932-1055) are among the most important known Persian fabrics. A simplification of the draw-loom, which was used to produce figured textiles, allowed craftsmen to weave intricate geometric patterns, as well as the curvilinear designs to which they had been previously limited. In this silk twill fragment, typical of Buyid fabrics, the natural-colored background sets off the silhouette of the darker brown, double-headed eagle; the triangular wings are bounded by inscribed borders. Another piece of the fabric is in the Textile Museum, Washington, D.C.

Coptic tapestry fragment, Egypt, 6th century. Linen. 45.7 x 25.4 cm. Neusteter Institute Fund. 1967.11

Coptic textiles, with their symmetrical compositions and vivid colors, are considered some of the world's finest examples of tapestry weaving. The Christian Copts often retained pagan imagery in their art. Here, the central image is surrounded by four kneeling representations of Eros, the Greek god of love, and by baskets of flowers, symbols of fertility. Equestrian images appeared frequently in Coptic textiles. The central figure in this fragment probably represents a king about to strike something, perhaps an animal, with the whip held in his upraised hand.

Woven fragment, Iran, Isfahan, Safavid dynasty, 16th century. Silk. 30.5 cm. I. Neusteter Institute Fund. 1965.5

Notable for its perfection of design and technique, silk weaving during the Safavid dynasty (1499-1736) became the most important industry in Persia, with skilled weavers being granted a social prestige rarely extended to artisans. Encouraged by Shah Tahmasp (1524-1576), himself a designer of rugs, court painters achieved new refinement and sophistication in the designs they produced for woven fabrics. Figural subjects based on Persian history and legend were popular for silk robes commonly worn by dignitaries. In Isfahan, from which this fragment is thought to have come, skilled craftsmen often used as many as 30 shuttles on a single loom to produce a length of brocade.

Mogul sash (detail), India, Benares, late 17th/early 18th century. Silk with gold thread. 50.8 x 210.9 cm. with fringe. Neusteter Institute Fund. 1967.56

Mogul court sashes (patkās) were both decorative and practical. Wrapped several times around the waist so that the ornamental ends hung down in front, patkās served as carriers for personal possessions such as daggers, pens, and thumb rings. A typical sash bore narrow borders of floral vine motifs, and the ends were embellished with bands of floral designs woven in gold damask or brocade. Prior to the 17th century, patkās were made of fine cotton, but under Jahangir, the fourth Mogul emperor (1605-1627), court sashes made from opulent materials became de rigueur. Many of the sashes were probably made in the royal workshops of Gujarat, which employed some 4,000 silk weavers.

Rug, Turkey, Hereke, c. 1890. Silk with gold and silver threads. 3 x 1.73 m. with fringe. Anonymous gift. 1973.111

During the 19th century, Hereke, a small town on the Sea of Marmora east of Istanbul, was famous for the manufacture of silk rugs commissioned for European palaces and grand hotels. The rugs were also popular with American tourists, who purchased them in smaller sizes like this example. The unique character of the rugs derives from their designs, which Hereke artisans copied from those of Kirman weaving instructors brought to Turkey by the Sultan. While Persian motifs predominate, the Hereke versions have a stylized and rectangular character, and floral elements are arbitrarily arranged to achieve color masses rather than to create a naturalistic effect.

Embroidered wall hanging, China, Qing dynasty, 1821-1850. Gold and silver bullion threads on silk damask. 2.75 x 3.66 m. Gift of Dr. Arnold L. Tanis. 1974.216

The dragon, long regarded as the king of animals throughout China, was especially popular during the Qing dynasty (1664-1912). Not only was it the principal design motif for the robes of courtiers and officials, but, as the symbol of the country and the emperor, it appeared on coins and the national flag. Worked entirely in gold and silver threads on a deep blue ground, the dragon is depicted here in three sections with its nine resemblances; both nine and three were lucky numbers. The phoenixes on either side of the dragon are symbols of the empress. The superb workmanship of this wall hanging suggests that it was commissioned by the emperor Daoguang (1821-1850), the exclusive employer of the best Chinese craftsmen. The colophon beneath the dragon's head reads: "The Emperor and the Empress bring you tidings of Good Omens."

Bride's headdress, China, Qing dynasty, 18th/19th century. Silk, gold wire, jade, pearls, rose quartz, kingfisher feathers. 21.6 cm. h. Gift of Mrs. J. Churchill Owen. 1973.23

Headdresses like this could be worn only by Manchu princesses. A dazzling combination of materials, in keeping with the royal status, was used to form motifs appropriate for a bridal costume: the phoenix, a symbol of peace and prosperity worn by every bride on her wedding day; the bat, a symbol of longevity and happiness; and the butterfly, an emblem of joy and conjugal felicity. Mounted on gold wire springs, the ornaments quiver as the wearer moves, creating a delicate, shimmery effect.

Uncut collar, China, Qing dynasty, 18th century. Silk and gold threads on silk brocade. 1.27 m. dia. Charles Bayly Jr. Collection by exchange. 1951.18

Elaborate ornamentation of dragon robe accessories, such as collars, lapels, and cuffs for horses' hooves, flourished during the reign of Emperor Yongzheng (1723-1735). This uncut blue collar is embroidered with two four-clawed dragons, described in Chinese literature as having the heads of horses and the tails of serpents. The dragon's nine ideal characteristics, or resemblances, are easily seen here: horns like a stag, forehead like a camel, demonlike eyes, ears like an ox, neck like a snake, belly like a sea monster, scales like a carp, claws like an eagle, and pads like a tiger.

Pair of orphreys, Germany, Cologne, 15th century. Linen. Each band 94 x 7 cm. Neusteter Institute Fund. 1970.182.1-2

Orphreys are decorative borders used in various configurations to ornament chasubles, dalmatics, and copes, outer vestments worn by ecclesiastics. The narrow width and extreme length of these orphreys suggest that they were used on a dalmatic or chasuble since copes required wider borders. In the 13th century when Cologne became the center for weaving such bands, patterns came from Paris, but by the 15th century weavers had adopted distinctive decorative patterns drawn from paintings produced by the Cologne school. The unique designs, Gothic lettering, and complicated weave of 15th century Cologne borders make them prized possessions in museum collections.

Embroidered panel, Spain, 16th century. Silk and metallic threads on linen. 86.4 x 62.9 cm. Simon Guggenheim Memorial Collection. 1952.70

In 15th and 16th century Spain, stories of saints and heroes were frequently used as themes for embroideries. Artists or their assistants usually painted the cartoons for the embroiderer to follow, but designs were also taken from woodcut illustrations of Biblical scenes published in Florence or Venice. Although they now constitute a rectangular unit, these six scenes, illustrating events following Christ's Resurrection, were probably originally arranged in bands to form an altar frontal or an orphrey for a chasuble. Rich metallic and silk embroidery was common in ecclesiastical attire of the period.

Avatars of Vishnu (detail), pair of rumals, India, Himachal Pradesh, Chamba Valley, 17th century. Silk thread and foil strips on cotton. Each rumal 183.8 x 33. 1 cm. Anonymous gift. 1965.13ab

The embroidery of ceremonial rumals was a traditional craft in the Chamba Valley on the western edge of the Himalayas. Used as offerings to deities or as bridal gifts, Chamba rumals were first documented in the 16th century and showed little change in pictorial style in later times although interwoven silver threads and a predominance of blue were favored in the 17th century. Employing untwisted, multicolored silk threads in a relief technique called *dorukhā,* the embroiderer filled in motifs drawn in charcoal by an artist on thin Punjab homespun. Because the Hindu Vaishnava cult was prominent in Chamba during the 17th and 18th centuries, designs representing Vishnu and his incarnations were popular.

Feast of the Passover, embroidery, Flanders, 1515-1525. Silk and gold- and silver-wrapped threads on velvet. 50.9 x 191.9 cm. Gift of The Fashion Group, Inc., Denver Regional Group. 1964.122

This is one of four embroidered panels thought to have been the border hangings of a canopy, or baldachin, which was carried over the Host and the holy cross during church processions. Such canopies were first used in the 14th century when the Corpus Christi procession was very popular. Part of a traditional iconography, the four panels of this set represent: *Abraham and Melchizedek* (Allen Memorial Art Museum, Oberlin, Ohio); *Gathering of Manna* (The Baltimore Museum of Art); and *The Last Supper* (Christ Church, Cranbrook Academy of Art, Bloomfield Hills, Michigan), as well as *The Feast of the Passover.* Embroidered on red velvet with fine needle painting on the faces, the panels employ the costumes and narrative style characteristic of the Netherlands during the first quarter of the 16th century.

Altar frontal, Italy, c. 1475. Velvet brocade, gold cloth. 73.8 x 205.9 cm. Purchased with gifts from Mrs. J. Churchill Owen and an anonymous donor. 1961.66

The vestments and trappings of the Roman Catholic church have provided textile collections with some of their finest treasures. Particularly rich pieces were made during the 15th century, a period distinguished throughout Europe for the production of fine velvets and gold cloth. Gold work was the specialty of Italian weavers, and the convent workshops of the Via Ghibellina in Florence were considered the finest producers of altar frontals, often given to a church sanctuary in celebration of a royal wedding. This beautiful frontal of red velvet brocade on gold displays the pomegranate motif popular at this time.

Brocade fragment, Italy, Lucca, 14th/15th century. Silk. 45.7 x 50.8 cm. Neusteter Institute Fund. 1967.10

Following the fall of the Sicilian house of Hohenstaufen in 1266, southern Italian weavers emigrated to the Ghibelline textile center of Lucca in Tuscany, where they made the small city famous for the production of silk fabrics in the 14th and 15th centuries. Although weavers continued to rely on symmetrically organized Romanesque-style compositions of heraldic animals and birds, strong influences from the Orient brought a new liveliness and rhythm to the designs. The flaming ray pattern in this fragment from an ecclesiastical vestment is one of the Eastern motifs appearing frequently in Lucca textiles.

Sampler, England, 1794. Cotton thread on linen.
57.2 cm. sq. Julia Wolf Glasser Collection. 1965.167

The term "sampler" comes from the French *exemplaire,*
initially anglicized as "exampler." Samplers were first
made toward the end of the 15th century as a means of
practicing stitches and recording embroidery patterns.
By the early 17th century they had become part of basic
schooling for girls and a social pastime for women. Signed
and dated samplers first appeared during the reign of
Charles I (1625-1649). This 18th century example by 10-
year-old Sarah Webb was executed during a transitional
period in sampler design. Formerly long and narrow,
samplers were now nearly square, and a center inscription
was bordered by multicolored pictorial motifs in a variety
of embroidery stitches.

Sampler, United States, 1823. Silk thread on linen.
40 x 38.5 cm. Julia Wolf Glasser Collection. 1965.114

By the 18th century, needlework had become part of the
curriculum at American private schools for girls. Teachers,
many of whom came from England, usually provided
sampler designs for their pupils to follow, with buildings,
trees, birds, and flowers being the favored motifs.
American samplers typically displayed an overall use of
cross-stitch worked in silk or cotton thread on linen, the
most common background material well into the 19th
century. Following the custom of including the teacher's
name and school, this charming sampler tells us that Lany
Nestell, aged 14 years, was instructed by Mrs. Sally Ackley
at the Oppenheim School.

First sampler:

THY Hand unseen sustains the Poles
On which this huge Creation rolls
The starry Arch proclaims thy Pow'r
Thy Pencil glows in evry Flow'r
In thousand shapes and Colours rise
Thy painted wonders to our Eyes
Whilst Beasts and Birds with labring Throats
Teach us a God in thousand Notes
The meanest Pin in Nature's Frame
Marks out some Letter of thy Name
Where Sense can reach or Fancy rove
From Hill to Hill from Field to Grove
Across the Waves around the Sky
There's not a Spot or deep or high
Where the Creator has not trod
And left the Footsteps of a God

First unto God thy humble homage pay
The greatest this and first of laws obey

Sloop William Webb Edward Webb

Sarah Webb April the 30 1794 Aged 11 Years
Instructed by the two Sisters E and S Taylor

Second sampler:

ABCDEFGHIJKLMNO PQRSTTUV
abcdefghiklmnopqrstuvwxyz.1234567890 &c

Eany Restell

Placed on the coast of youth my mind
Lifes oppining scene surveyd
...... of various kind

Afflicted and afraid hell wretch and
Eany Restell Sampler bray nigh and
was markd Sept 23 away fight away
1823 Aged 14 years and wi

Mrs Sally Ackley Teacher Oppenheim 1823

The Triumph of Mars (detail), tapestry, Flanders, c. 1725. Wool, silk. 3.36 x 6.51 m. Weaver's mark "D. Leyniers" (?). Gift of Mrs. Verner Z. Reed. 1933.26

The Triumph of Mars is one of a series of five tapestries commissioned in 1716 for the castle governor's house in Ghent. Cartoons for the series, which included triumphs of Minerva, Venus, Diana, and Apollo and the nine Muses, were created by Jan van Orley (1665-1735), designer of the foreground scenes, and Augustin Coppens (born c. 1668), who provided the landscape backgrounds. Woven in the Brussels atelier of Urbanus Leyniers (1674-1747), the initial set had borders resembling frames carved with a profusion of foliage. Subsequent sets varied both in size and number according to the space to be decorated. The last set was woven in 1734. A slightly smaller *Triumph of Mars* from this series is in the Royal Museums of Art and History, Brussels.

December, tapestry, Flanders, c. 1530. Wool. 3.84 x 3.14 m. Atelier mark of Willem de Pannemaker. Gift of W. Averell Harriman in memory of his mother, Mrs. E.H. Harriman. 1944.20

In the 15th and 16th centuries tapestries were usually designed as narrative series intended to cover the massive interior walls of important buildings. Since artists' fees were high, several sets were often produced from a single group of designs. Woven with lavish amounts of gold and silver thread, the first set of *The Months of Lucas,* the series from which this tapestry comes, was commissioned for Infante Ferdinand of Portugal about 1510. The set survived until 1797 when it was burned to salvage the metal. The atelier mark of Brussels weaver Willem de Pannemaker indicates that the museum's tapestry, from a set which once belonged to Pope Urban VIII, was made before 1550. Original designs for the series have long been credited to Lucas van Leyden (1494?-1533), but recent scholarship has rescinded the attribution, leaving the artist unknown.

Embroidered burial mantle (detail), Paracas culture, Peru, 300-100 BC. Wool. 1.24 x 2.24 m. Mr. and Mrs. Samuel Gary, Neusteter Institute Fund, Mr. and Mrs. Alvin L. Cohen, Mr. and Mrs. Thomas E. Congdon, Miss Hannah Levy, Mr. and Mrs. Frederick R. Mayer, Mr. and Mrs. Thomas Taplin, Mr. and Mrs. Morris A. Long, Mr. and Mrs. Irving Shwayder, Mr. and Mrs. Edward M. Strauss, Mr. and Mrs. Myron Miller, Mrs. Charles Rosenbaum, Margaret Powers, and the Denver Art Museum volunteers. 1980.44

Since its discovery in 1925, the Paracas necropolis on the south coast of Peru has yielded over 400 mummy bundles, each consisting of a dried body that had been placed in a shallow basket and then wrapped in a large, embroidered shroud, or mantle. Cloth for the mantles was normally woven by women and embroidered by men, who executed stylized designs with a few simple stitches in superbly blended colors. The figures here represent anthropomorphic condors holding trophy heads, a popular motif in pre-Columbian art. In its meticulous execution, sophisticated design, and excellent state of preservation, this mantle ranks among the finest examples of textiles from the ancient Paracas culture.

Josep Grau-Garriga (b. 1929), Spanish, *Ecumenisme,* tapestry, 1969/70. Wool, copper wire. 3.33 x 3.99 m. Signed lower right. Neusteter Institute Fund, Estate of John C. Long, Elizabeth Firth Wade Endowment Fund, and special subscription. 1972.120

Like painting and sculpture, tapestry in the 20th century broke with tradition and emerged in new and experimental forms. Josep Grau-Garriga, one of the world's leading contemporary tapestry artists, was a noted collagist and creator of designs for murals and stained glass before turning to tapestry in 1957. He spent the next year working in the studio of Jean Lurçat (1892-1966), the French artist primarily responsible for the revival of interest in the art of tapestry. Grau-Garriga typically combines a variety of weaving techniques and media to produce his bold, sculptural textiles. The design for *Ecumenisme* began in 1969, and the execution was completed in March 1970 at the Escola Catalana de Tapis, Sant Cugat del Valles, Barcelona.

Turban, Chancay culture (?), Peru, c. 1000. Feathers, cotton. 48.4 cm. h. Gift of James Economos in memory of Alan Lapiner. 1975.52

Feathers were one of the principal materials used to ornament Peruvian clothing. In Inca times, the decoration became so popular that feather depots were set up to ensure an adequate supply of plumage from hummingbirds, toucans, parakeets, and macaws, brilliantly colored birds not native to central Peru. Attached to garments in previously assembled horizontal bands, feather ornaments often created the impression of birds in flight as the wearer moved. Because of their varied colors and delicate size, hummingbird feathers were used on ponchos while coarser specimens were selected for fans and headdresses. Only a few turbans have been recorded to date.

Plush hat, Tiahuanaco culture, Peru, 10th/11th century. Wool. 10.2 cm. h. Neusteter Institute Fund. 1968.190

Four-cornered caps, similar in shape to ecclesiastical birettas, were worn in a limited area in southern Peru. While the shape is thought to have originated with the coastal Nazca culture (100 BC-AD 700), many later examples bear the geometric motifs associated with the highland Huari/Tiahuanaco civilization, which had spread its influence over most of Peru by the end of the 10th century. Illustrating another Peruvian textile technique, this cap is made of plush, a velvetlike fabric produced by trimming the loose ends of threads knotted through a net base.

Plaited band (detail), Nazca culture, Peru, 400. Wool. 2.03 m. l. Neusteter Institute Fund. 1968.189

Primitive plaiting is usually associated with basketry rather than fiber art, but in Peru, where a high level of weaving technology was established as early as 2000 BC, weaving principles were applied in plaiting. In this complex technique, the colored diagonal bands are woven so that they are seen crossing continuously from right to left and intermittently from left to right. Because the threads are worked at a 45-degree angle, each strand reverses direction at a right angle at the selvage. This example is woven in six colors rather than the customary four. The extreme length of the fabric suggests that it was used as a wound turban or a waist wrapping for a plain poncho.

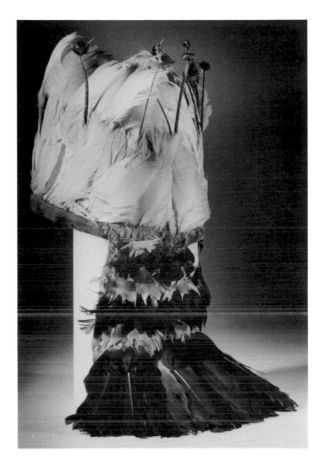

Colcha, United States, New Mexico, c. 1875. Wool thread on wool homespun. 2.29 x 1.44 m. Gift of Mrs. Frederic H. Douglas. 1956.54

Embroidery was the primary decorative art practiced by Spanish colonial women from the time of their arrival in New Mexico with the Oñate expedition in 1598. Colchas, crewellike embroideries worked on wool homespun or cotton twill, were commonly used as bedspreads, furniture coverings, and altar cloths. Executed in colors obtained from native vegetable dyes, the floral designs reflect Asian and Moorish motifs found in Spanish decorative arts. Because early pieces were destroyed in the Indian uprisings, most surviving colchas date between 1700 and 1850, after which their popularity declined.

Fabric tree, Chancay culture, Peru, c. 1300. Cotton, rushes, wool, straw. 71.2 cm. h. Neusteter Institute Fund. 1969.503

In the Chancay culture, fabric dolls and trees often constituted part of the grave goods buried with the deceased. Trees were made to resemble the pacay, a Peruvian species whose pods produce a sweet pulp still eaten by the Indians of the coastal Chancay Valley north of Lima. Rushes bunched together and wrapped with brown cotton thread form the trunks and branches, which are decorated with woven wool seed pods and little birds made of straw covered with loop-chain needlework. Perched at the top of this tree, a doll wears a costume which demonstrates the remarkable virtuosity of ancient Peruvian weaving techniques rather than accuracy of garb. Examples of fabric trees from Chancay graves are rare.

Colonial tapestry, Peru, late 17th/early 18th century. Wool, cotton. 3.1 x 1.73 m. Neusteter Institute Fund. 1970.346

When they arrived in Peru early in the 16th century, the Spaniards were amazed to find a native textile industry more advanced than their own and promptly set up workshops for the production of wall hangings, table covers, and rugs, as well as clothing. Imported yarns were combined with native cotton and wool to increase textural variety, but weavers apparently continued to use native dyes. In European tapestry weaving, natural breaks occurred at the point where colors changed; Peruvian weavers, however, used a technique which eliminated these slits and made most of their tapestries reversible. The presence in the central panel of the double-headed eagle, a motif associated with the Hapsburgs, suggests that this hanging was woven during that family's control of Spain, which ended in 1700.

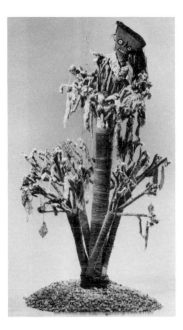

Elizabeth Ann Cline, *Steeple Chase* (detail), pieced quilt, United States, c. 1865. Cotton. 2.08 x 1.81 m. Gift of Charlotte Jane Whitehill. 1955.85

Quilt making gave American women an opportunity to express their artistic creativity while producing practical items for their homes. After long winter evenings spent sewing decorative quilt tops, women gathered together socially during the spring and summer at quilting bees, where they joined the tops to filler and backing with thousands of tiny stitches, each ideally one-sixteenth of an inch long. Quilt patterns, which varied with each maker, were generally based on natural motifs, while pattern names often reflected geographic origins or social or political interests. Here, the artist has created a stunning visual effect by her skillful arrangement of 20 different blue and white printed cottons in a pattern called *Steeple Chase*.

Archibald Davidson, *Liberty and Independence* (detail), coverlet, United States, Ithaca, New York, 1830. Wool, linen. 2.06 x 2.05 m. Signed and dated lower left and right corners. Gift of James Economos. 1976.130

Joseph-Marie Jacquard (1752-1834) revolutionized the technology of pattern weaving when he introduced his card-fed loom at the Paris Exposition in 1801. By 1824 a Jacquard attachment for the handloom had been introduced in the United States, making it possible for guild-trained European weavers working here to create pictorial, as well as rectilinear, designs. The high cost of the apparatus soon led weavers to regulate competition by purchasing patent rights for specific geographic areas. One of the first to do so was Scottish weaver Archibald Davidson, who purchased rights for Ithaca, New York, "superior to any patent heretofore in the United States for weaving carpet and carpet coverlets." Davidson was noted for his fine coverlets bearing patriotic motifs.

289

Hands All Around, pieced quilt, Amish, United States, c. 1910. Cotton. 2.41 x 1.6 m. Gift of Marcia Spark. 1974.153

Amish quilts, produced in Pennsylvania and the Midwest, are unique in the tradition of American quilt making. Because their religious scruples forbade the use of patterned cloth, Amish quilt makers executed beautifully balanced geometric designs in intensely colored plain wools and cottons. The most remarkable features of their work were the decorative hex signs, stars, pinwheels, and botanical motifs exquisitely quilted across the surface. This version of *Hands All Around,* a traditional pattern from the Ohio area, displays various shades of rose and turquoise on a black ground with finely quilted vine motifs in the outer borders.

Appliquéd quilt, United States, Hawaii, c. 1930. Cotton. 1.85 x 1.9 m. Gift of Wilma Cason. 1978.149

The art of quilt making was first introduced to Hawaiian women over 150 years ago by the wives of New England missionaries. Lacking a common spoken language, the women turned to needle arts as a means of communication. The Hawaiians, accustomed to making and using a beaten bark cloth (tapa) for clothing and other fabric needs, were slow to acquire sewing skills, but as their proficiency increased they developed unique styles and methods of needlework, such as their manner of quilt making. Although they employ New England stitching techniques, Hawaiian quilt makers cut their appliqué designs in one piece from a single length of cloth instead of assembling them from many pieces of different fabrics in the mainland fashion. This example is unusual because the design has been executed in two colors rather than the customary one.

Charlotte Jane Whitehill (1866-1964), American, *The Tomato Flower,* appliquéd quilt, 1931. Cotton. 2.21 m. sq. Signed and dated on back. Gift of Charlotte Jane Whitehill. 1955.66

Charlotte Jane Whitehill, who made the first of 29 quilt tops at the age of 63, was prominent in the quilt-making revival which swept Kansas in the early 1930s. *The Tomato Flower* is a superb example of her artistry, as well as of the appliqué technique. Unlike pieced quilts, which lend themselves to allover designs and random quilting patterns, appliquéd quilts give the artist an opportunity to elaborate complex designs and to display her skill in executing complicated quilted motifs. The quilted figures of circles, hearts, and birds in this pattern suggest that it may originally have been made for a wedding.

Length of needlepoint lace (detail), Belgium, Brussels, 19th century. 26.6 x 180.5 cm. Gift of Mrs. J. E. Springarn. 1963.96

While the Italians claim to have invented needlepoint lace, it was Belgian lace makers who brought its production to a high art in the early 19th century and gained international recognition for their perfection of workmanship. Known variously as rose point, *point à l'aiguille, point de gaze,* and *point de Venise,* point lace is worked directly over a design drawn on parchment or paper. The extremely fine thread used to create this filmy delicacy is spun from flax grown especially for the purpose in Saint-Nicolas, Tournai, and Courtrai. In this example of early Brussels lace, the interlocking mesh, or *réseau,* background was worked simultaneously with the floral designs, a time-consuming technique rarely practiced today.

Pair of men's gloves, England, 17th century. Leather, silk, gold and silver cord, gold and silver lace. 30.5 cm. l. Neusteter Institute Fund. 1965.152ab

Gloves, albeit fingerless ones, existed as early as the Twenty-First Dynasty (1185-950 BC) in Egypt. In later European times they were worn as symbols of protection, power, and security. In 17th century England, they acquired romantic associations when it became customary for a man's mother to present his bride-to-be with a pair of gloves, an act intended to cement the relationship between the two families. This pair from the Stuart period reflects the change from the stiff, overly decorated late Renaissance styles of Elizabeth I and James I to the graceful baroque style of dress favored by Charles I, who ascended the throne in 1625. Imported from France or manufactured in England from fine Spanish leathers, gloves were an important and extremely expensive part of 17th century male attire.

Gown, France, c. 1750. Silk brocade, lace. Neusteter Institute Fund. 1963.282

Ruffles, lace, ruching, and ribbons adorn this exquisite example of the rococo style of dress brought into fashion by Louis XV's influential mistress the Marquise de Pompadour (1721-1764). The graceful sweep of the gown is enhanced by "Watteau pleats"—double box pleats falling freely from the back of the neckline to the ground—named for the French artist famous for his elegant portrayals of the *haut monde.* To achieve the refined silhouette demanded of the fashionable, both men and women made relentless use of corsets, whose construction rose to a fine art during this period. The rich silk brocade is a superb example of the sumptuous fabrics manufactured in France for export, as well as for use at home.

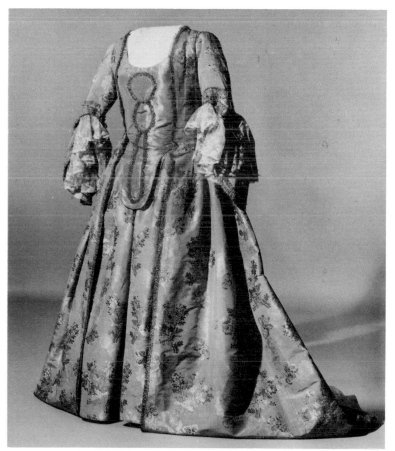

Bridesmaid's dress, England, c. 1835. Cotton challis, Neusteter Institute Fund. 1969.274

Between 1830 and 1840 the classic Empire style gave way to the romantic gowns of the early Victorian period. Enormous sleeves known as "gigots" were a distinctive fashion trait during the transition. By widening the arms and shoulders visually, the sleeves minimized the waist, which was gradually descending from its Empire heights to a more normal placement. To support the sleeves' balloon shape, ladies wore special underbodices incorporating down cushions. Increased trade with India made fabrics printed with floral motifs on soft background colors commonly available.

Man's suit, France, c. 1775. Embroidered silk and velvet brocade. Gift of Alexander Girard. 1963.109.1-4

The three-piece suit was standard male attire throughout the 18th century, and accessories such as padded stockings, powdered wigs, and tricorn hats completed the costume. Richly patterned fabrics embellished with colorful embroidery were favored during the early part of the century, but by the 1770s trade with Asian countries had introduced materials woven in smaller patterns and more subtle colors. The monarch himself, Louis XVI, contributed to 18th century fashions by launching the handsomely buckled round-toed shoe with a shaped heel known as the "Louis heel."

Wedding gown, United States, 1881. Silk, silk damask, seed pearls, crystal beads, lace. Gift of Miss Edith Thomas. 1942.30ab

Toward the end of the 19th century, French couturier designs, as well as luxurious fabrics from the mills at Lyons, came into vogue in America. Charles Frederick Worth (1826-1895), generally considered the founder of Parisian *haute couture,* was the first European couturier to sell designs specifically intended for transatlantic copy. Although this damask gown, lavishly trimmed with beads and pearls, does not carry the Worth label, it represents many fashion innovations introduced by that influential Englishman. Bustles gave way to a back fullness achieved through drapery, and the "cuirasse" bodice often had a square, low-cut neckline to emphasize the vertical line. This gown was worn in Leadville, Colorado, by Mary Godell on January 18, 1881, when she married James B. Grant, the state's governor from 1883 to 1885.

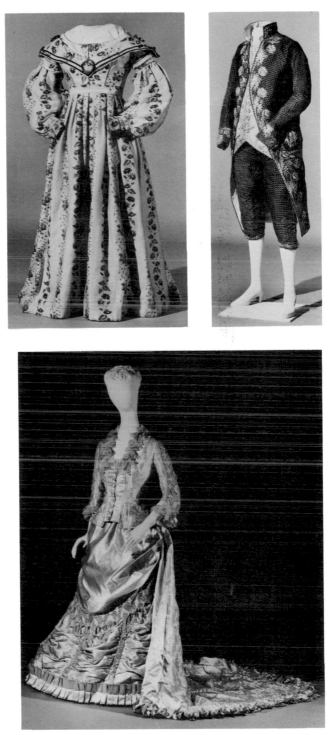

Dress, United States, c. 1875. Silk taffeta. Gift of Mrs. William Downs. 1956.79ab

Costumes of the 1870s reflected the growing prosperity of the times. Wealthy women chose silks and velvets for their gowns while those of lesser means opted for wools and cottons. But whether a dress was plain or fancy, it was the undergarments that established a fashionable silhouette. Figure-molding corsets built of wire, steel, canvas, and whalebone, padded with horsehair and stiffened with gauze, were covered with fine lawn and decorated with lace. Camisoles and petticoats were piled on top of this formidable construction to soften the line of the bodice and support the skirts, which were tucked, swagged, and fringed to give a well-made appearance. As a final touch, a decorative fan pocket was often sewn on the skirt to carry a lady's favorite accessory.

Court gown, England, 1924. Silk satin, silk velvet, sable, rhinestones, pearls, bugles. Gift of Mrs. Uvedale Lambert. 1972.123

Following World War I, *haute couture* underwent a drastic change. As increased numbers of women joined the work force and demonstrated for women's suffrage, restrictive gowns and corsets were discarded in favor of more functional raised hemlines and unshaped dresses. A straight silhouette and patterned beading distinguish this elegantly understated gown, a sharp contrast to the regal shapes and exaggerated embellishments of the Edwardian era. For court occasions, the gown's tubular form was given a royal air by the fur-trimmed train, a fashion which originated in the early 15th century. For less formal affairs, it could be worn without the train, which is detachable at the shoulders.

Cristóbal Balenciaga (1895-1972), Spanish, evening gown, c. 1965. Silk satin, net, sequins. Gift of the Smithsonian Institution, National Museum of History and Technology. 1979.253ab

Among the giants of 20th century couture was the Spaniard Cristóbal Balenciaga. The son of a seamstress, he operated his first tailor shop at the age of 20 and soon established the design firm known as "Eisa" in Madrid and Barcelona. In 1937 he opened his Paris salon on the avenue George V, where, with the introduction of fashions such as the chemise, the sack, and the soft-shouldered suit, he acquired an international reputation as "the prophet of the silhouette." This classically simple satin gown and sequin-decorated jacket illustrate Balenciaga's insistence on the finest materials and perfection of construction, standards which challenged even the most gifted tailors.

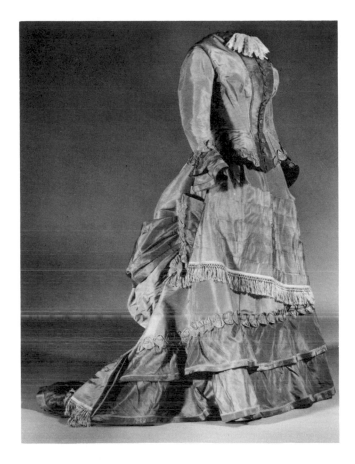

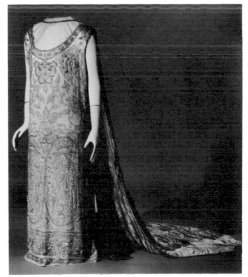

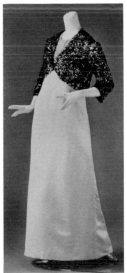

Index